art:21

Laylah Ali

Ida Applebroog

Cai Guo-Qiang

Ellen Gallagher

Arturo Herrera

Oliver Herring

Roni Horn

Teresa Hubbard / Alexander Birchler

Mike Kelley

Josiah McElheny

Matthew Ritchie

Susan Rothenberg

Jessica Stockholder

Hiroshi Sugimoto

Richard Tuttle

Fred Wilson

Krzysztof Wodiczko

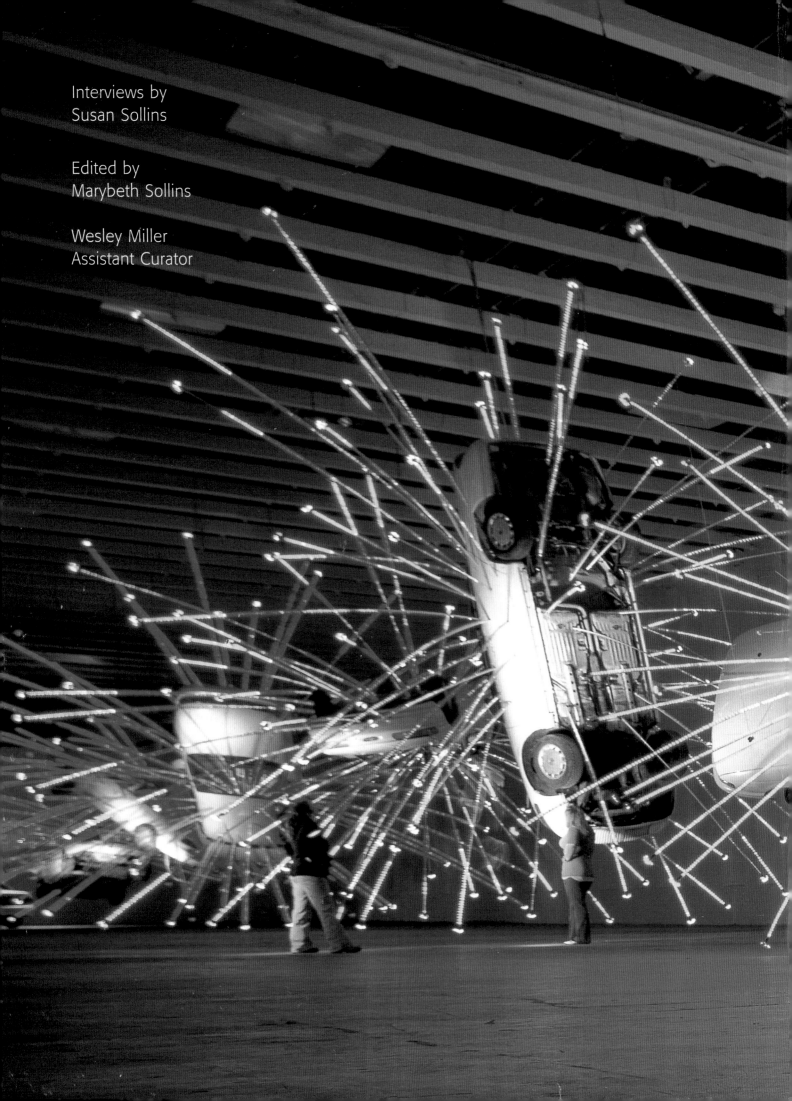

Interviews by
Susan Sollins

Edited by
Marybeth Sollins

Wesley Miller
Assistant Curator

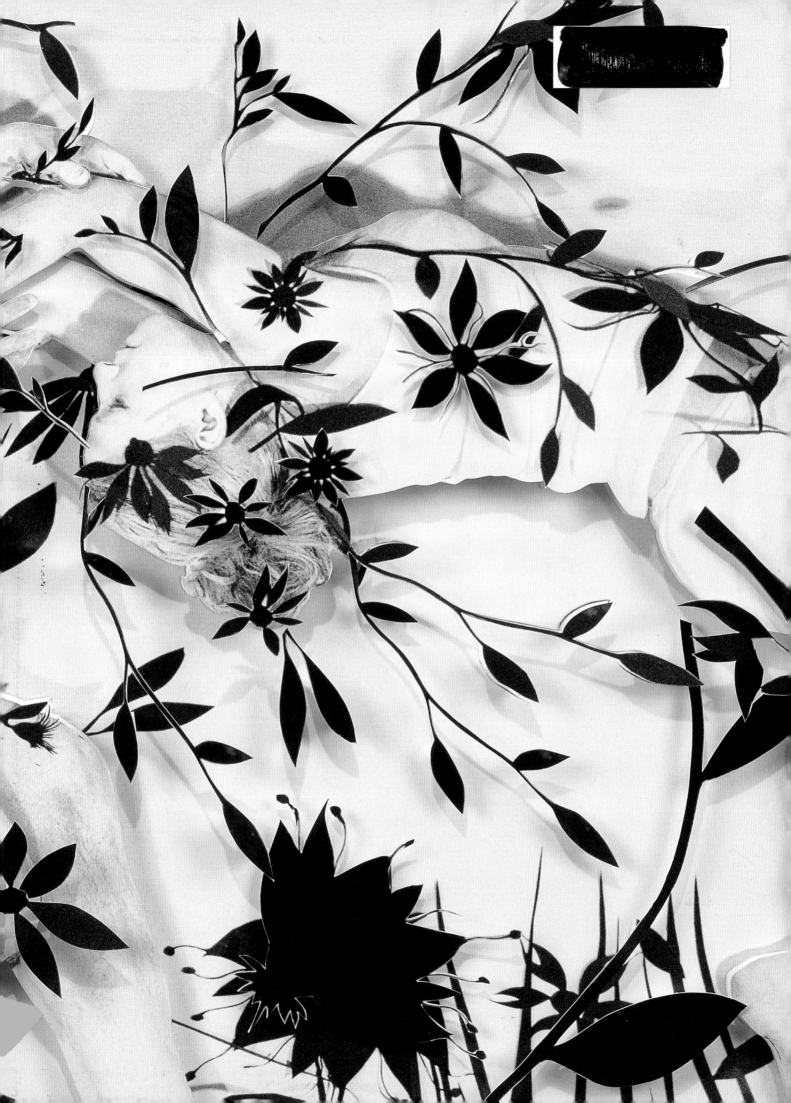

art:21

ART IN THE TWENTY-FIRST CENTURY

3

HARRY N. ABRAMS, INC., PUBLISHERS

Contents

Foreword

Acknowledgments

Commissioned Video Segments

Power

Memory

Play

Structures

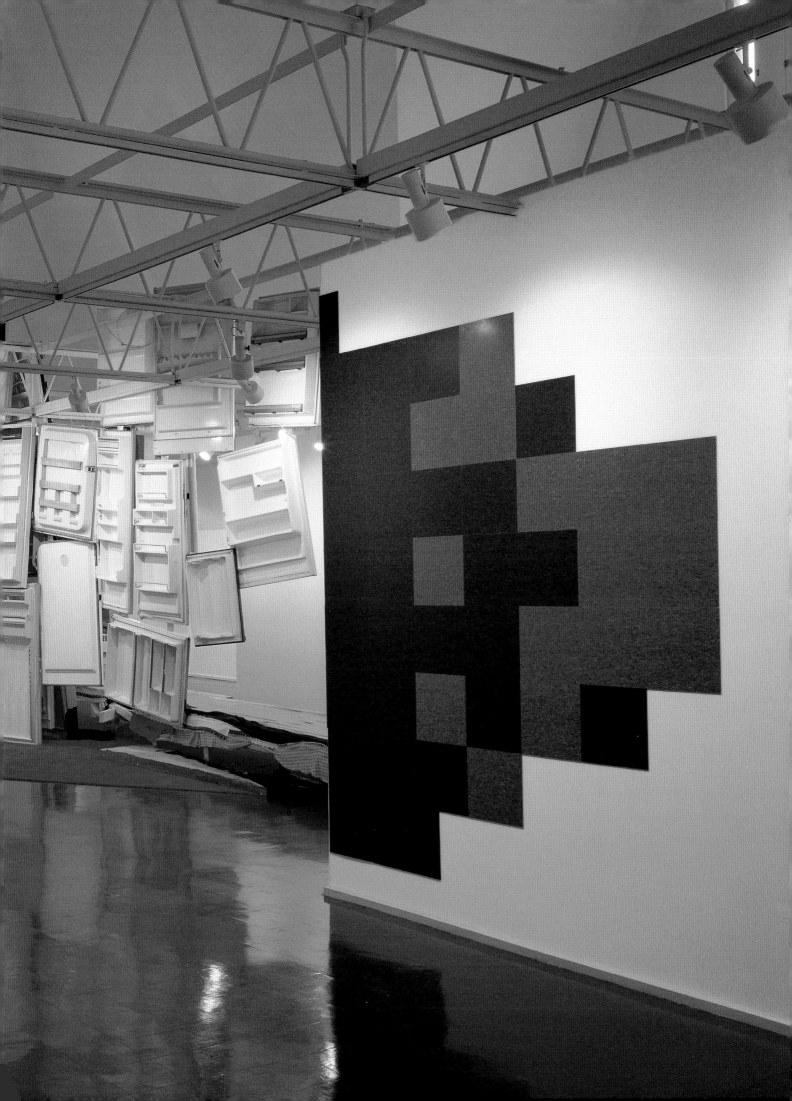

Foreword

The unknown is where I want to be.
—Roni Horn

If the unknown is the space in which creativity flourishes, I want to bring it forward, illuminate it for others, and revel in it. This is Art 21's work—to reveal the existence of those regions which all the Art 21 artists traverse, forging paths of exploration and study that take them into uncharted realms of creativity. By revealing the existence of those unknown territories, inhabited by all creative thinkers, I hope to educate, delight, and provoke.

It is difficult to imagine that anyone works harder than an artist. This—the non-stop work, accumulation of information, concentration, the need to be *in* the studio—is a continuing mini-theme for Art 21. Most artists experience intuitive leaps of recognition and connection, and find new ideas through introspection and research in many fields beyond art, although the art of the past remains a profound resource.

Through interviews during the past eighteen months, I have learned, for example, that Matthew Ritchie's true subject is information; that Susan Rothenberg hates limits; that Mike Kelley considers himself a Marxist who, contrary to common critical assumptions, dislikes popular culture rather than celebrating it. Metaphor, repetition, and narrative: these words recurred time and again. That language is a base for much visual work was a surprise; that drawing is crucial for almost all the artists, that a camera might be thought of as a chisel, that computer-based technology could inspire creative rejuvenation—these were revelations.

Each artist's studio speaks of intimate concerns. Images especially, mounted on walls for contemplation, told stories that were often new to me and striking. Stravinsky and Balanchine live on in photographs in Arturo Herrera's New York

studio; in his Berlin studio it is Matisse. For Sugimoto, it is Duchamp. In Richard Tuttle's New Mexico studio there is an *hommage* to artist-art dealer Betty Parsons. In his home a sublime painting by Agnes Martin illuminates a room. Folders filled with images cover one corner of Laylah Ali's studio wall, an unusual storage system for information that fuels aspects of her work. Stuffed birds, paintings from paint-by-the-numbers kits, works by naïve or untutored artists—all from country auctions—adorn walls at Ida Applebroog's upstate New York home; in her city studio, a table and chair painted with an image of a cow are poignantly humorous reminders of a conversation with her mother, long ago. A photograph of a Polish street sign on a studio desk reveals Krzysztof Wodiczko as a child "born on the ruins of war" to heroic parents, presaging the story of his youth in Poland.

This book cannot recount all that I discovered on location. You cannot see Cai Guo-Qiang's face, suffused with love, as he showed me his father's traditional Chinese landscape paintings on minuscule match boxes—nor, adjacent to Roni Horn's studio, the calm oasis of an extensive library that reveals her devotion to literature and language. Artists' hands move with practiced dexterity, and well-honed skills abound: Josiah McElheny making glass with master glass-blowers; Ellen Gallagher working with talented collaborators, creating a technically complex new print series; Sugimoto in the darkroom or at the drafting table; Oliver Herring using stop-motion as a cutting tool in video work; Jessica Stockholder creating a large installation; or Hubbard and Birchler collaborating as artist/directors.

Surprises were everywhere: Richard Tuttle practicing the piano; Mike Kelley's vast

record and cd collection; Ellen Gallagher, revealing herself as a carpenter who once worked bridge-building in Alaska; Arturo Herrera explaining that, as a Venezuelan, his influences include fragments of European, South American, and North American culture, with Disney and Picasso as much his heritage as the samba or pre-Columbian art. Fred Wilson revealed childhood sorrows still present deep within. He created a new piece as we filmed in his studio. Susan Rothenberg re-worked an entire painting on film. Oliver Herring spoke of learning English, explaining that his desire to attend a British university led him to apply to art school, where he thought fluency in English would be less important. Cai Guo-Qiang preferred not to speak English on camera, believing that he could only express his thoughts with appropriate eloquence in Mandarin or Fukinese; thus, our conversation was slow and thoughtful, moving from English to Chinese and back again.

Locations for this season included Iceland and Sweden, Berlin, Paris, São Paulo, Santiago de Compostela, and London, California, New York, Texas, and others. The book and television series represent two years of travel and conversation, of generous collaborations with artists, film crews, book and film editors, directors, Art 21's production, curatorial, and research team, and many others. Exhilarating and exhausting, remarkable in every way, it has been a journey into the creative unknown that has proven enormously rewarding. This is a place to which I want to travel again and again, whenever possible, in the company of artists such as those you will encounter in this book and television series.

Susan Sollins

Acknowledgments

I prepare these acknowledgments with pleasure, in anticipation of this volume's publication and the broadcast of Season Three, *Art:21—Art in the Twenty-First Century*. I extend my thanks to Art 21's diligent, dedicated staff, without whose creative vision this third season would not be possible. I am grateful to Eve Moros Ortega, Migs Wright, Wesley Miller, Alice Bertoni, Jessica Hamlin, Kathi Pavlick, Sara Simonson, and Kelly Shindler.

I thank Margaret L. Kaplan who has been a strong advocate at Harry N. Abrams, Inc., for the publication of all of Art 21's companion volumes, and Elaine Stainton for guiding this volume to publication. I am also grateful to Jacoba Atlas and her colleagues at PBS for their involvement and support; to Charles Atlas and Catherine Tatge; Elizabeth Donahue and Steven Wechsler; and to all who worked with us in the filming and production of Season Three.

Neither this volume, nor the television series, education programs, or website would exist without the generous support of Art 21's funders: the National Endowment for the Arts; the Public Broadcasting Service; Agnes Gund and Daniel Shapiro; the Nathan Cummings Foundation; the Jon and Mary Shirley Foundation; the Bagley Wright Fund; Bloomberg; the Horace W. Goldsmith Foundation; JPMorgan Chase; Melva Bucksbaum and Raymond Learsy; the Paul G. Allen Charitable Foundation; the Andy Warhol Foundation for the Visual Arts; Sonnenschein Nath & Rosenthal LLP; the Jerry and Emily Spiegel Foundation; the Gilder Foundation; the Daniel P. & Nancy C. Paduano Foundation; the Constance R. Caplan Foundation; Ronald and Frayda Feldman; Delta Air Lines; the O'Grady Foundation; the Kathy and Richard S. Fuld, Jr. Foundation; Bruce MacCorkindale; Lewis Bernard; Jeffrey Bishop; Furthermore, a program of the J. M. Kaplan Fund; the New York State Council on the Arts; and Jennifer and David Stockman. I also acknowledge the extraordinary, creative support of Art 21's Board of Trustees and distinguished Advisory Council for the Visual Arts, Humanities, and Education.

For the provision of images reproduced in this volume, I thank 303 Gallery; Blaffer Gallery; Miller Block Gallery; Tanya Bonakdar Gallery; the Contemporary Arts Museum, St. Louis; Crown Point Press; Dieu Donné Papermill; Ronald Feldman Fine Arts; Gagosian Gallery; Galerie Lelong; Jablonka Galerie; Matthew Marks Gallery; Mitchell Innes and Nash; PaceWildenstein; Max Protetch Gallery; Andrea Rosen Gallery; Brent Sikkema; Sperone Westwater Gallery; Two Palms Press; Donald Young Gallery; the Walker Art Center; and the Whitney Museum of American Art. I especially acknowledge Jen Aihara, Jordan Bastien, Martina Batan, Katie Block, Cliff Borress, Ellie Bronson, Josie Browne, Julia Chiang, Victoria Cuthbert, Amanda Elliot, Andrea Green, Simon Greenberg, Breck Ann Hostetter, Stephanie Joson, Michael Jenkins, Brad Kaye, Peter Krashes, Sarah Kurz, Jeremy Lawson, Emily Letourneau, Jennifer Wen Ma, Rita MacDonald, Simone Montemurno, Birgit Müller, Nicole Parente, Marlo Pascual, Sheri L. Pasquarella, Sarah H. Paulson, Ian Pedigo, Karen Polack, Renee Reyes, Natasha Roje, Mari Spirito, Gregg Stanger, Mary Clare Stevens, Lanka Tattersall, Charwei Tsai, Valerie Wade, and Lisa Williamson. I also acknowledge Art 21 interns Susan Agliata, Agnes Bolt, Mary Chou, David Mark Kupperberg, Jihan Robinson, and Jennifer Smith who assisted in compiling information for this volume. I also owe gratitude and appreciation to Jamie Bennett for his help.

The support and involvement of my sister Marybeth Sollins, who edited this volume and created the text from my interviews with the artists, has been invaluable. Her editorial skills, wisdom, and calm have made this book possible. To Russell Hassell, the designer who has applied his magical touch and talent to create yet another splendid Art 21 publication, I extend affectionate gratitude and admiration. In this third companion volume to the television series, he has once again designed a book that mirrors Art 21's spirit and philosophy. Wesley Miller worked ceaselessly with artists and galleries to select the images for the book and made important contributions in all phases of its production. We are grateful to him for his attention to myriad details.

To each artist in the series, I send heartfelt thanks for their generous and open participation in the series and its ancillary education projects. In closing, I acknowledge the generous participation of Agnes Gund. Her insights, wisdom, and support in many facets of this project have proven invaluable. Susan Dowling, Andy Griffiths, and Ed Sherin have all been creative participants and advisors. Their friendship and staunch support from Art 21's inception have given great joy.

Susan Sollins
Executive Producer and Curator
Art 21, Inc.

Commissioned Video Segments

Teresa Hubbard / Alexander Birchler

Teresa Hubbard and Alexander Birchler created a video segment for each one-hour program of the PBS television series. The images in this chapter are examples of their video installations.

ALEXANDER: I think it's important to understand that Teresa and I, we're not from the same place. It's very difficult to find a place where we both fit in. Our work becomes almost like our third persona because we collaborate. So we always try to find a place for that persona, this third place where we both have the same investment in terms of relation or attachment—or *dis*attachment. Because we felt that in places where one of us is much more there than the other, it was always difficult because one person was less integrated than the other one and that created an imbalance. And it's always been the work that we produce in a place that's part of the process of putting down roots. Integration is maybe too strong a word, but just a kind of dialogue with the place.

It probably points out exactly that contrast we're interested in—that we can, or that we do, make a work about this trailer home. Then a year later we make a work about this upscale suburban kind

of modernist house. . . . We're interested in these two stories because they are part of our experience. The place where we shot *Single Wide* (2002) is about five minutes away from our studio. We drove past there every day. And the house (*House with Pool,* 2004) that we chose is a house of a collector that we met in the process of looking for a location. So both of these worlds seem to be part of our everyday experience, and maybe more specific about where we live right now. But we've always tried to make work about where we live.

TERESA: Living where we live (in Austin), we find that there's a lot of source material. There's something about being a contemporary artist in a context where it's not a given that others understand what the hell that is. It's been important when we work on our projects that very often they're involved with people who have perhaps never been to a museum of contemporary art . . . which makes it very interesting. Because you have to explain yourself again and again and again— explain what you do, why you do it. So when you work with film crews you have to explain what it is, why you show video projections in a dark room.

Detached Building, 2001
High-definition video with sound transferred to DVD
5 min 38 sec, loop
Installation view, Kunstmuseum St. Gallen, St. Gallen, Switzerland

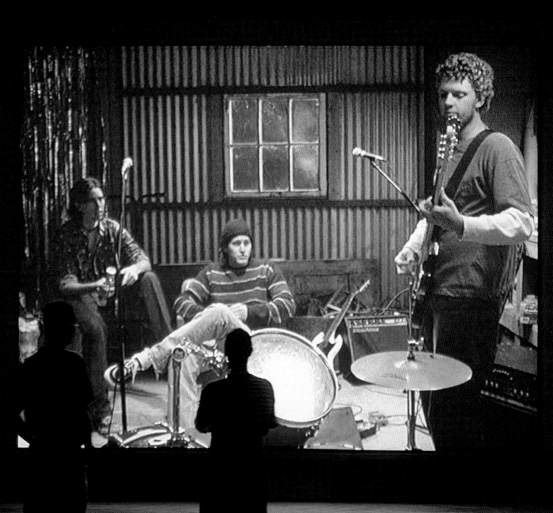

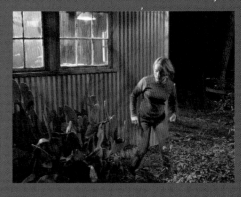

ALEXANDER: In our work there is this element of every-place. It's not the reason why the protagonists don't speak, but it lends itself to that reading. They become multilingual in their silence. There is enough openness in terms of where exactly this place is— it's not designated with signs or words or language—so this every-place is in the work. Even though you say you recognize a very specific place, and even though we draw our ideas from just in front of our doorstep, we quite consciously try to make this place a non-place, or an every-place, as much as one can make an every-place about something very specific. And because it's sort of about this non-place, it's much more like the memory of a place or the idea of a place.

TERESA: We come from photography— large scale photography, using large-format cameras. And part of how we thought of *these* works in the beginning was that we referred to them as *long* photographs. And coming from photography, we've also been very attached to taking Polaroids before and during a shoot to see where we're at. So, in one sense, turning to high-def video was about wanting a photographic, filmic look, but having the immediacy on set to see what it is that we're actually getting.

I want to imbue the shots, in some sense, with quite a conscious intensity, both with the camera work and the color— with heightened consciousness of both those elements—and this idea that the story has a shape.

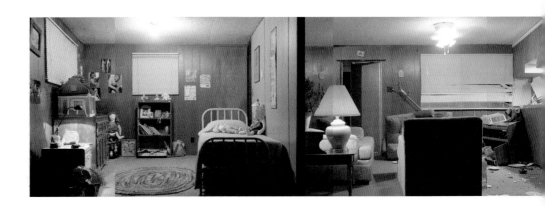

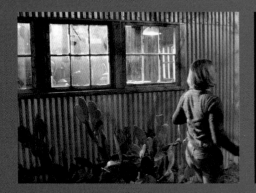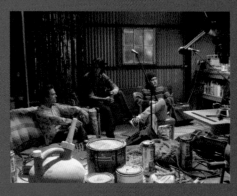

When we first moved to Texas from Berlin several years ago, *Eight* (2001), *Detached Building* (2001), and *Single Wide* were three works that we made in quick succession. Some people call them a trilogy. That makes sense, as in some ways they all share a structural interest where the story unfolds, it has a shape, and the shape is a physical shape that drives everything that unfolds in that story.

ALEXANDER: The biggest change—besides moving from photography to video work, these *long* photographs—was that the sound element allows us to expand the space beyond the frame—which was already an idea in photography. It's a new way to open up the possibility of telling stories. There's references to things you hear in our pieces now that you don't see, but you link them together. They are all scored. All the sound is post-production. We have sound recording on site, but we post-produce all the sound. We treat it entirely, so every cricket is pretty much scored. It's funny but it's true.

TERESA: Because we feel that sound—the audio environment—is to a large degree a dialogue of a different order, it also allows us to work with defining, but also confounding, the visuals. It's a way of extending the space beyond the frame of what's seen and not seen. And it also allows us to work with proximity and distance—again expanding the frame.

Hubbard / Birchler

ABOVE
Detached Building, 2001
High-definition video with sound transferred to DVD
5 min 38 sec, loop

BELOW
Set for Single Wide, 2003
C-Print on Fujicolor crystal archive paper, 18 ½ x 94 ½ inches

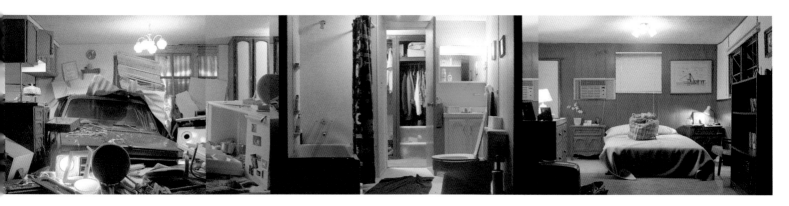

Hubbard/Birchler

Single Wide, 2002
High-definition video with
sound transferred to DVD
6 min 10 sec, loop

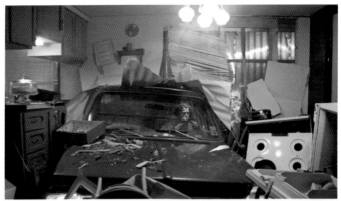

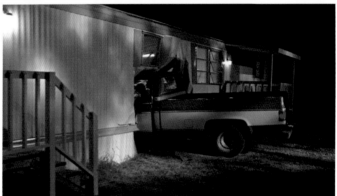

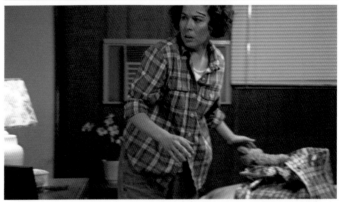

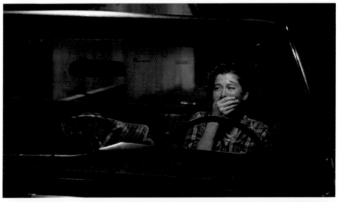

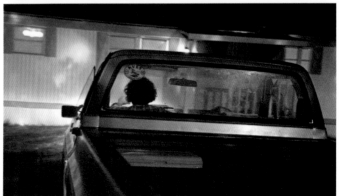

TERESA: In our early photographic works I
was really interested in looking at literature
written around the time that photography
entered the cultural mainstream. . . .
always looking at from which vantage
point, from which perspective, which
voice one is using, and how one can slip
between different voices. Specifically
looking at *Madame Bovary*, Flaubert
seemed to have written the book with
a camera strapped around his neck. He
would sort of swoop through the wall
and be zoomed in on Emma in her
moment of anguish. Then, the very next
sentence, we would be outside—from her
point of view as she's looking outside of
the room that enclosed her. The whole
build-up around her seemed to be shot
and counter-shot, and a zoom. He sees
the whole village and then, in the next
shot, he's in the cupboard with Emma.
There's the village, and also this kind of
slipperiness between the subjective and
the objective. And that's still the place
where I don't think we're finished explor-
ing. In a lot of the camera work that
we use it's this mechanical, objective,
unblinking, unfeeling eye that seems
not to give a damn. However there are
moments, rather like when you walk past
someone in trouble on the street, that
moment when you might pause, and
then obviously the decision is to keep
going or to stop and actually change
something. And particularly in this trilogy
(*Eight*, *Detached Building*, *Single Wide*),
one of the consequences of that unblink-
ing and uncaring eye is that it might slow
down but it's probably more slowing
down in a moment of curiosity rather
than one of sympathy.

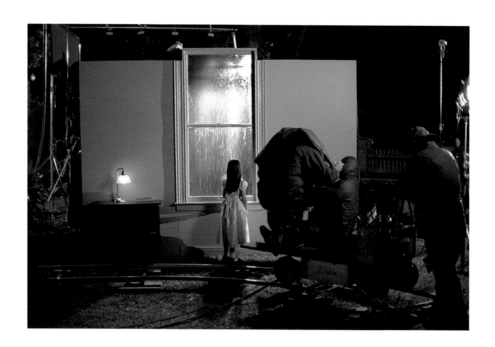

Hubbard/Birchler

ALEXANDER: In *Eight,* there's this girl who seems to be aware of something else at her party. We hear the kids in the background, maybe some adults, singing songs. She leaves the party; she goes outside. And she seems to have this obsession to try to get her piece of cake back inside. So, we are very close with her and she seems to see something as she looks outside. That's this moment of awareness—and the struggle is obvious. The struggle is to go through that rain. It's a metaphorical struggle, a girl in this nice dress being followed by the storm. And the storm is following her, even inside the house. So there's a moment of disturbance in this seemingly perfect setting of a young girl growing up in this very nice home. The loop is inherent to the story. It indicates a kind of self-centeredness. It's the charac-

ter's state of being. . . . And by seeing the story unfolding again and again, there seems a sense of a certain amount of obsession that becomes more and more obvious. It's like she always gets the piece of cake and never gets to eat it. She doesn't get to, so there's a very strong sense of obsession about that character.

One thing about these looping pieces is that at any point somebody can enter, and they're really creating their own meaning—depending on where they enter, how long they stay. It gives a different form of interpretation where it's basically up to the viewer. Of course, we structure these loops, and we think about every second—what happens if you come in or exit here—and make that structure. But in the end, we leave that open as with the beginning and the end of the story.

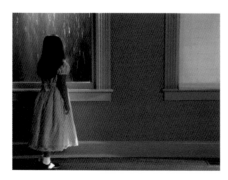

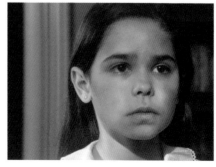

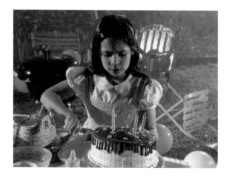

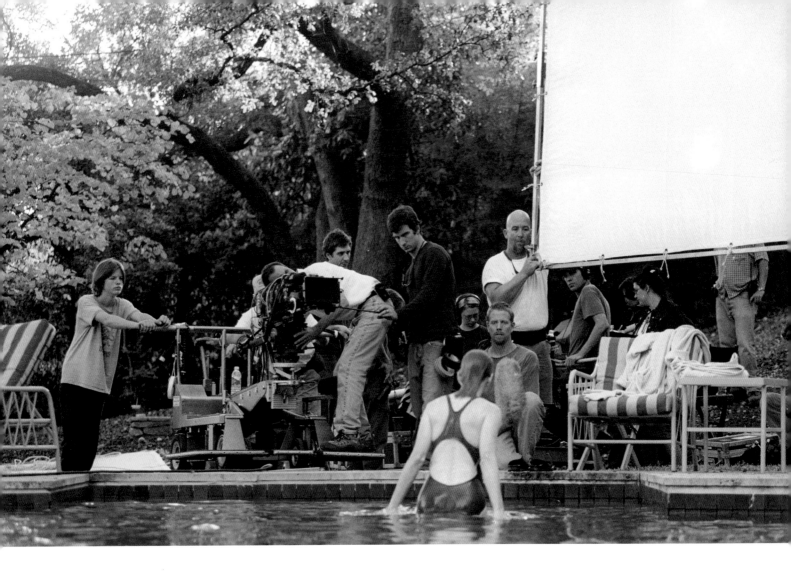

TERESA: Embedded in how we make and exhibit, and how we think about these works, is the requirement that a viewer participate in the authorship of the story. I don't want you to lose yourself in the same way that you're being taken on a rollercoaster ride, which is the common Hollywood experience.

ALEXANDER: Classic Hollywood—standard Hollywood—is you enter the cinema, you lose yourself, and you exit. What we do—you're going in and out—it's your entrance, your exit. There's complete absorption and then there's rejection of absorption. That's what we're trying to do—to reflect back onto you.

We play very consciously with the fact that we want to make the viewer aware of the medium in itself, or in the story—that you sort of step in and out of a story. It's not like we want a complete absorption, and then, "Boom, you're out of it!" But there's a moment when we strongly want you as a viewer—you're in this house, around the pool. . . . You're fully immersed. And then there's a moment when we go through the wall. For a moment, we want the person who's questioning that . . . and then the viewer is back into full immersion.

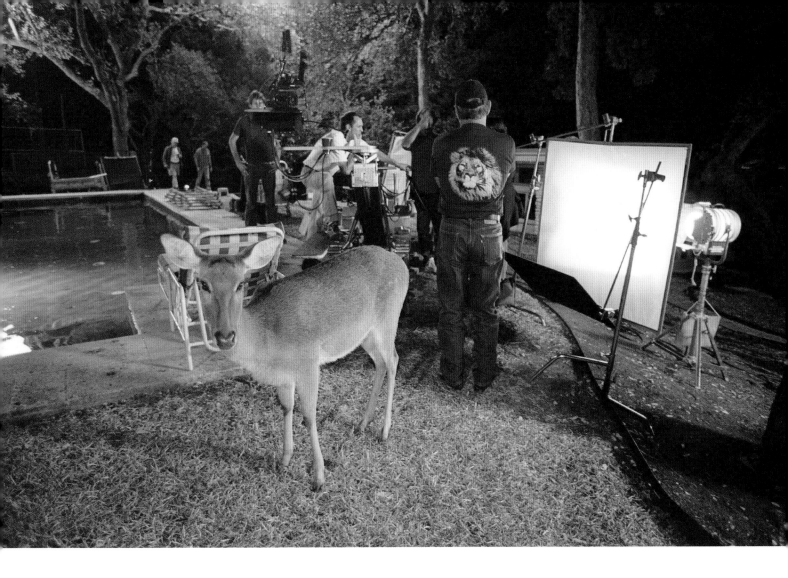

TERESA: *House with Pool* is a longer looping piece, with different readings, depending on when one enters. One person at the opening in New York came in when the young woman is putting a sweater on the chair. His reading was, "It's hers, and she's putting it there to be picked up later."

ALEXANDER: If you come in earlier, you have much more feeling that it's the mother's and that she leaves it there unconsciously for the daughter. However, you didn't see the gesture.

When we started this piece, we basically just spent the whole summer in this house. All of our ideas for *House with Pool* came from our experience of being there. In the process, we made a decision that some things had to be unveiled somewhere and it was the pool that we chose because it's metaphoric—the transparency with a hint of possible hiddenness, the drowning, and all these things. What drew us to the deer was that it was a wild animal. And the teenaged daughter character has this wildness. . . .

TERESA: And we thought the deer that arrive in the middle of the night were in that same realm of silence that all the characters are.

Hubbard / Birchler

OPPOSITE AND ABOVE
House with Pool, production stills, 2004
High-definition video with sound
transferred to DVD
20 min 39 sec, loop

FOLLOWING SPREAD
House with Pool, 2004
High-definition video with sound
transferred to DVD
20 min 39 sec, loop

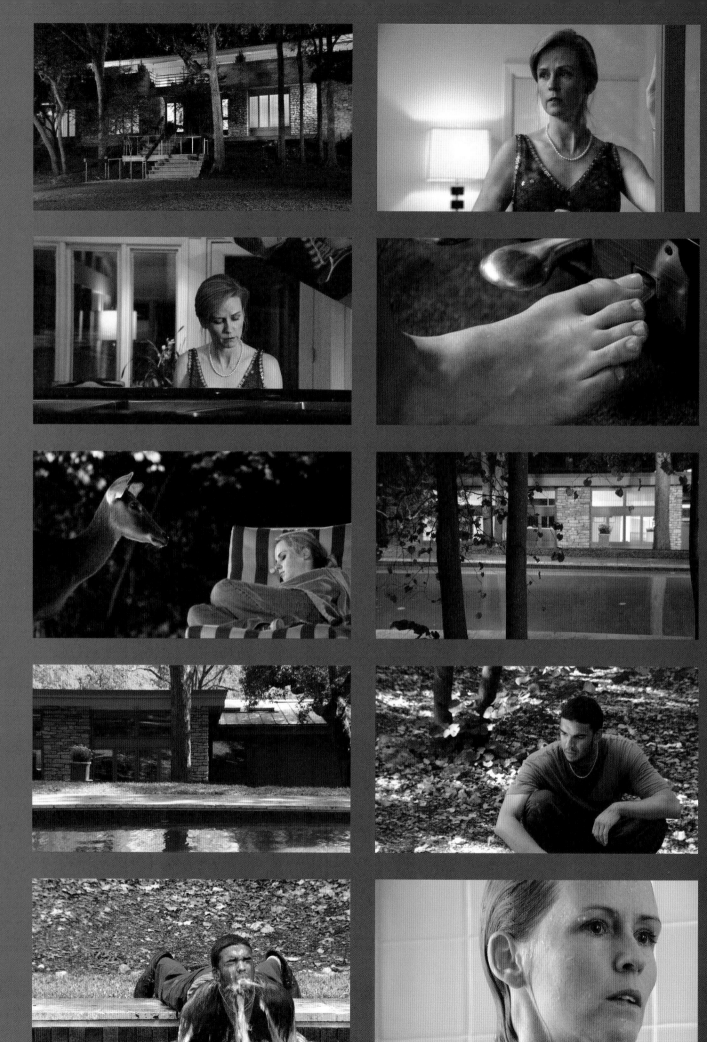

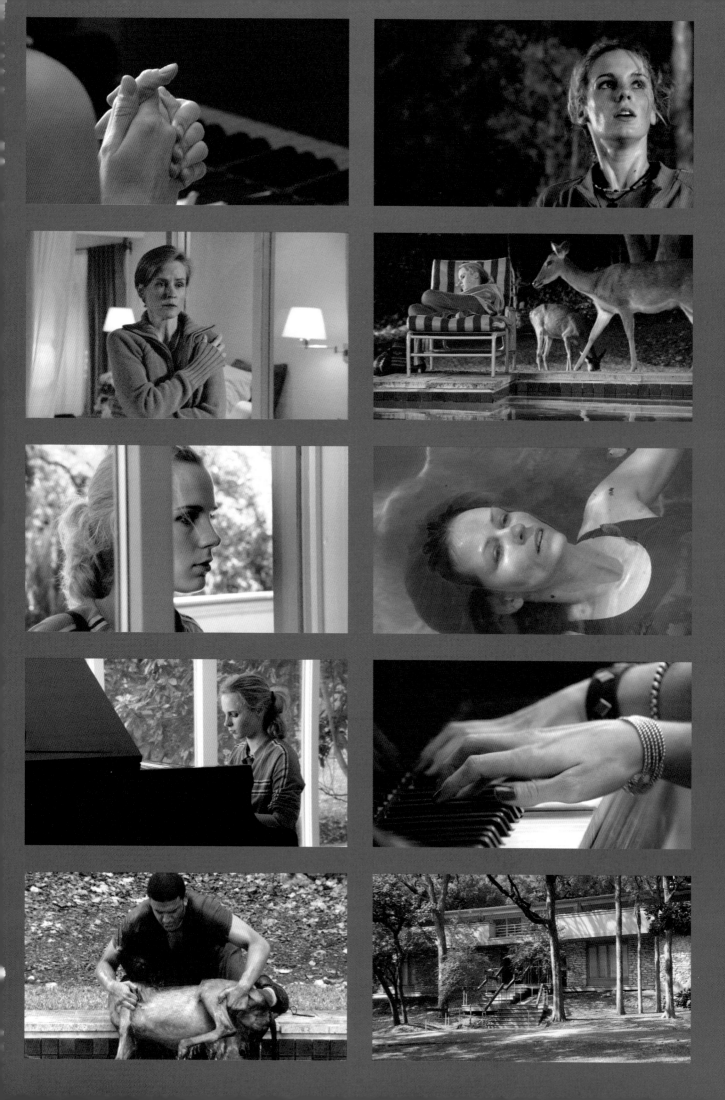

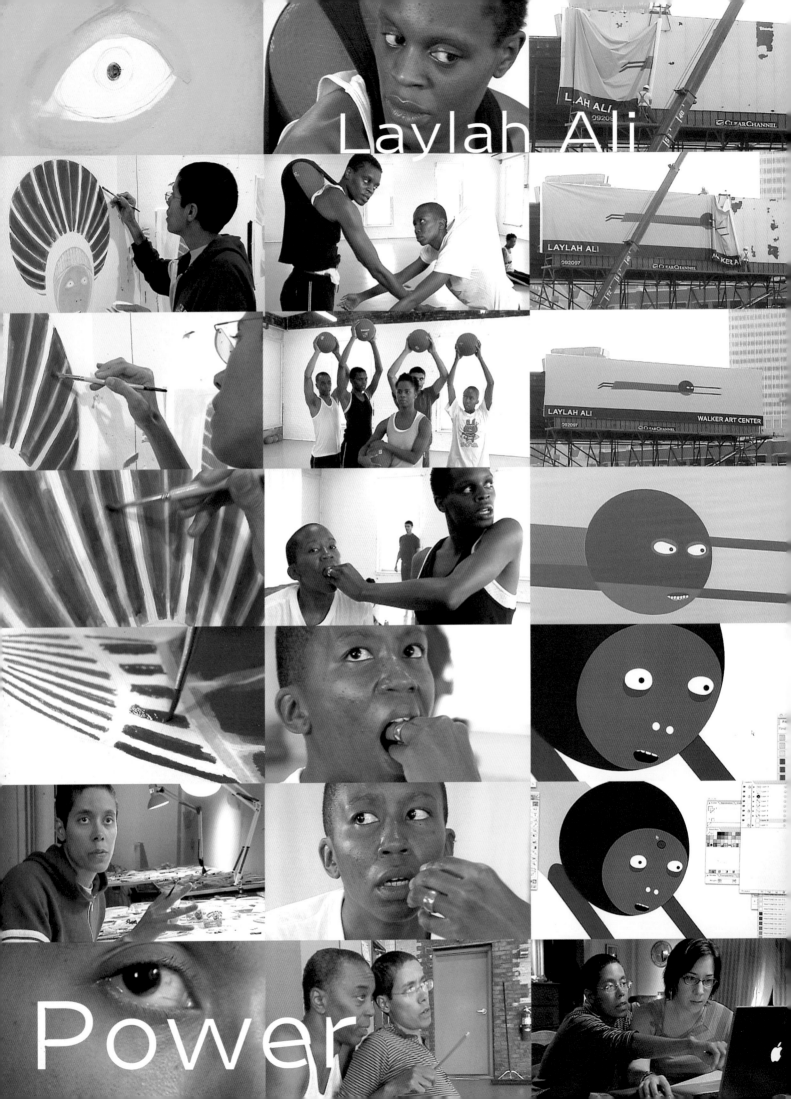

Laylah Ali

Power

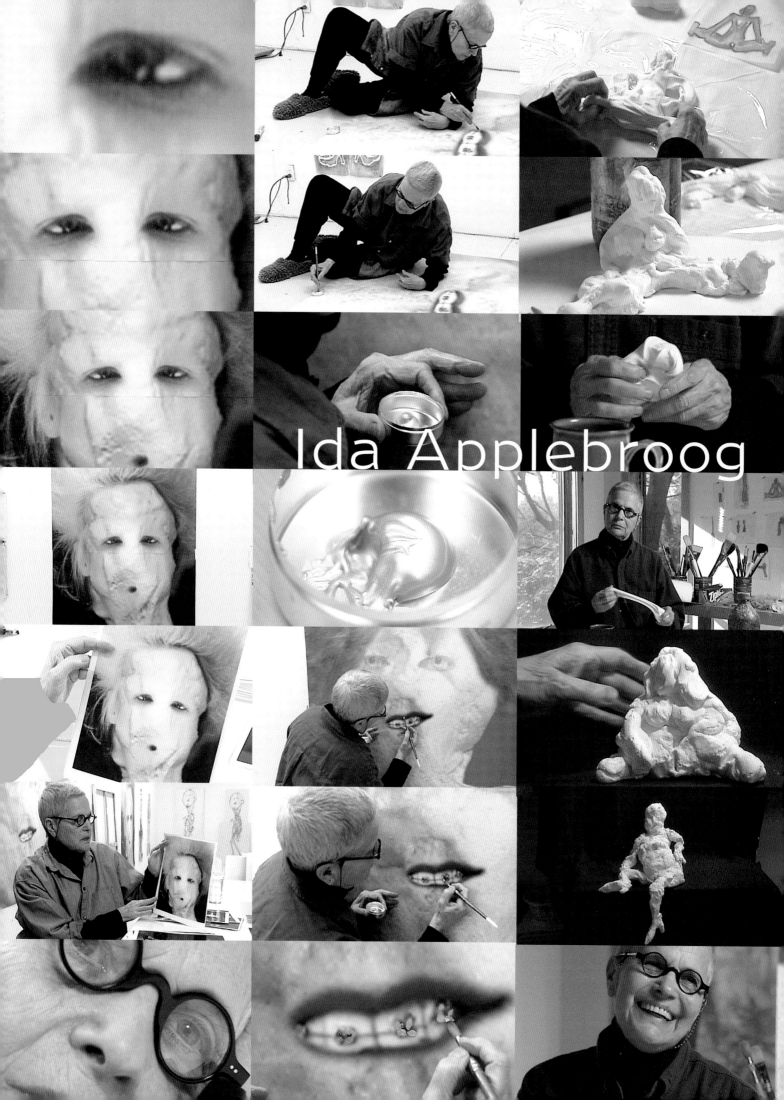

Ida Applebroog

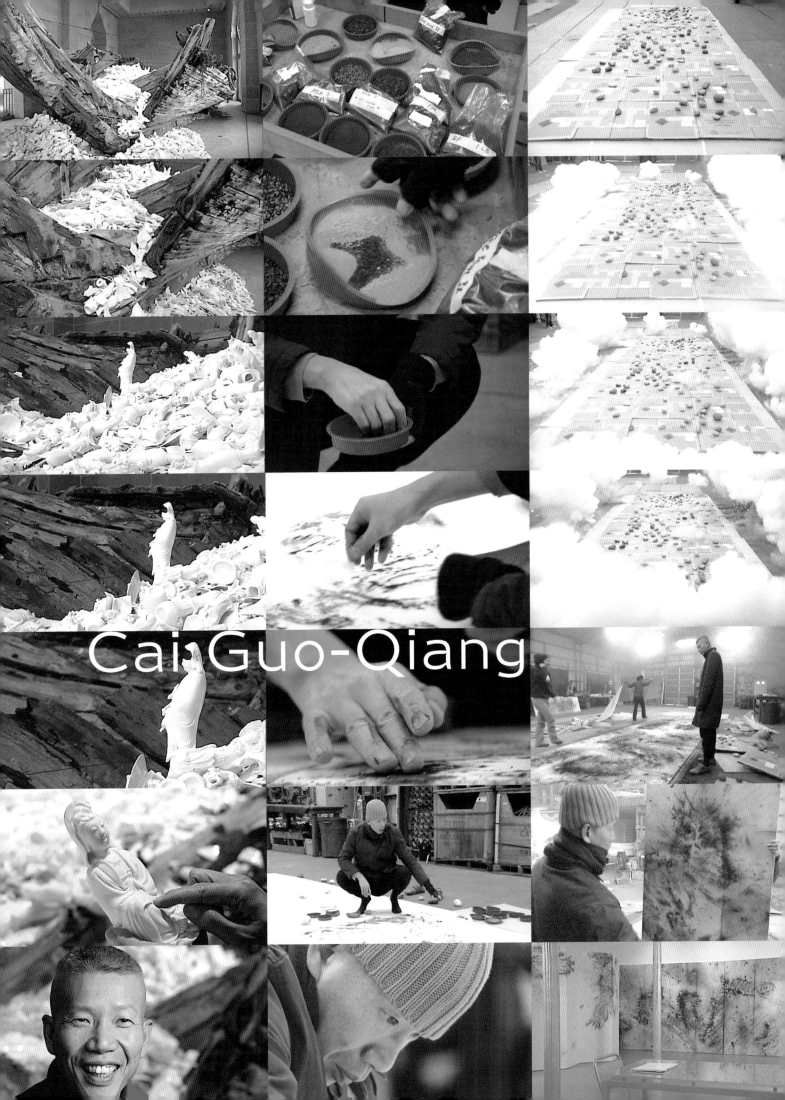

Cai Guo-Qiang

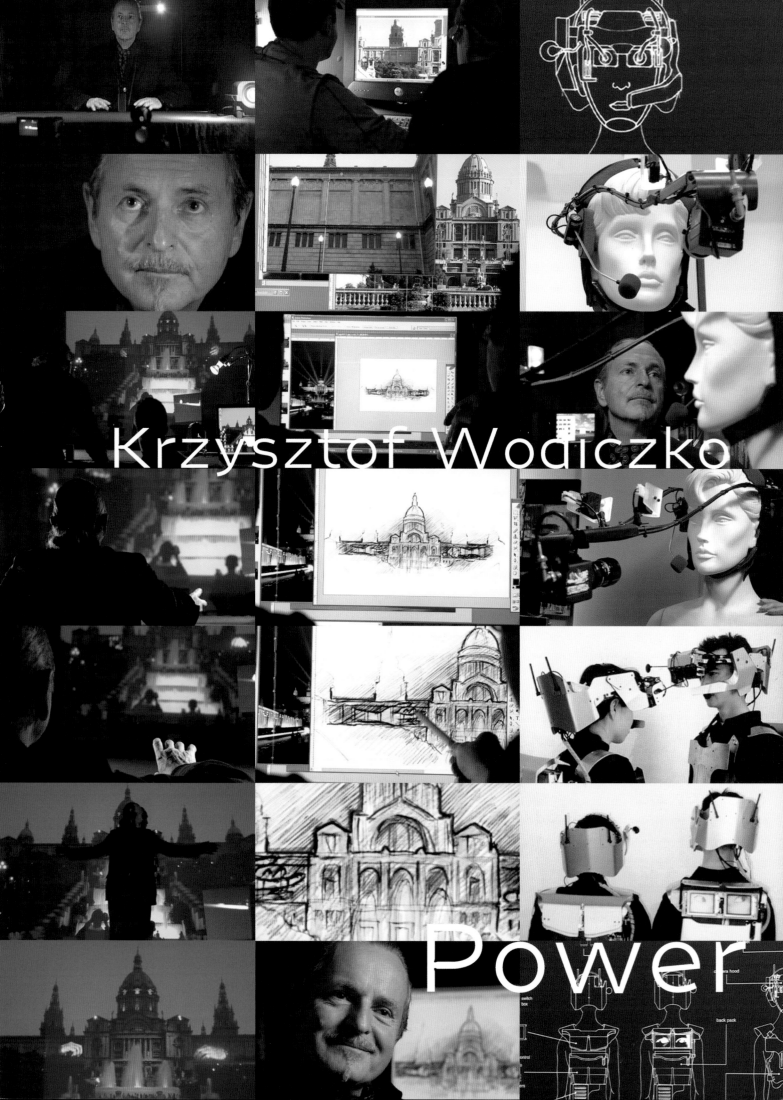

Krzysztof Wodiczko

Power

Laylah Ali

It started with figures I made in '96. I put this big green head on this brown superhero body, but not really a superhero—because it was an emaciated, silly, almost child's body that didn't look like our conception of a superhero. It had on Underroos, or something between a 1940s' bathing suit and super-hero gear. I looked at it and thought, "What am I looking at? What have I done? What does this mean?" The figure was like a question mark. I would look at it, and I had no idea what it was. That prompted further examination. As I worked further I wanted to see more. As they developed, they got more things. . . . Belts, boots, sneakers, masks, hats, scalps. Belts, because of the multiple ways they can be used. Belts being practical, to hold up their pants. Belts as instruments of domestic violence. Belts to hang some of my characters. Superheroes most often have belts. If we're going to use that word, *power*, belts connote some kind of power. Imagine policemen without belts. You couldn't take them seriously. . . .

Often I talk about getting something back from my work. I mean something that I didn't expect. Here's the strange thing about the way I work: everything's very much planned, laid out, and contemplated. Spontaneity happens early, when I'm coming up with and eliminating ideas, doing drawings. As they become paintings, the process becomes much more rigid. Still, what's mysterious is—for all the control I have over the paintings—the ones that are successful for me are the ones where something happens that I didn't expect. And I don't mean like, "Ooh, what's that? What happened over there?" It means that they are giving back a kind of energy or presence, as if they've taken on a personality of their own in the making through the interactions of color, the way I've designed them. And even though I plotted it out, still when I look at it I think, "Wow, I didn't expect to see that in that way." It's a strange tension between totally knowing what you're doing and expecting it one way, and looking at it and having it become its own thing, looking back at you. It doesn't need you anymore. Those are the pieces that work for me—the ones that don't need me anymore. I'm very much a part of them, but when they're done, it's like they seal themselves off.

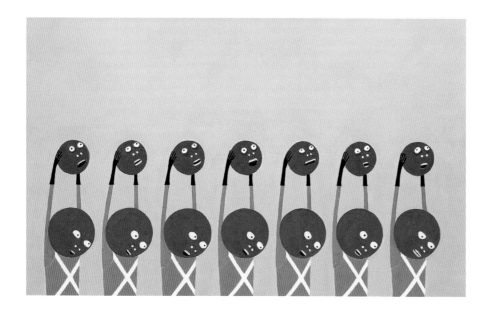

Laylah Ali

OPPOSITE
B Painting (Greenheads), 1996
Gouache on paper, 7½ x 11 inches

TOP
Untitled, 2000
Gouache on paper, 8 x 14 inches

CENTER
Untitled, 2000
Gouache on paper, 13 x 19 inches

BOTTOM
Untitled, 2000
Gouache on paper, 13 x 21 inches

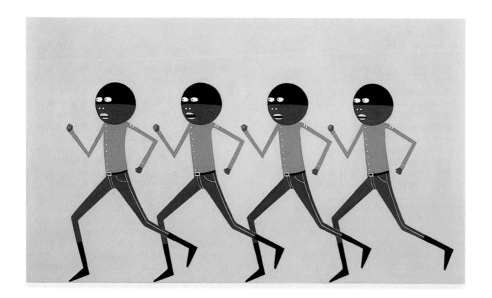

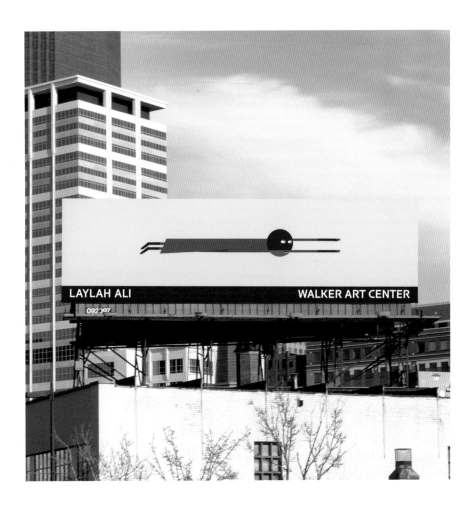

Laylah Ali

LEFT
Untitled, 2004
Billboard artwork, street view

OPPOSITE
No title, 2002
Artist's book, digital production
by Nicole Parente
Produced for the Museum of
Modern Art, New York

I've always been interested in figurative work and narrative. My earlier work was more involved with language, more explicitly about storytelling. And these are very narrative, but I leave a lot to the viewer to fill in. I trust the viewer more than I did when I was younger, where I felt like I had to be in control and dictate meaning.

Sometimes, I like to choose situations that have multiple readings, but oftentimes there are more readings than I even had thought of. Things happen that I didn't anticipate in terms of potential narrative relationships, strands of stories, character motivations. I often say 'character' in my paintings instead of 'figure.' Figure is the way you're supposed to talk as an artist—but character, which is more of a writing term, seems more appropriate for my work. Sometimes I feel like I'm making an extended alphabet, or that images encapsulate parts of an idea. By using parts of that alphabet or hieroglyphic system, I can recombine them and come up with new meanings. Because they're so crisp and have definite shape, sometimes I think it feels like they're letters.

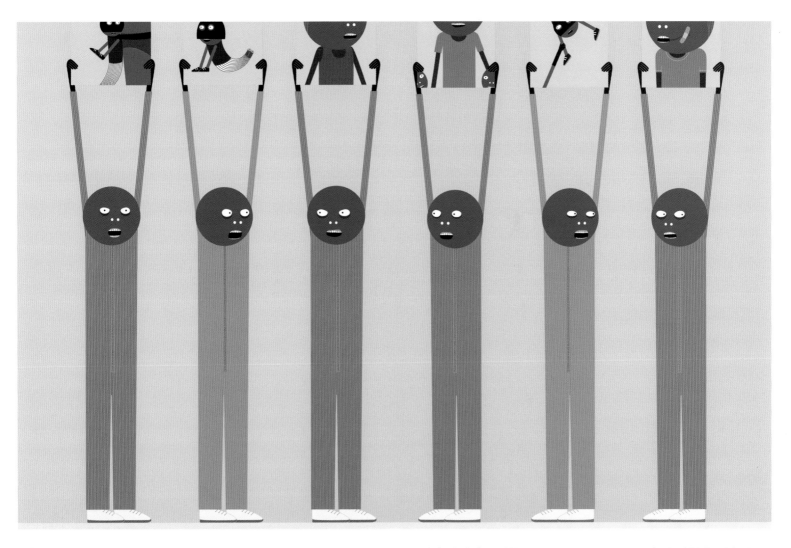
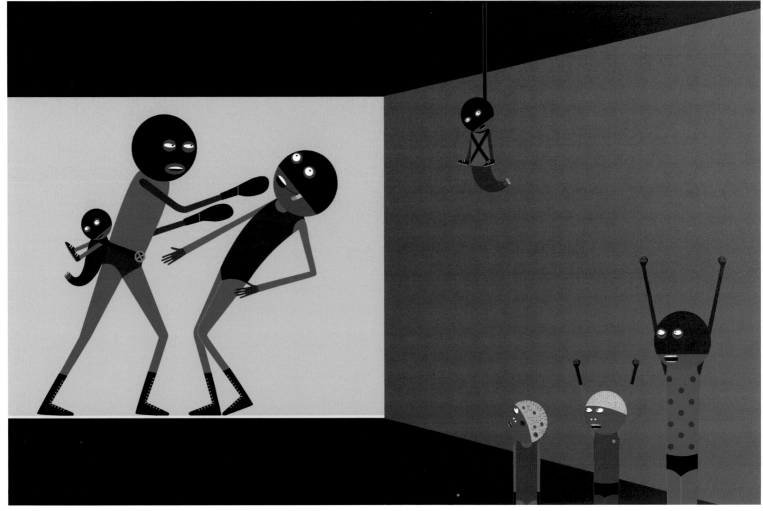

Laylah Ali

LEFT
Untitled, 2003
Gouache on paper, 8 x 7 13/16 inches

BELOW
Untitled, 2004
Gouache on paper, 15 7/16 x 15 1/8 inches

OPPOSITE
Untitled, 2004
Gouache on paper, 10 15/16 x 8 3/16 inches

I'm also working on more fragmented pieces—of body parts that sprout from mounds, that have on tube socks or sneakers. They're not obviously attached to any body that we would recognize as a body. I'm also still very interested in looking at those structures and that way of dealing with the figure as part of this larger conglomerate. I'm also working on these in conjunction with portraits because I see them as related.

In the newer work, the figures just have legs. They don't really have the gift of arms. Removing arms, I can figure out what can be done without arms, what kinds of commands can be given through other kinds of gestures. There's still a lot of power left in the body, and I'm trying to see how much I can take out and still retain a powerful or influential core, or one that can tell a story.

Power? I don't know how to think about the word 'power'. It's so overused. To empower, that's supposed to be a good thing. People who have power, that's a bad thing. So power, to me, is too slippery. Control speaks to power, but it's more about the mechanism, which I think interests me. So I would say there's a lot of contemplation about control. So much of the work is about me trying to control it. Yet it still defies me.

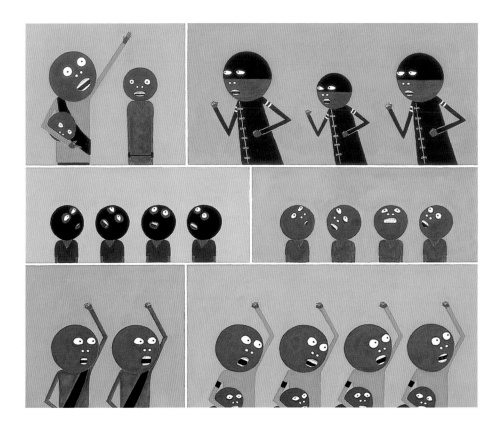

Laylah Ali

ABOVE
Untitled, 2000
Gouache on paper, 12 x 14 inches

OPPOSITE, ABOVE
Untitled, 1999
Gouache on paper, 8¼ x 13¾ inches

OPPOSITE, BELOW
Untitled, 1998
Gouache on paper, 8 x 12½ inches

I'm not good at saying, "This is what the work is about." There are things very much connected to me and the time I'm living in, but I just can't say, "This is about the IRA, and this is about South Africa." It's as if the information comes in, goes through me, and comes out in my hands. I don't mean to make this mysterious, like I'm guided by some external force—but there's still something that happens that I'm not entirely in control of. I can't point to this and say, "This is about slavery and this is about my father's African-American heritage." It's all in there, but it doesn't help my process to name it specifically, connected to a painting.

I think when people say the word 'violence', oftentimes we think of the violent *act.* In my earlier work it was more about the moment that somebody was getting strangled or hanged, whereas now there's very little concentration on the moment when violence occurs. I'm more interested in what happens before and after. The figure is the perpetrator of the violence and the victim, the negotiator. We understand or read violent acts through the characters and the figures.

Pre-violence and post-violence. There's always another violent act around the corner. So, pre-violence—when was that moment? Post-violence—the anticipation of the next act. The repetition is what I think is so striking. It's not like one thing happens and you say, "Wow! That was just so terrible," and it will never happen again. You know it will happen again—either where you're caught up in a system, whether a family or war . . . or—if you're in a situation as I happen to be now, not involved in a violent cycle, witnessing violent situations erupt. I'm more in a witness position now. Not a direct witness. A kind of removed witness.

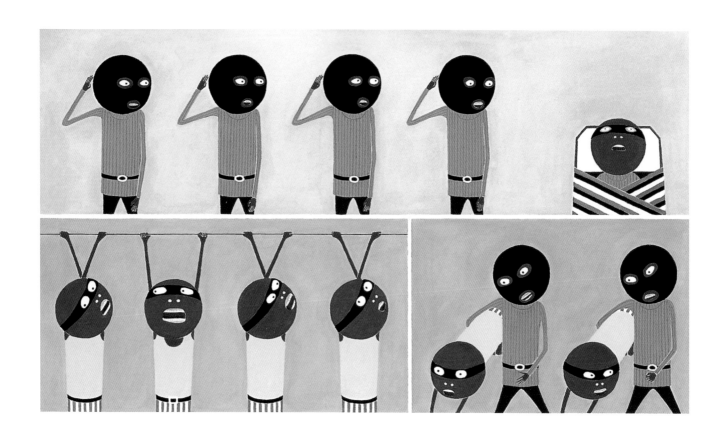

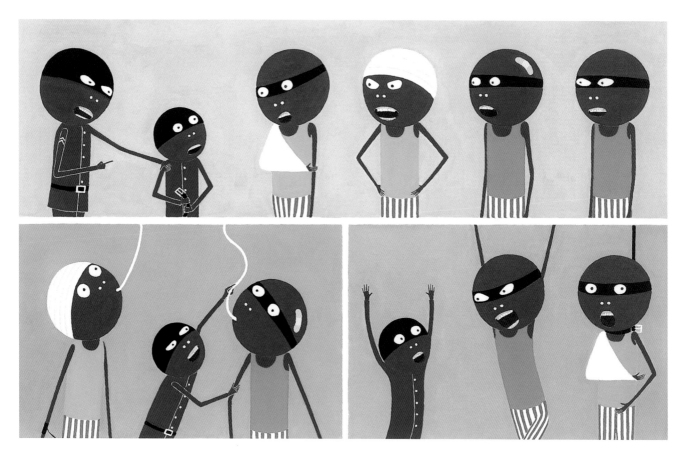

Laylah Ali

RIGHT
Untitled, 2002
Gouache, watercolor pencil and
ink on paper, 10¼ x 11½ inches

BELOW
Type Drawings, 2004
Oil pastel and watercolor pencil
on paper, 15 1/16 x 11 3/16 inches each

OPPOSITE
Untitled, 2002
Ink and watercolor pencil on paper,
11¾ x 8¼ inches

I collect images. When I'm reading the newspaper, I tear them out and file them. My filing system is strange, according to categories that make sense for my work—American flags, sports, uniforms, hands and gestures. . . . Looking at news clippings is one way that I start thinking about some of the overarching narratives that are reported. The clippings often correlate to a public narrative that people might recognize in the work—the strands of things that you've been reading or hearing about.

I'm influenced by all of the kinds of looking that I'm doing at different images. But when I sit down to do these drawings, I don't look at anything. I just sit down to do them. So the drawing process is extremely important for the paintings. The paintings are very controlled; the drawings are when I actually come up with the material for the paintings. So there are no paintings without the drawings, but they're very different from each other. Sometimes it looks like two different people have done them. I'm acting on impulse in the draw-

ings. Because they're not so studied, they can capture something I didn't anticipate. They're more playful than the paintings, and that keeps the paintings from being too one-note. Some of the drawings work really well, but there's a part of me that really believes that the more I put into a piece, the more I can get back from it. And that's where the paintings are valuable. There's more layers of meaning—in terms of standing in front of them and trying to uncover something. The drawings offer themselves up more immediately.

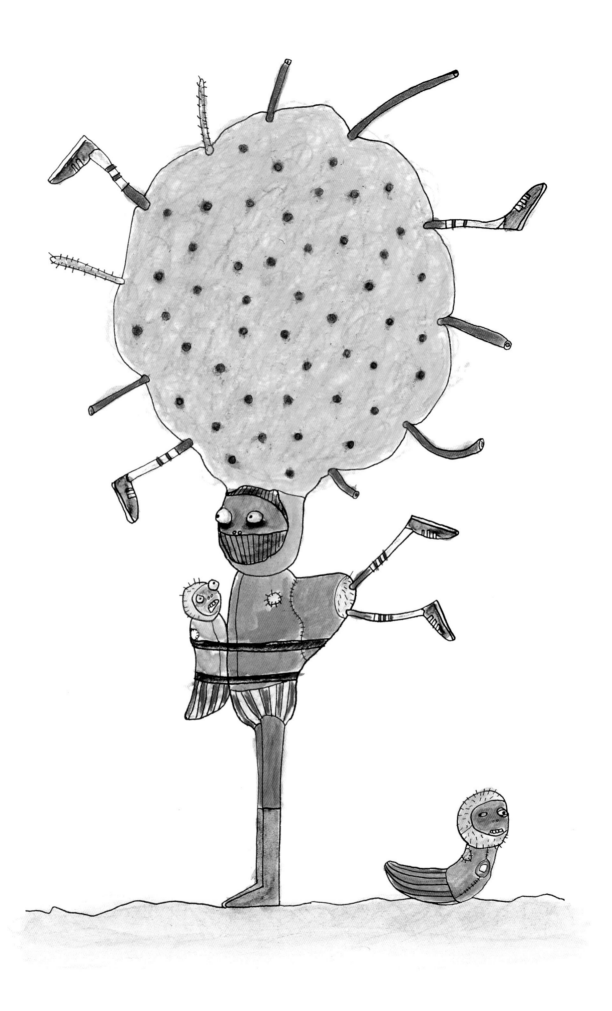

Laylah Ali

LEFT
Untitled, 2004
Gouache on paper, 15 13/16 x 9 1/2 inches

CENTER
Untitled, 2004
Gouache on paper, 10 3/8 x 8 inches

RIGHT
Untitled, 2004
Gouache on paper, 28 3/16 x 20 1/16 inches

OPPOSITE
Untitled, 2004
Gouache on paper, 28 3/8 x 20 5/16 inches

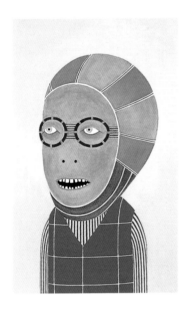 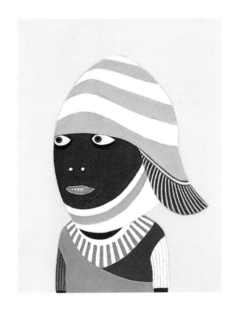 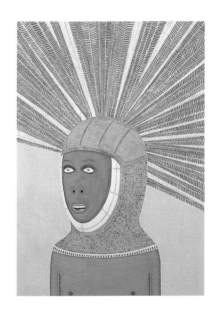

The idea of portraiture is a kind of storytelling—a distilled storytelling. I am interested in distilled narratives, so the idea of trying to tell a story or hint at something larger than the individual, through the individual, became interesting to me. Given the language that I use, it made sense for me to look to my own characters. I'm also thinking of the portraits as of distinct individuals who exist or have existed. The idea is for the distinctness of that individual to come through, to speak in some way about a narrative that is not readily apparent. Something about the way the person is dressed . . . the look on their face, the weathering of their face, tells you a story. The look in their eyes speaks of something larger.

I have no idea whether they're male or female. I've almost eliminated that as a category, although they still get gendered because of what they wear. It's interesting, because race still exists in the work. Recently it's come to the forefront a little bit more. These new characters have a wider range of facial coloring. I hesitate to call it race—because sometimes I think of them as having a skin condition rather than a race. Like when your skin gets burned, it turns a different color or has a different texture—somewhere between race and skin condition. Whether they're even human is still a question to me. I make these portraits or characters and they can be unto themselves—have their own realm, their own features. Or they're

hybrids—a mix between all my characters. I'm still thinking about what it means. I'm fascinated, how a different facial color directs you. Green absorbs you into it. Pink or red comes out at you. Light pink doesn't recede into the page but has a flatness. Bright pink jumps out. Those phenomena affect your reading of the figure—nothing related to anything but what a color does, how it affects your eyeball. I sometimes wonder, "Is that what it is about?" Dark-skinned people—their faces absorb more light so you have to look at them more? They're more mysterious? What *is* that? Could racism just be attributed to bizarre visual phenomena? There's a question

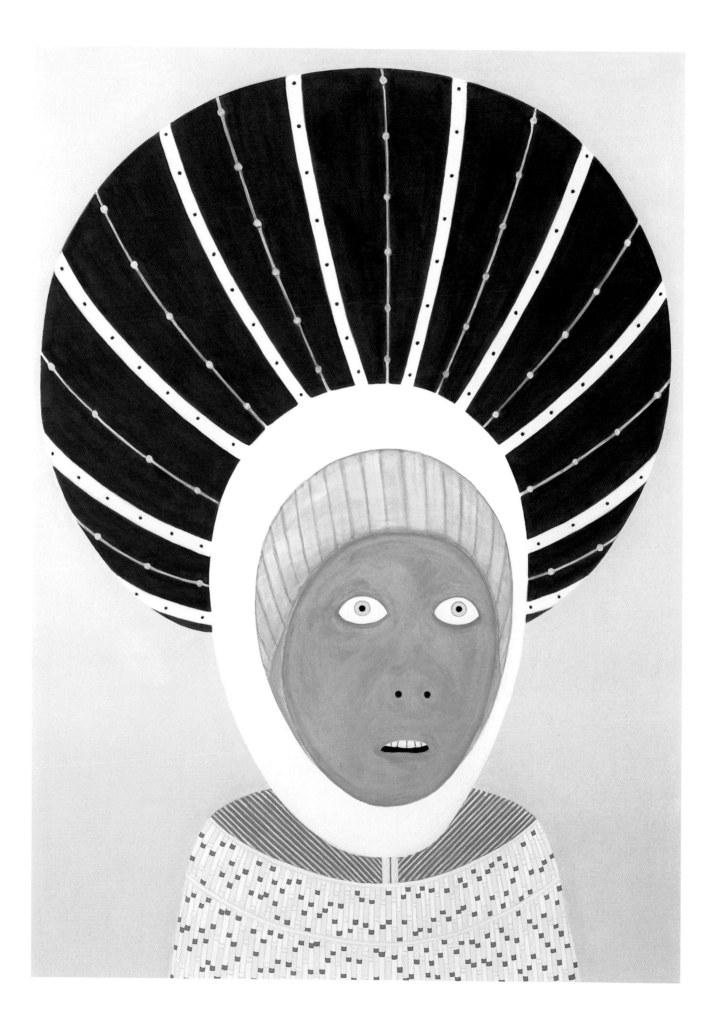

Ida Applebroog

I don't even like the word political! I don't like any words. No, I hate being labeled. I really hate being labeled. I do a lot of work on violence all the time, you know. I've also had that come at me, "Why are you so obsessed with violence?" And you know my answer? I look at them and I think, "Why do you say I'm obsessed with violence? I live in this world—this is what's going on around me." I can't change that. So when I'm doing the work, it's like I'm in the studio and I have all this stuff on my back. I have all this baggage, and I try desperately to start working. . . . I'm carrying in how the postman looked at me that morning, what happened in my personal life, what did my dealer say to me, what did my friend say on the telephone—all the different things that go on in your mind. What do I have to do? What appointments do I have? And then how do you get to do the actual marks on the canvas where that disappears? It takes a long, long time. . . . And then this is not really what you're doing, but in a way it's like peeling off the layers, peeling off the layers. And finally you're not conscious any more of anything being there, and you're free and you're working and you don't know that time has gone by—and it's hours and hours and hours. But then you have to go back into the real world and the real world is the world that the six o'clock news is about and your own personal life, because your own personal life is involved in that also.

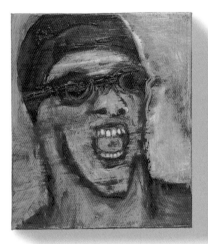
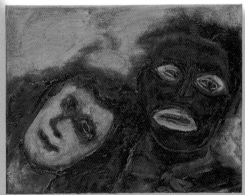

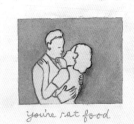
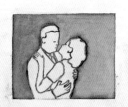
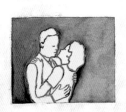

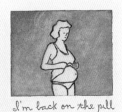

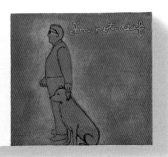

Ida Applebroog

TOP
You're rat food, 1986
Oil on canvas, 14 x 66 inches

BOTTOM
I'm back on the pill, 1986
Oil on canvas, 14 x 66 inches

OPPOSITE, CLOCKWISE FROM TOP LEFT
K-Mart Village I, 1987
K-Mart Village II, 1987
K-Mart Village III, 1989
K-Mart Village IV, 1989
Each: oil on canvas, 5 panels, 48 x 32 inches
Collection of the artist

I'm just interested in narratives. Everyone has a way of remembering storytelling when they were very young and piecing it together in their own way. And I guess mine started out in terms of the actual sending out of books. Those images told a story without really saying very much. And from there it was like a snowball that gains momentum. You have this one idea and this one concept—it's what you do the first time. And even though it might feel like a one-liner, how much can you push it and explore it the next time?

And then when I started to work on the paintings, the paintings were more structures than actual canvas. They were not done like a traditional painting—you know, you take a stretcher, you put your canvas over it and then you paint on this rectangular size or whatever size that you're painting on. Mine were always different pieces, and different ways of thinking about what I was working with. And the structure was as important as whatever it was I was painting.

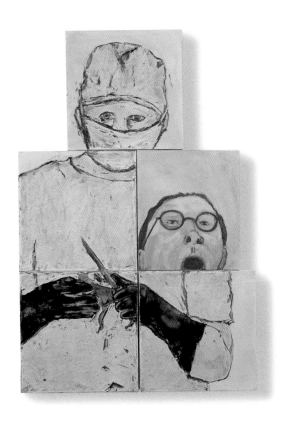

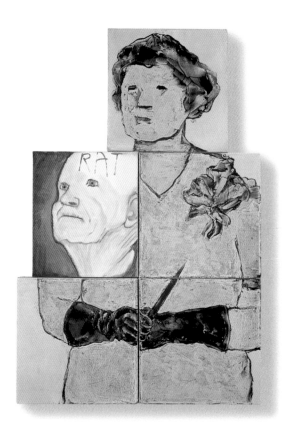

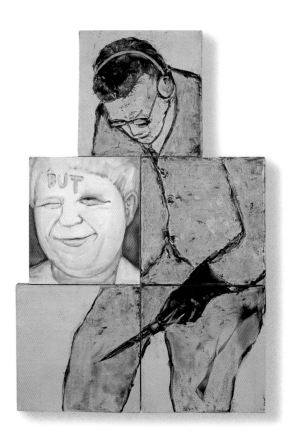

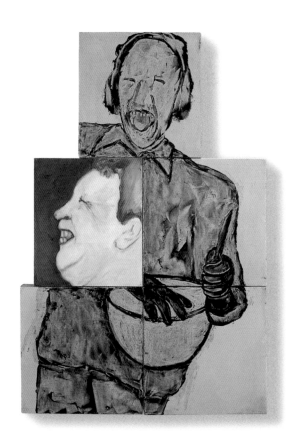

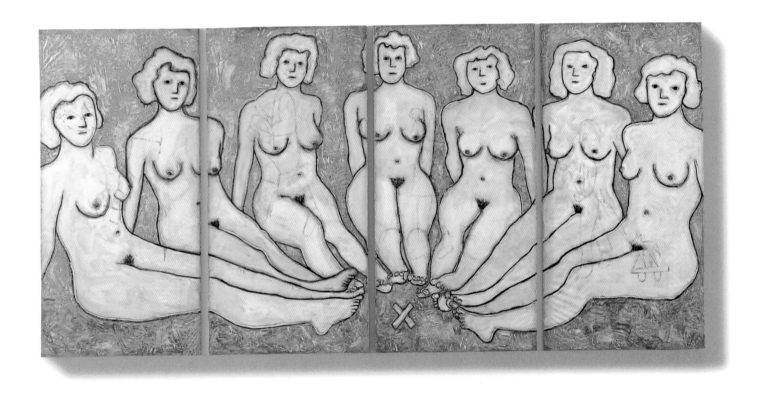

Ida Applebroog

I define beauty first of all in the way I paint. And even though the work is not comfortable work, I feel like the paint is absolutely beautiful. It's something that I love working in. I love the colors, the coloration. And it's almost like I'm creating flypaper to get you over to look at the kinds of brushstrokes or the impasto layer—and it's always interesting-looking enough to draw the viewer into it. Then once they're there, they are confronted with material that they have to think about or just walk away from very fast.

I use a lot of repetition. And the repetition becomes a filmic way of talking because as you put one image after the other, even though it's the exact identical image, everyone sees something changing from one image to the next. And it's just really bizarre—because I know what I've done and I know they're exact, though of course my hand is not exact, but they see actual gestures and they see actual changes in the expression which I never put there. And that's not the reason why I use repetition. It's just because it's a performance, and it's my way of animating one image, from one image to the next without the image actually changing.

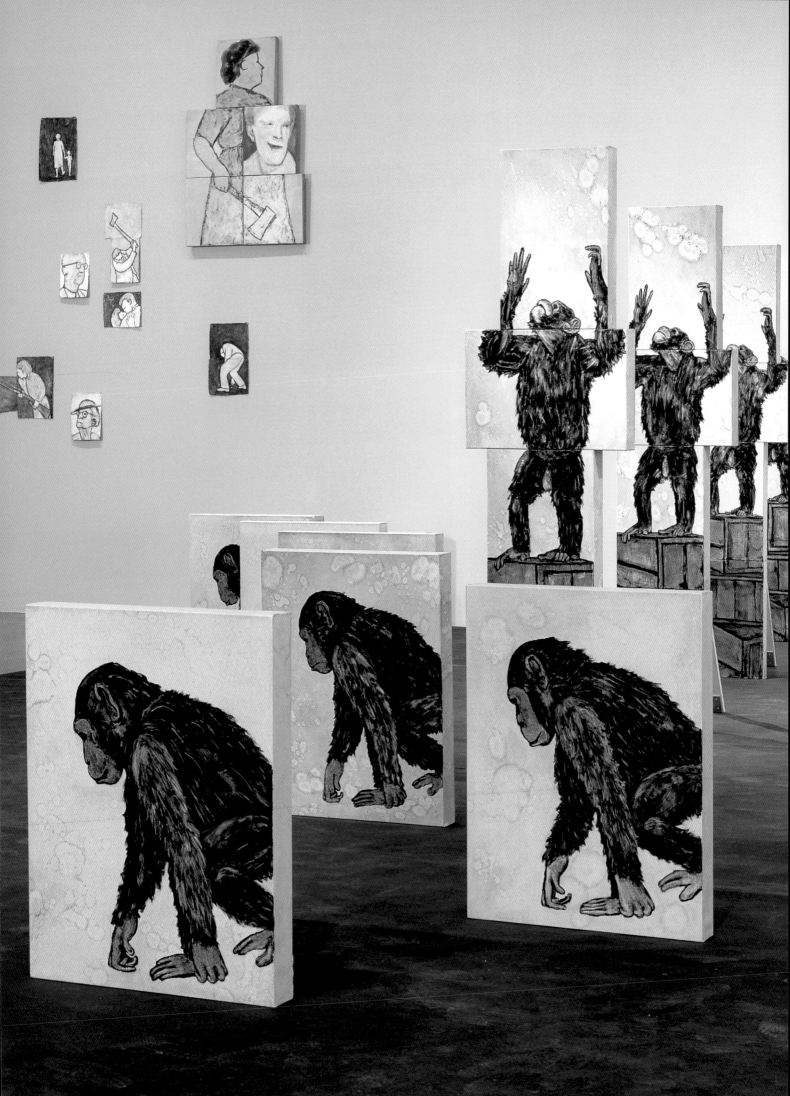

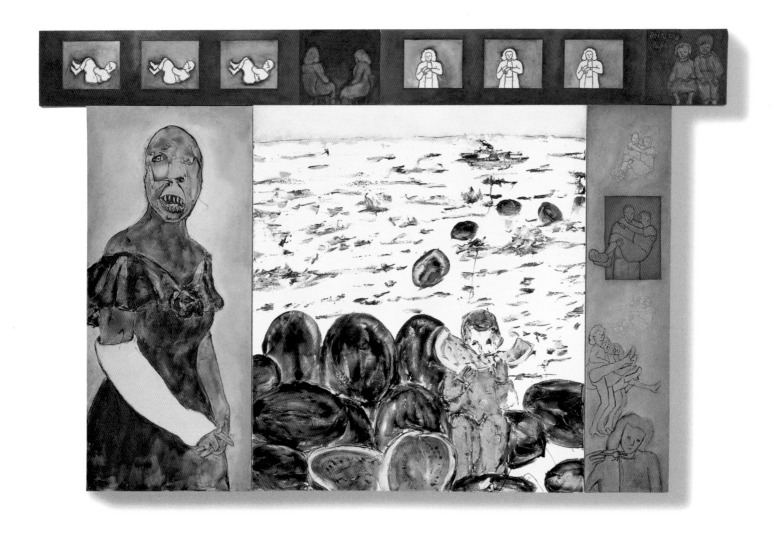

Ida Applebroog

Noble Fields, 1987
Oil on canvas, 5 panels, 86 x 132 inches overall
Collection of the Solomon R. Guggenheim
Museum, New York

I don't understand why people pick up on that I'm so involved with violence, when the whole world is so involved with violence. . . . I am not involved in violence; I am involved with *reporting* the violence or at least a little bit of a different take on the six o'clock news. But there is so much violence in terms of mass destruction and sexism, ageism, all the *isms* out there. This is not something that's weird or odd that I'm doing. I think this is the most natural thing in the world to do. Yes—my work is not about beauty, and I know it does not hang over a couch very well, matching the burgundy colors on the pillows. It's not work one hangs over a couch in that way. But I make the work, and I make it because for me it's necessary. It's not coming from anything bizarre or hidden or covert. It's coming from everything around us. I mean, I am witnessing it. I am a witness to everything that goes on in the world. But everyone is. It's just that everyone has different ways of reacting to it. . . . It's always there and it's the kind of thing—in terms of art history—that goes back to before Goya.

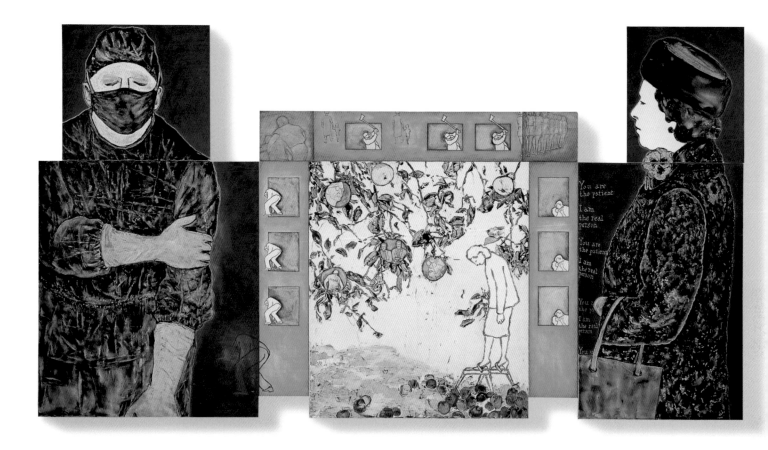

Ida Applebroog

Emetic Fields, 1989
Oil on canvas, 8 panels,
102 x 204½ inches overall
Collection of the Whitney Museum of
American Art, New York

I love Queen Elizabeth. . . . Here's this woman called 'Queen'—she gives that little wave—and she has no power whatsoever. In *Emetic Fields* (1989), there is the figure of Queen Elizabeth and there is the figure of a surgeon. And that all goes back to my own sense of how power works. Queen Elizabeth, to me, is the epitome of how power works. Not too well.

I like the idea, the power part. And it's the kind of thing where every time someone asks me what my work is about I always say, "It's hard to say what your work is about" (nobody really wants to say it, or they make up something that

they have stuck in their heads that would sound right), "but for me—it's really about how power works." And I learned that at a very early age. I come from a very rigid, religious background. And it's the idea of how power works—male over female, parents over children, governments over people, doctors over patients—that operates continuously. So it's not as though I set out to say, "Well let's see what the power balance is between this piece in my painting and that piece in my painting." This is the part we're talking about—that you never really know what you're doing until at the end you realize, "Ah, that's what I'm doing . . . that's what I've done."

Ida Applebroog

A lot of the pieces that I do—these
single pieces—they're comments on
the larger work that I'm working with
or whatever the subject matter happens
to be at that point. So they're very
short comments—marginalia—and I have
many, many short comments. My work
is full of marginalia.

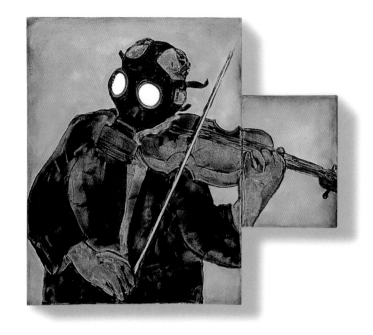

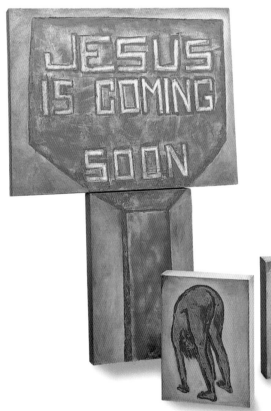

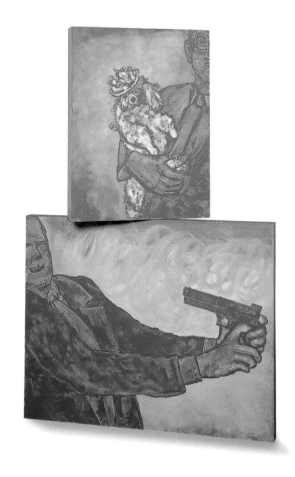

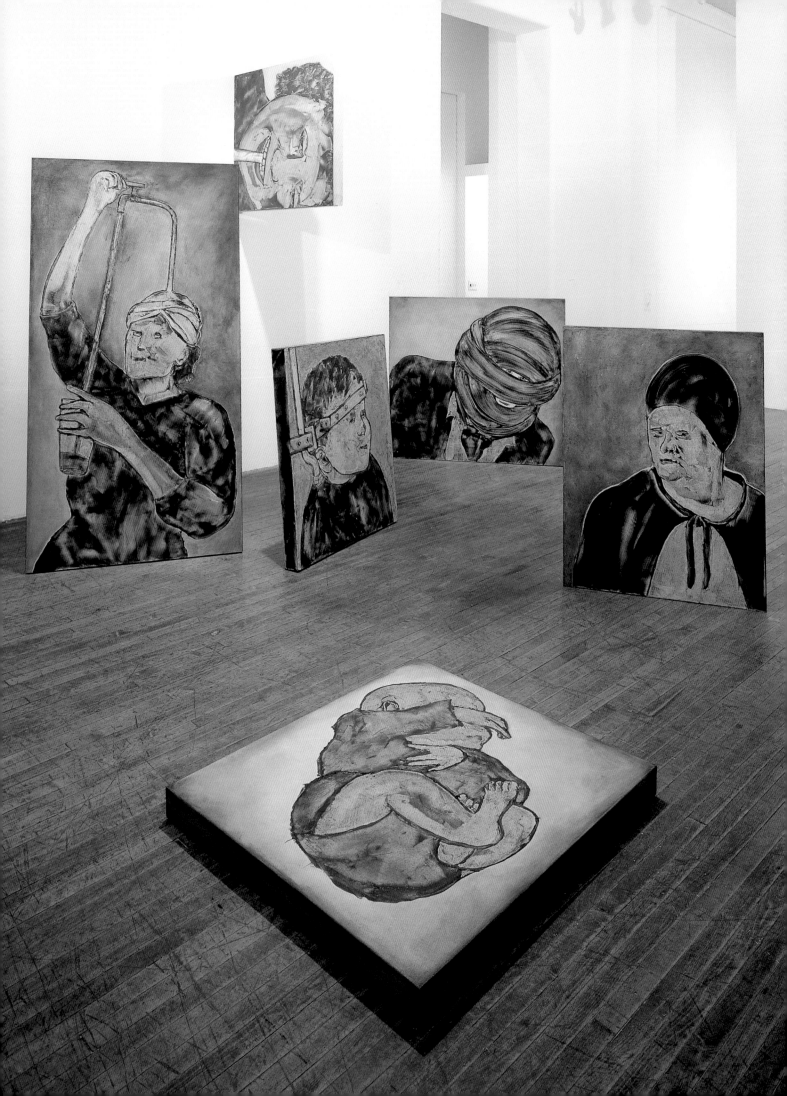

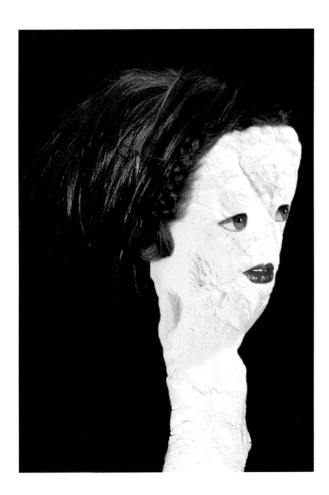

Ida Applebroog

The photographs actually start off making art out of children's modeling clay. When I say art, I mean just doing some very primitive-feeling sculptures. And that's just the beginning. It's like making art out of art and continuing the process all the way through. For the first time, technology is at my service when I go from working with the material to the next step and the next.

These little pieces seem so ordinary and like nothing. If I place them on my stage, these little mounds of clay become monumental. You photograph them any way you like, zoom in on any part of the body, and they become something totally different. I take each one—and they're very small. I set them up as though I'm posing them the way a photographer would. Whatever else goes on has to do with the camera, because they have to be posed in such a way that they do

something, say something. They're able to express the next few steps, and I never know what they are. The best part is that I really never know what these things are going to morph into. The good part about working with the camera is that you have no sense of what the camera's going to give you until you see your contact sheets. And then the rest of it will take place in the computer. It's like I'm cloning these little pieces from one thing into the other. . . . The art really makes itself—art creating art with the use of technology as I've never used technology before, except to turn on a light or a radio or a TV.

At one point, the term 'cloning' occurred to me and I thought, "Oh my God, am I creating all these deformed pieces?" I can't explain what they do to me except that they feel like they're not deformities—they're just very beautiful.

Cai Guo-Qiang

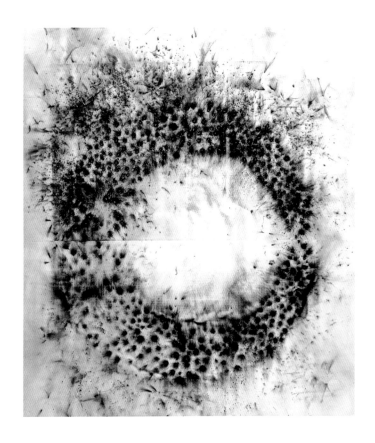

ABOVE
Drawing for Transient Rainbow, 2003
Gunpowder on paper, 198 x 157 inches
Collection Museum of Modern Art,
New York

OPPOSITE
Transient Rainbow, 2002
1000 three-inch multicolor peonies
fitted with computer chips, 300 x
600 feet, duration 15 seconds
Commisioned by Museum of
Modern Art, New York

In the traditional Chinese home, what you will have is your table, your chairs, and it could actually be very empty. Nothing adorns the walls. But next to your host's chair, there may be a very large ceramic jar that holds many things sticking out of it, and they're actually scrolls rolled up. And as he receives you he will sense what your level of sophistication is and what your interests and perspectives might be, and then he will select the piece that he may want to show you. If he feels like you are worthy of a certain work, he might unroll it in front of you, and then you have a whole world all of a sudden opened up to you. . . . So in that vessel, in that jar, is his museum. It is a collection that is only shown at the appropriate time and occasion, and to the right person. And then after the viewing he will roll everything back up and put it back into the jar again, as if nothing has happened. So this is something (perhaps a bit contradictory) that I look for in my work as well. I look for something big, grand in scale. Yet I look for that emptiness that's there too. The scroll in a way

is an essence of that. After the viewing it's rolled up and it's empty again. But this emptiness holds endless possibilities. When the space is not commanded by the physicality of something but, rather, is dependent on time, it's unraveled in time. And that's when you can really truly hold something that is truly large. When you have something that holds a permanent physical presence, you see its limitations. No matter how large it is, you see it for what it is and it doesn't have infinite possibilities . . . it can be very limiting in that way. So sometimes I see my explosion projects almost like these scrolls: once you open them, they open up the universe and, around that, it seems boundless. Then it disappears. But what holds in your mind is also that realm that's limitless. So as the explosion project unfolds in the night, when the colors and light are exploding into view, it's like opening up the scroll. And then it's like closing a scroll. Everything is dissipated, it's gone, and it's just leaving the empty night there. But it's pregnant with all kinds of possibilities.

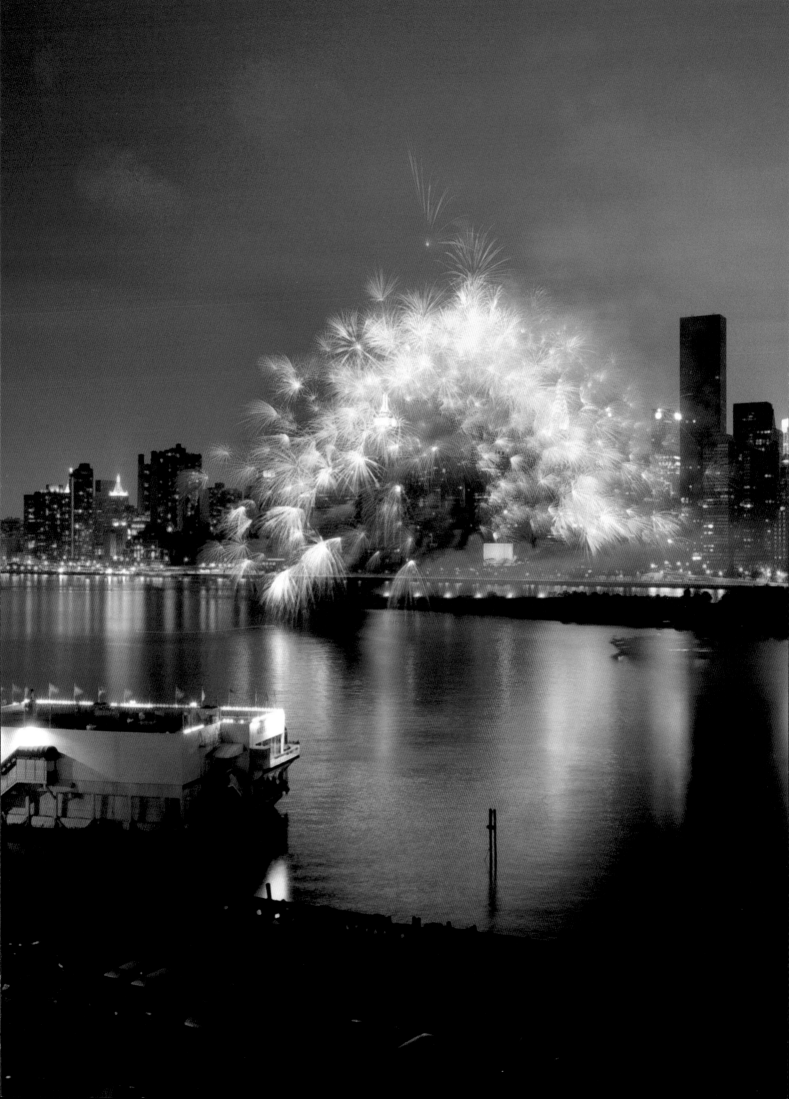

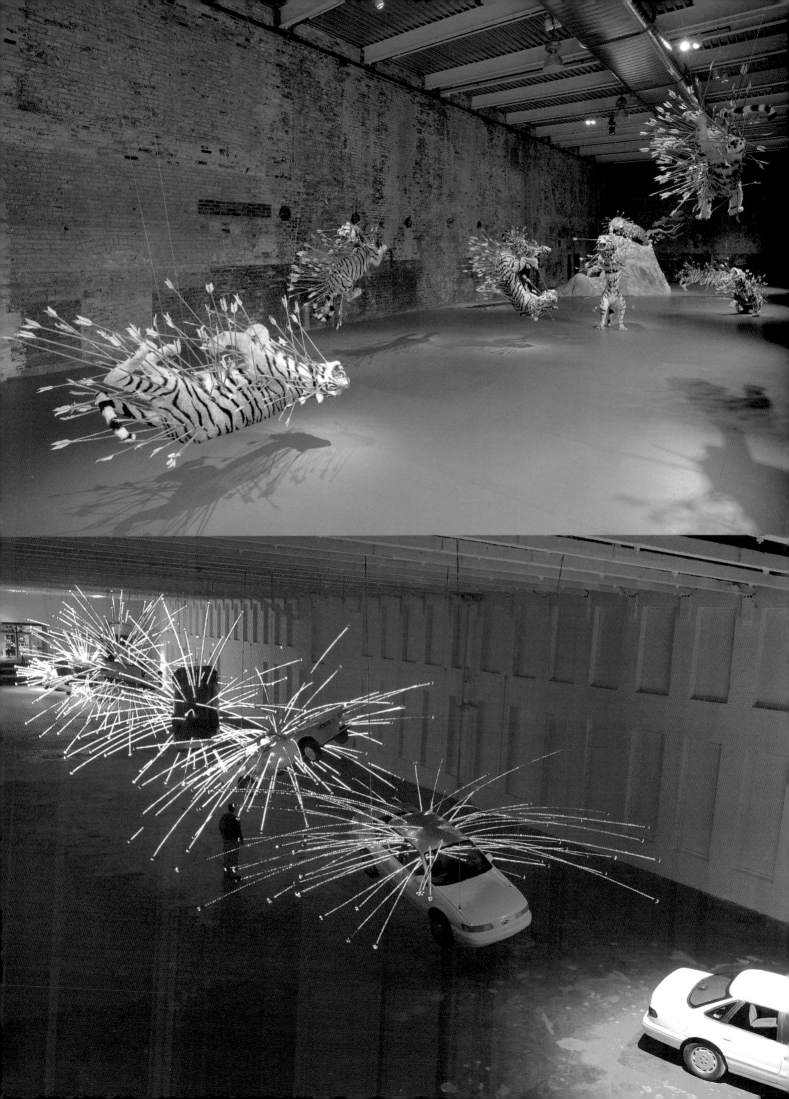

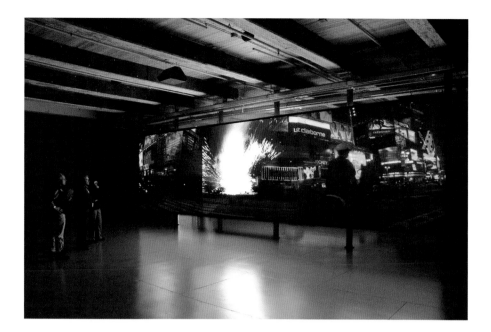

Ever since September 11th, the idea of terrorism is always on our minds. It's ever so present. And while car explosions have been around for a long time, they have a heightened sense of reality in our minds. *Inopportune* (2004) obviously has a direct reference to these conditions that we live in now. But making an installation that is so beautiful and mesmerizing that also borrows the image of the car bomb already has inappropriateness in it. Of course, there's a concept behind it, but never mind the concept—just the very fact is a difficult thing to overcome. It's difficult to resolve for some people. Whatever it is, it's a quite direct reference and commentary about some of these issues. So maybe in this way it's kind of unfashionable or inappropriate, or *inopportune*.

When I first saw the exhibition space—that elongated space, one hundred meters long and eighteen meters wide, for the work that became *Inopportune*, I felt that it was like a section of an avenue, a road that had been transported there with that concrete floor. The idea of doing a project having to do with car explosions had been on our minds for some time. But these kinds of conditions that are presented to you bring forward concrete ideas, so it seemed like a really perfect opportunity to show this idea. And of course the physical manifestation was also inspired by the space itself. And then while we were looking at how to lay out the entire exhibition, it wasn't just an avenue I was given—it was like a landscape. You travel upstairs, you

come back down again, and then you go up these ramps or go into the adjacent space. I wanted to further that idea, and that's one of the reasons for having that stage prop that actually creates a little mountain where the tiger is sitting on top, in the tiger room. There was even a little staircase one could go up, symbolically. So these elements were actually further extending the idea of this path or journey, and we can say that the entire exhibition is like a long scroll unfolding.

As the first car takes off, tumbling through the air in a very dreamlike fashion, it lands back on its four wheels safely, undamaged, unharmed. It repeats. It's just repetition. It goes right back to the very first car again. It suggests that it's just one car. It starts out with more realistic colors of light, bright flash, and flame colors. Then it goes into more fireworks-like lights, various colors, and then the more dreamlike blues, pinks, purples. As you walk through, it's almost like frames in a stop-action film, but instead of the film flicking through it where you see the images it's as if the imagery is unfolding in front of you. And like *Illusion* (2004), the video piece in the installation, it happens—yet it looks back, right back into itself and it plays out again. The perspective of the camera is that of a pedestrian watching Times Square in all its glittery glory at night, pulsating with life—and seeing a car exploding through the streets as if it's an illusion, as if it's happened or maybe *not* happened.

Cai Guo-Qiang

Cai Guo-Qiang

Inopportune: Stage Two, 2004
Installation view at MASS MoCA,
North Adams, Massachusetts
Tigers: paper mâché, plaster,
fiberglass, resin, painted hide
Arrows: brass, bamboo, feathers
Stage prop: Styrofoam, wood, canvas,
acrylic paint, dimensions variable
Collection of the artist

Entering the tiger room, you see the violent
act—tigers with arrows pierced into their
bodies—and there's a very visceral response.
Even though it's completely fake, the tigers
are so realistically made that the audience
feels pain when they see them. The pain
is not in the tigers, which obviously can't
feel. The pain is really in the person who's
viewing this. So it's through the artwork,
because it represents pain, that one feels
this pain and has this very visceral relation-
ship or reaction to it. There's a lot of talk
about the content of my work, about the
subject matter or the historical background.
But there's not a real in-depth investigation
into the visual impact. It's through visual
impact that you transmit these ideas. And
it's through visual impact that this pain is
felt, and you can actually elicit a very direct
response from the audience, a very strong
response. But it's the treatment of all the
elements that has the power to do this.

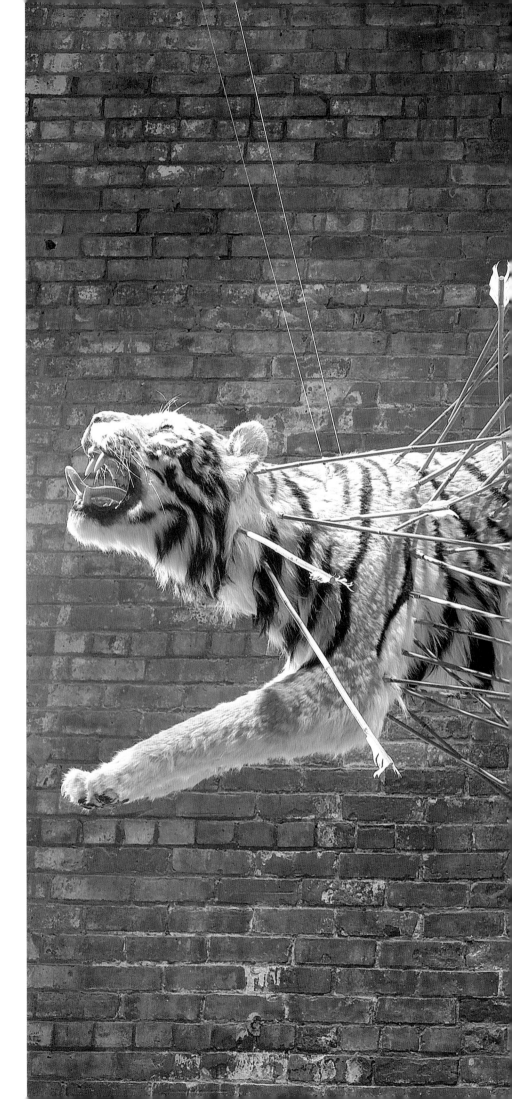

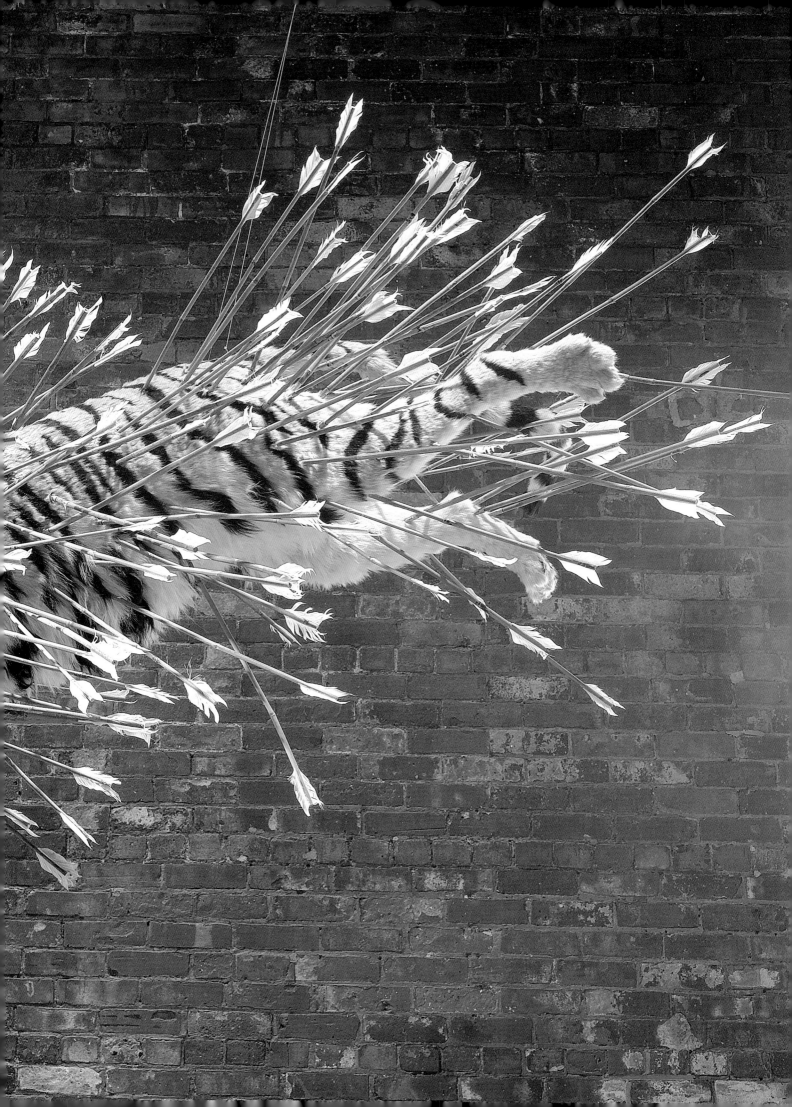

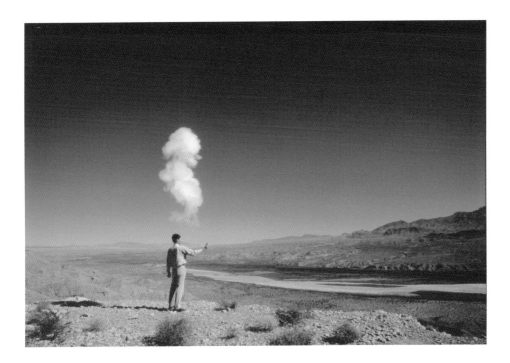

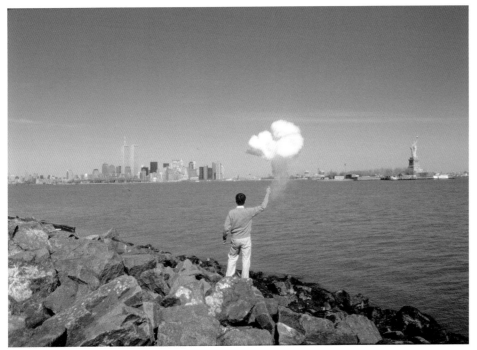

Maybe my work sometimes is like the poppy flower. It's very beautiful, but yet because of circumstances it also represents a poison to society as well. So from gunpowder, from its very essence, you can see so much of the power of the universe—how we came to be. You can express these grand ideas about the cosmos. But at the same time, we live in a world where explosions kill people, and then you have this other immediate context for the work.

Borrowing Your Enemy's Arrows (1998) uses three thousand arrows on a boat that's hanging. I've used the image of the arrow quite a lot. And I also like to hang things up. Perhaps it's the physical response one has with an object that's been pierced through—and then also to the change of gravity when you lift things off the ground. Of course, with the cars in *Inopportune* there are lights exploding out—but in a way we can see that things are stuck into them as well.

Cai Guo-Qiang

ABOVE
The Century with Mushroom Clouds: Project for the 20th Century, 1996
10 grams of gunpowder,
duration about 1 second each
Top: Nuclear Test Site, Nevada
Bottom: New York City

OPPOSITE
Borrowing Your Enemy's Arrows, 1998
Wooden boat, 3000 arrows, electric fan,
light, Chinese flag
Boat: approximately 60 x 283 x 90 inches
Arrrows: 24 inches each
Collection Museum of Modern Art, New York

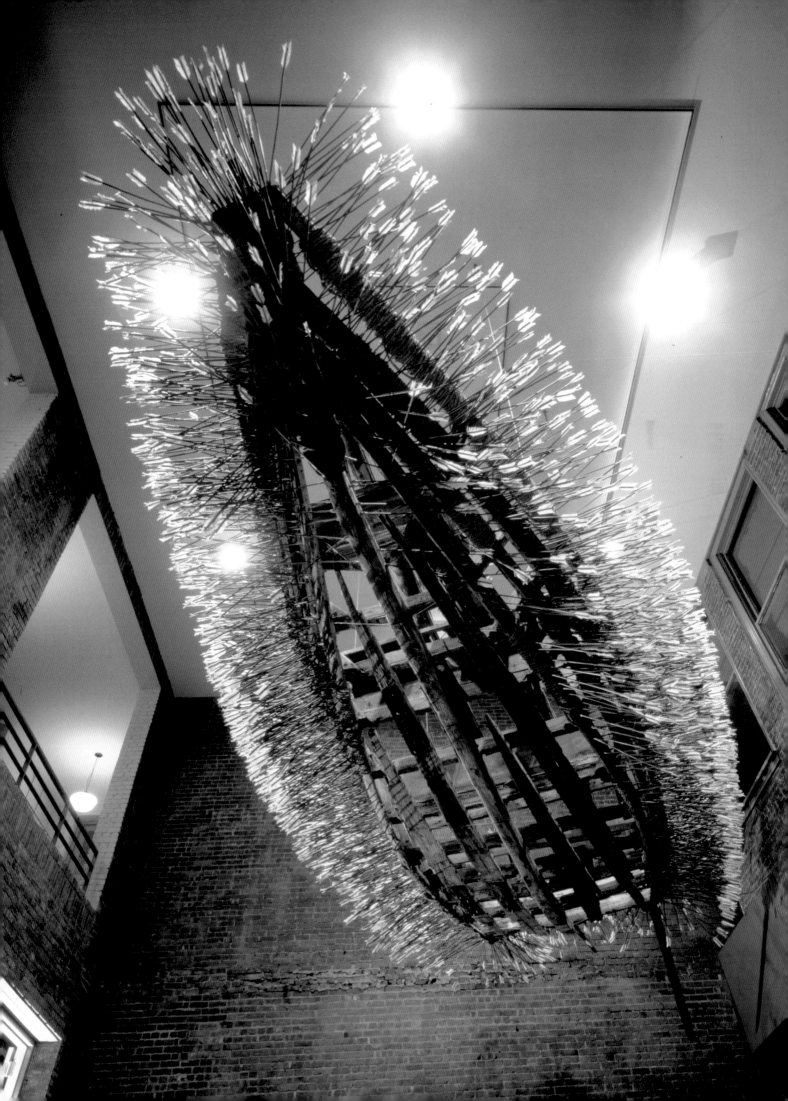

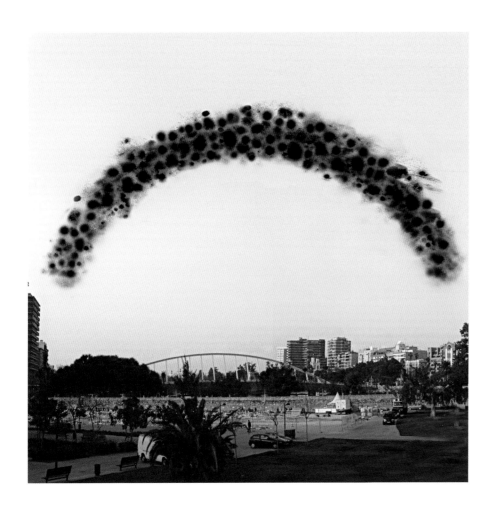

Why is it important to make these violent explosions beautiful? Because the artist has a talent, has the ability, to perhaps transform certain energies, almost working like an alchemist using poison against poison, which is very much a philosophy in Chinese medicine. And that's turning something bad into something good, or countering that force and that type of energy. So it's the whole idea of the alchemist, using dirt—dust—and getting gold out of it.

Black Rainbow (2005) is a work I'm preparing to do for Valencia, Spain. I was invited to see the site in March 2003, and three days prior to my departure the

Madrid bombing happened. Valencia is very famous for its really crazy explosive fireworks shows that they put on every year. But being there in that atmosphere, with the bombing that had just happened, I was really thinking about what possibilities there still are for fireworks. And what came to mind was making a black fireworks show. In some ways it will be very similar to a normal fireworks show, but instead of bright lights and colors, these will be entirely in black and it will be shot in daylight, around noon, against a blue sky. And after ten minutes of these black fireworks, there will be a dark cloud left hanging over the sky, slowly dissipating.

Cai Guo-Qiang

ABOVE
Black Rainbow, proposal, 2005
Explosion project for Valencia, Spain

OPPOSITE
No Destruction, No Construction: Bombing the Taiwan Museum of Art, 1998
25 kilograms of gunpowder, duration 10 seconds
Taiwan Museum of Art, Taichung, Taiwan

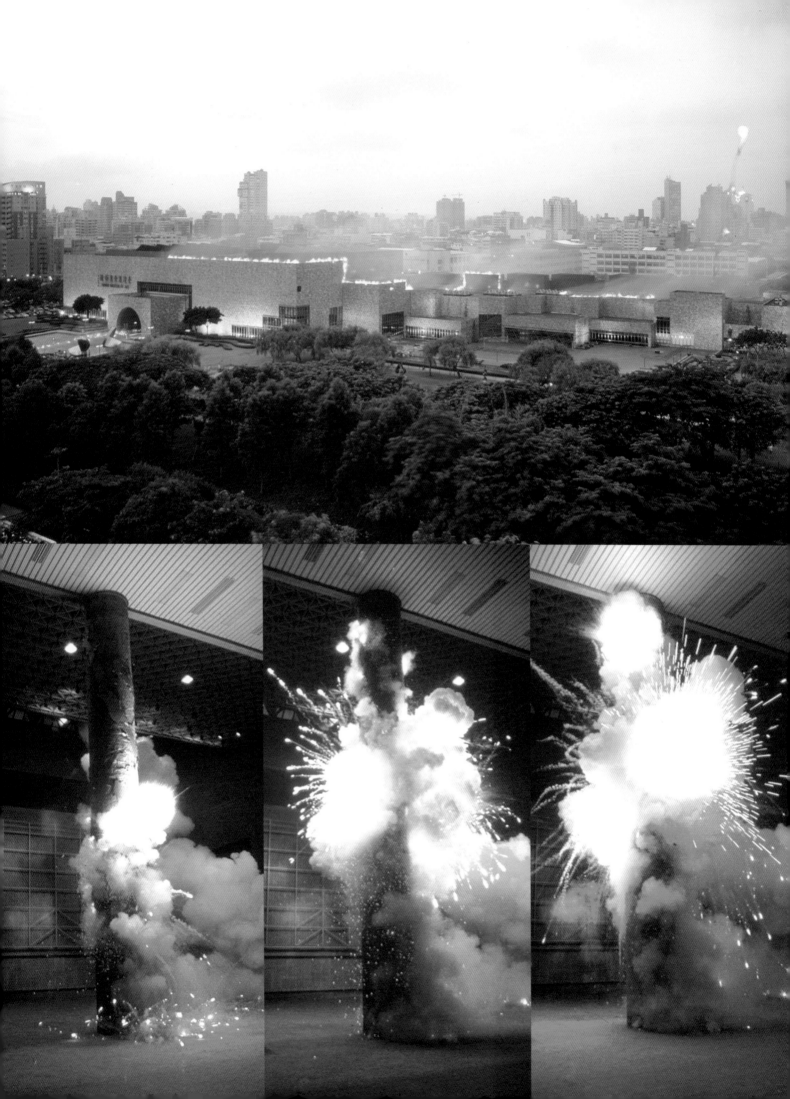

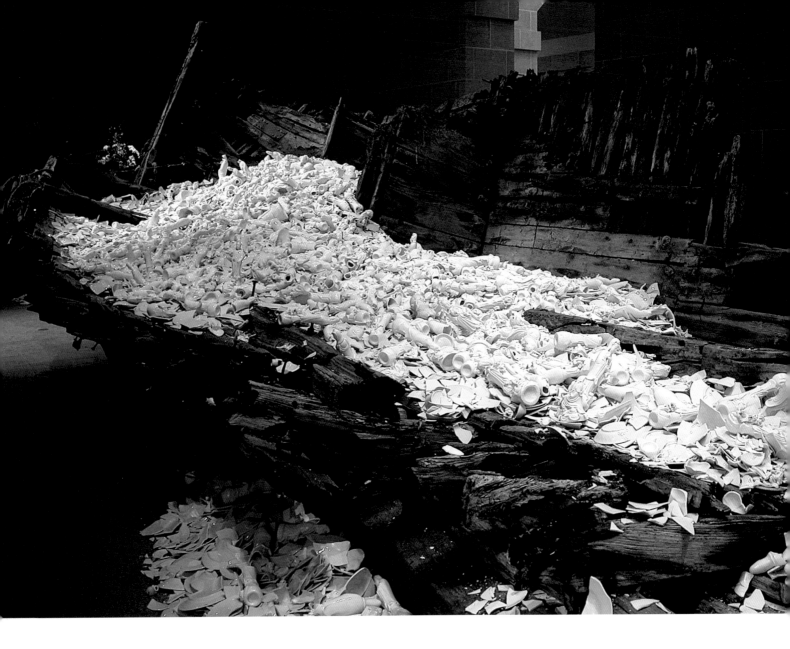

Cai Guo-Qiang

Reflection, 2004
Excavated boat, 7 tons of
porcelains, 18 x 50 x 16 feet
Installation view at the Freer
Gallery of Art and Arthur M.
Sackler Gallery, Smithsonian
Institution, Washington DC
Collection of the artist

Kuan Yin is a god or goddess that I hold very close, a god that I worship. And when you say that, you're relying on some kind of eternal power this figure has. However when I look at the Kuan Yin statues in the museum, I see that they are artworks. I do not see them as gods and goddesses. They are artistic representations that are different from the types of idols that we use to draw a link between us and the eternal power of the deity. So here, in *Reflection* (2004), we have a few tons of Kuan Yin figures, seen as artistic objects. They are placed here for

that purpose. But of course because of the nature of these statues, what they allude to brings on very strong emotions and that becomes part of the richness of the work. For me it's really important that the work here displays an aesthetic of decay along with the sunken boat with the broken ceramic pieces. They form a unity in show-ing the power of destruction, the beauty of destruction, whether it's from nature— because the boat has sunk—or through other forces. It's really the beauty of decay and death that holds a power here. . . .

Cai Guo-Qiang

*Out of Desperate Misfortune
Comes Bliss*, 2004
Gunpowder on paper, 90½ x 59 inches
Collection of the artist

When I was little, I would see what my father was doing and I would ask what he's painting. He might point and say, "Oh this is the sea of our hometown, where we're from. And this is the village." But then I went back with him to our home village and it was nothing like that. Our sea was nothing like that. I said, "What is this?" He said, "Oh, it's the mountain right behind our house." But it looks nothing like it. And we never had these fogs and clouds lacing in and out of the mountain. But from early on, very early on, I understood that art is not about what you say. It's about these other things that you don't say. For me, painting or drawing—art—doesn't need to be verified. It doesn't need to have something you check against. Anything's possible. It doesn't have to look like anything. But I also learned from my father that you still draw. You still make these images. Later on when I grew up, I said, "Well, why paint landscapes? Why even depict any real landscapes or whatever it might be that you're depicting? Why can't you just do colors or things that have nothing to do with these physical forms?" So perhaps it's that we—on this journey— have pushed the road a little further and that we travel a little further along.

Krzysztof Wodiczko

I don't like to explain my own work in terms of my biography and geography and historical context. Not because there is no good reason to build links between what one does and where one comes from—but because I don't want people to delegate and relegate responsibility for more risky and ambitious work only to those who went through some hell or turmoil in the early part of their lives. But it is important to mention who I am. The fact that I was born during World War II, and my childhood was on the ruins of war, both physical and political and perhaps moral, and definitely psychological is probably a sign that I am qualified to understand at least a little bit of what survivors have gone through—my mother being a Jew who survived the war, whose entire family was killed during the Warsaw Ghetto uprising, and who gave birth to me in the midst of all this. I would not like to think that one must go through the horrors of war or have heroic parents to create something that makes a difference, goes against the grain, or has a larger social and ethical ambition.

I don't know if this is political art. Or is this psychotherapeutic art? Or is this an ethical proposition? I don't know who I am. Sometimes I'm thinking of myself as what Derek Winnicott, the psychoanalyst, called a "good enough mother," someone who protects the process in which others can develop and create something in an atmosphere of trust, develop the ability to cope with life though often damaged and wounded by their experiences. Perhaps projects of the kind I'm working on help those who are ready to take advantage of them to make that leap.

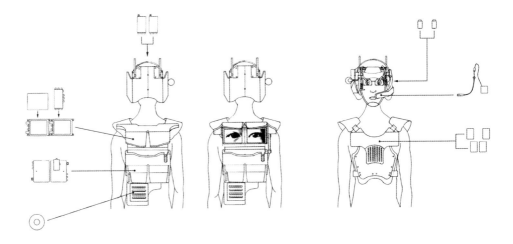

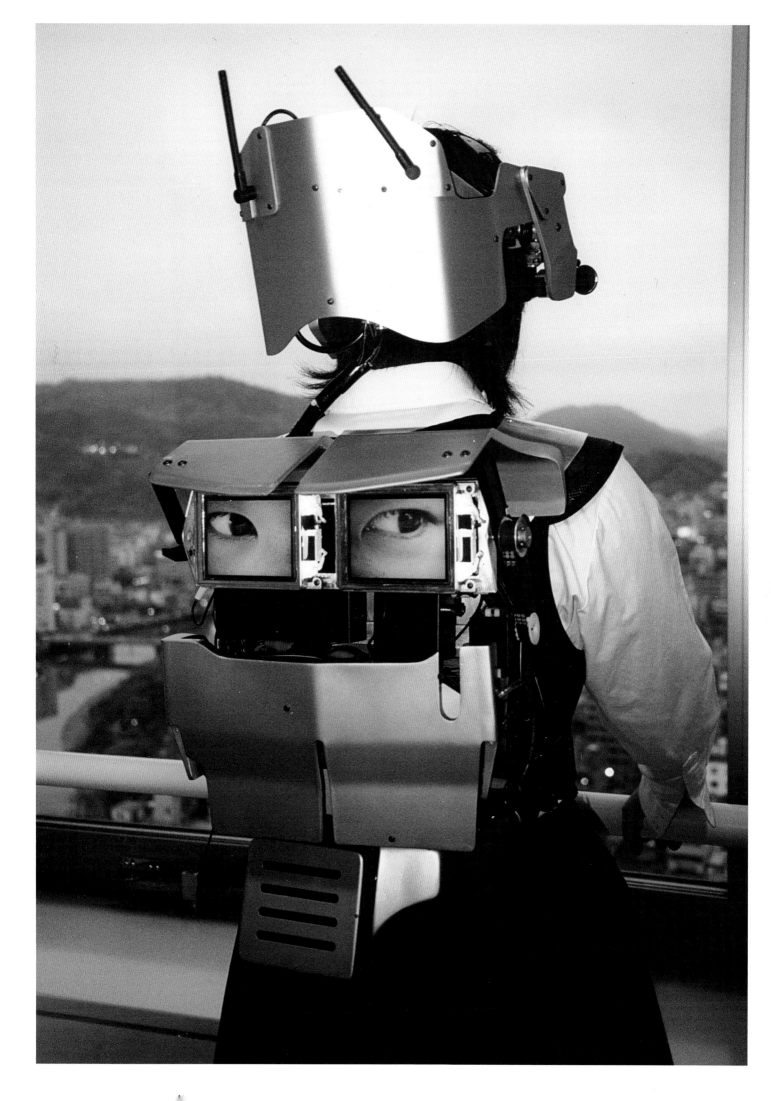

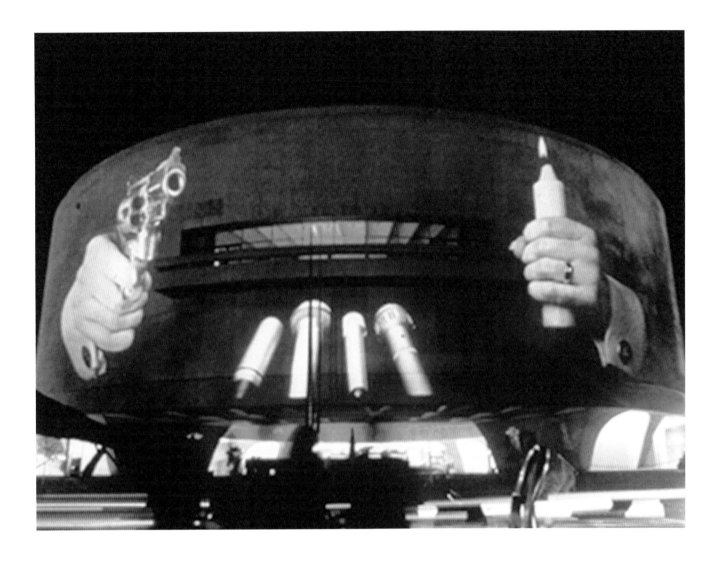

Krzysztof Wodiczko

When I first began this type of work in Krakow, I didn't have any experience in filming or projecting motion images on buildings. I'd been working on still slide projections. So the shift was radical. The projections might look similar in photographs and documents, especially photographs, but they are completely different. In the slide projections, I was animating the monuments with icons and images that I produced in order to actualize them so they could speak on contemporary issues. Now, I create a situation for others to animate monuments and project themselves. So the process of filming is a situation for them to learn what to say and how to say it—because I don't tell people what they should say. I don't know what they will say. They don't know themselves.

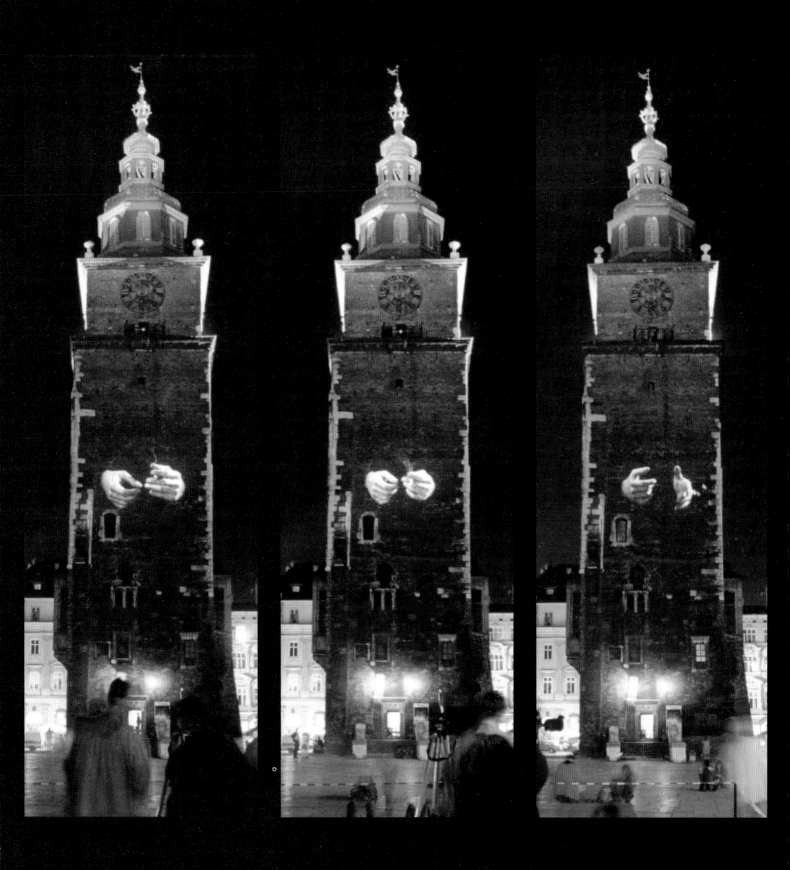

Krzysztof Wodiczko

The Hiroshima Projection, August 7–8, 1999
Public projection at A-Bomb Dome,
Hiroshima, Japan

My position is that you cannot work towards peace being peaceful. If the peace is to be one where everybody's quiet and doesn't open up . . . share what's unspeakable . . . offer unsolicited criticism . . . defend others' rights to speak and encourage discourse, that peace is worth nothing. It reminds me of the kind of peace that was secured in my old country under the Communist regime. That is the death of democracy. That might have consequences as bad as war—bloody war and conflict. So, to prevent the world from bloody conflict, we must sustain a certain kind of adversarial life in which we are struggling with our problems in public.

I started working on my Hiroshima projection with the assumption that we were going to 'reactualize' the A-Bomb Dome monument (one of the few structures that survived the bombing—just underneath the hypercenter of the explosion) and reanimate it with the voices and gestures of present-day Hiroshima inhabitants from various generations, starting with those who survived the bombing, who witnessed it; their children, who may still remember; their grandchildren and great-grandchildren. So all those generations somehow connect through this projection, not necessarily in agreement in terms of the way the bombing is important and the way the meaning of that bombing connects with their present experiences. The fallout of the bombing is physical and cultural, psychological. The river is as much a witness as the A-Bomb Dome building reflected in the water. It was in fact the river that became a graveyard for both people and buildings. The river was where people jumped to their death because they thought that it would help them to cool their burns, but in fact it only contributed to a quicker death. Those are the events or scenes recalled by some of the memorial projection participants and artists who were speaking through the building, as if they *were* the building, looking at the river and seeing all of this again—the bodies floating, the people jumping in. . . . At the same time, the river continues its flow as if nothing has happened. There is fresh water coming. The river is like a tragic witness—but also a hope—because it's moving. . . .

The fact that both the building and the projection reflected themselves into the river (that is both a witness and a hope of change, a new life) somehow completed the picture. During the recording of the testimonies, one person was drinking water. As she was about to drink, I realized that perhaps I should suggest something aesthetically . . . that she pour the water back into the river. That was maybe the only aesthetic intervention in this project, which was met with agreement and support on the part of everybody in the studio. So that's why we left it at the end of the projection. . . .

There's one important aspect in the Hiroshima projection that might be true with all of my projections—the visibility of the texture of the surface on which the image is projected. The images are not projected on a white screen, but on façades that are carved. They have their own iconic arrangements or texture, made of bricks or mortar. And this is important . . . There is an image, there is a building. There is a body of the person, projected, and there is a body of the building or the monument, animated. But it is also the skin of the building, the surface, which is seen as something in between. . . . And that's a very important protective layer that separates the overly confessional aspect of the speech of those who animate the building and our overly empathetic approach towards the speakers. So that creates a distance which is important for thinking—for recognizing that between them and us there is a wall. Any attempt to identify with the person is a danger. To say, "I understand what you went through," is the most unacceptable response. The opposite may be more appropriate. "I will *never* understand what you went through."

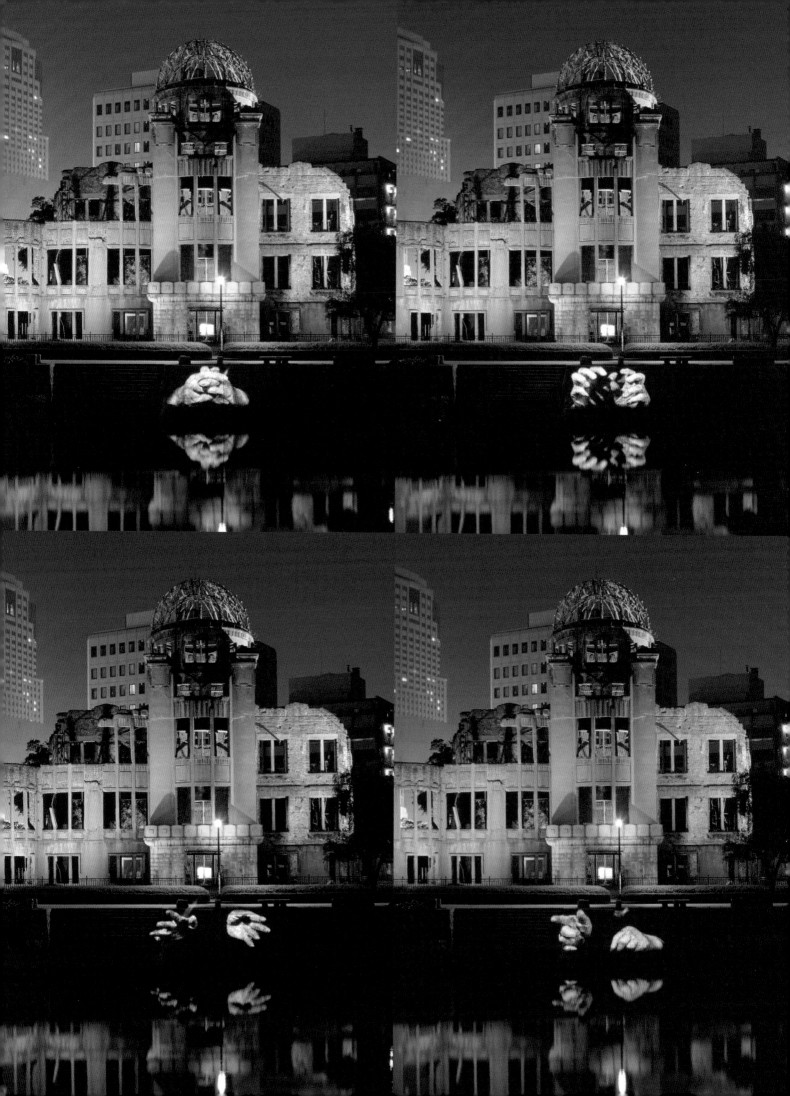

Krzysztof Wodiczko

Bunker Hill Monument, Boston,
September 24, 1998
Public projection at Bunker Hill Monument,
Boston, Massachusetts

What are our cities? Are they environments that are trying to say something to us? Are they environments in which we communicate with each other? Or are they perhaps the environments of things that we don't see, of silences, of the voices which we don't, or would rather not, hear? The places of all of those back alleys where perhaps the real public space is, where the experiences of which we *should* be speaking, where voices that we *should* be listening to, are hidden in the shadows of monuments and memorials. That's where the city that interests me is—in all of those places where we are even afraid to go, and all of those places that we get to when we make a mistake, take a wrong bus, a wrong subway line. One of the objectives behind my projections is to bring to light all of those voices and experiences, and to animate public space with them in a kind of inspiring and provocative way—maybe in a way of protest.

To some degree, we could say that most cities are populated by traumatized survivors and historic monuments that are witnessing conflicts and problems . . . present-day troubles and important events living juxtaposed with grand moments in history, celebrated and commemorated by monuments. I realized that there is one place in Boston where those two are extremely close to each other—that the Revolutionary War monument on Bunker Hill somehow connected with the daily struggle and battleground of Charlestown residents living in the shadow of that monument—where, on a weekly or monthly basis, someone was murdered, killed, or executed as part of the violence that was spreading in Charlestown and South Boston at that time.

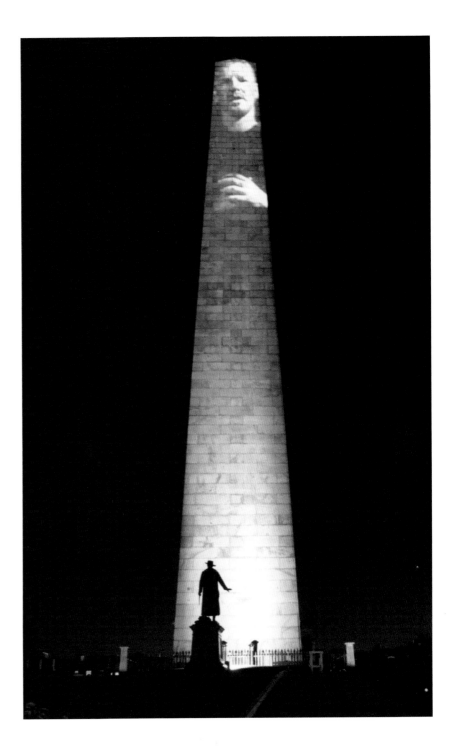

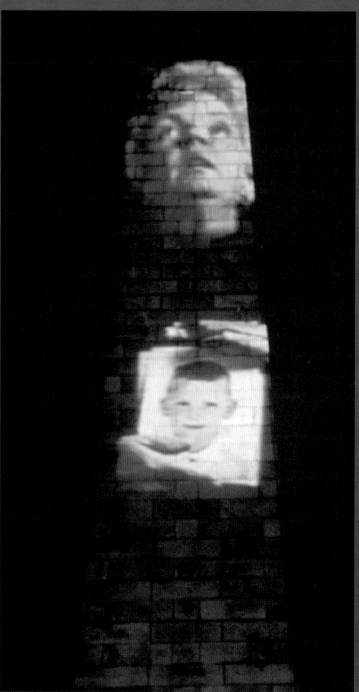

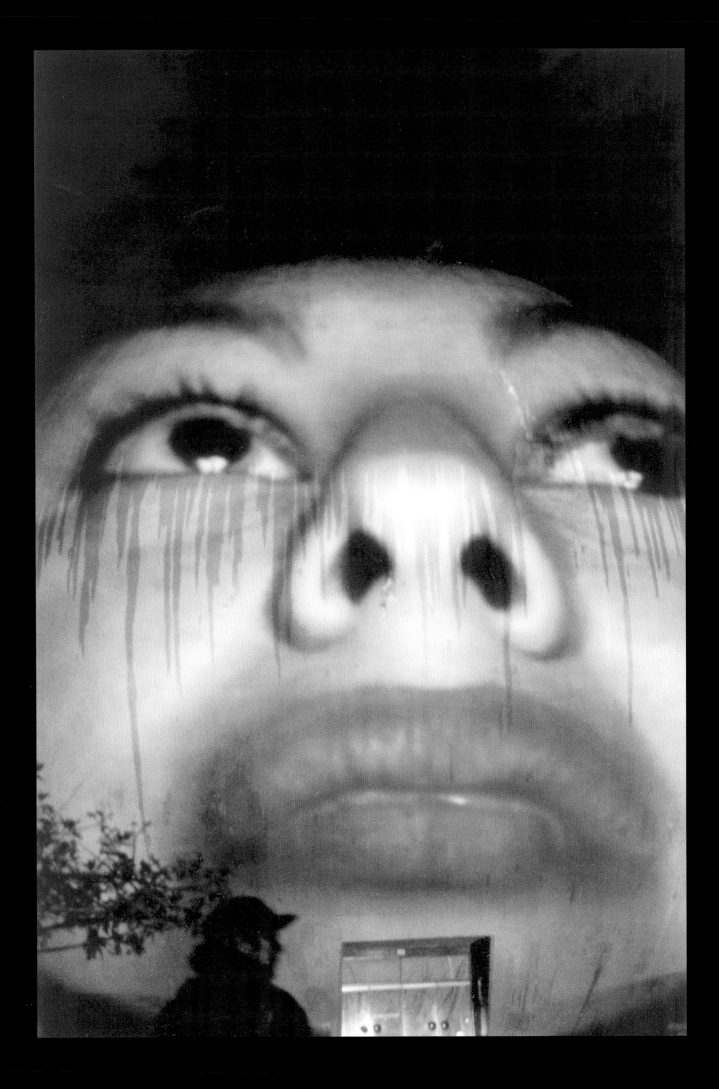

Krzysztof Wodiczko

OPPOSITE
The Tijuana Projection,
February 23–24, 2001
Public projection (as part of In-Site 2000)
at Centro Cultural de Tijuana, Mexico

RIGHT
The Tijuana Projection,
February 23–24, 2001
Public projection (as part of In-Site 2000)
at Centro Cultural de Tijuana, Mexico

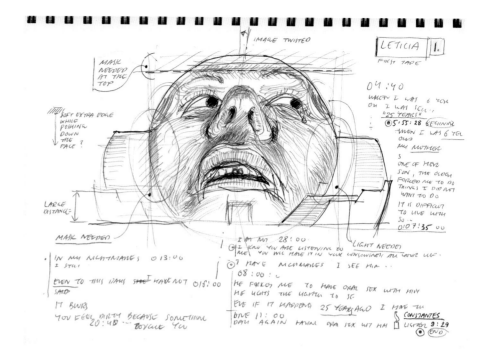

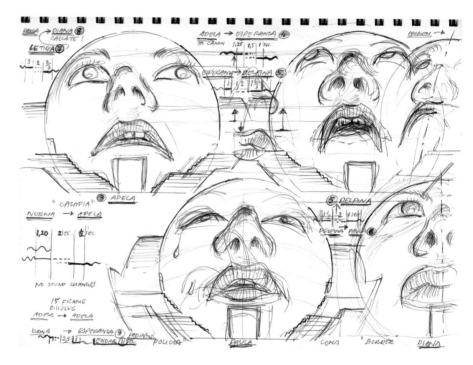

I make notes or sketches during the process of recording and editing to see how the body of the person will connect with the body of the monument or façade or sculpture. So I need to make sketches—over and over again—sketching the body of the building and trying to see the extreme cases where the movement of hands or head or both will be at risk to cross the boundary or outline of the architectural form. The technical reasons are obvious. But I have realized with time that there must be another reason why I'm occupying myself so much with those drawings. And that is to keep a certain distance from what I hear people say . . . over and over again about the same traumatic experience, repeating in the process of filming . . . and editing . . . in order to actualize and complete the statement in the present time. So those are important reasons why I need to hear and see things many times. And somehow the process of sketching keeps me sane. Because I cannot relive each time what I hear. It will trigger my own experiences and trauma, whether I remember them or not. So I need to have something in between.

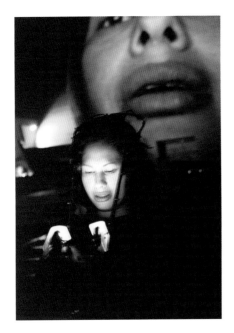

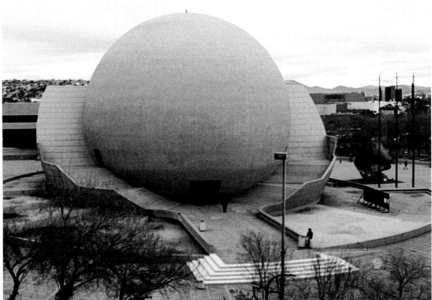

Krzysztof Wodiczko

The Tijuana Projection,
February 23–24, 2001
Public projection (as part of In-Site 2000)
at Centro Cultural de Tijuana, Mexico

Tijuana. It's a border not only between Mexico and the United States, but also between Tijuana and the rest of Mexico for many people who come from poor provinces such as Chiapas to try to advance their life by moving north. They cross the border *before* they reach Tijuana. That's the border between the feudal village . . . and work in the *maquiladora* factory as members of a new kind of industrial proletariat. They say they move from an old hell to a new hell. For many of them, that's an advantage. Perhaps there is nothing worse than to stay in the same hell all their life long. These very young women (the overwhelming number are young women) work in ways we don't even imagine. Their situation is incomparably worse than anything I have tried to understand before. But I seem to be working with people who manage to survive and heal themselves to the point where they can take advantage of my projects to make another leap towards reconnecting with society. . . .

The issues that were brought were taboo—of incest, rape—and issues of poisoning in the factories . . . irreversible damage to human health that, according to some major economic action groups in Tijuana, should not be public . . . to protect the interests of owners of factories and corrupt politicians.

Those hidden things came out so abruptly that I realized that this projection was not going to be easy for anybody. This was going to be a blast of truth that would be a shock to those who would like to be entertained. During the projection, you could sense the kind of electricity and pain among those who came to witness it. The position of the image was very special. Standing in front of the building we saw the face over our heads speaking to us (as if we were small children, tiny people looking at figures of authority), but also speaking to the larger world beyond. The speech was directed to the crowd, to the border, to San Diego . . . in the direction of the United States.

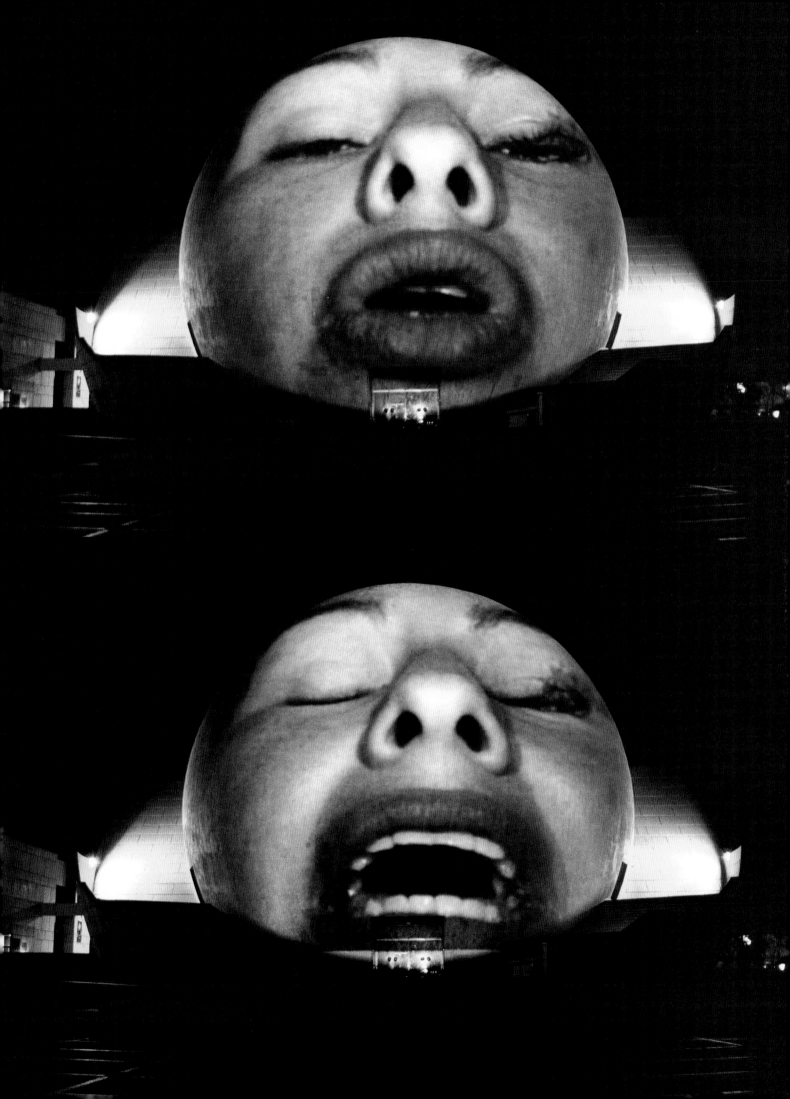

Mike Kelley

Memory

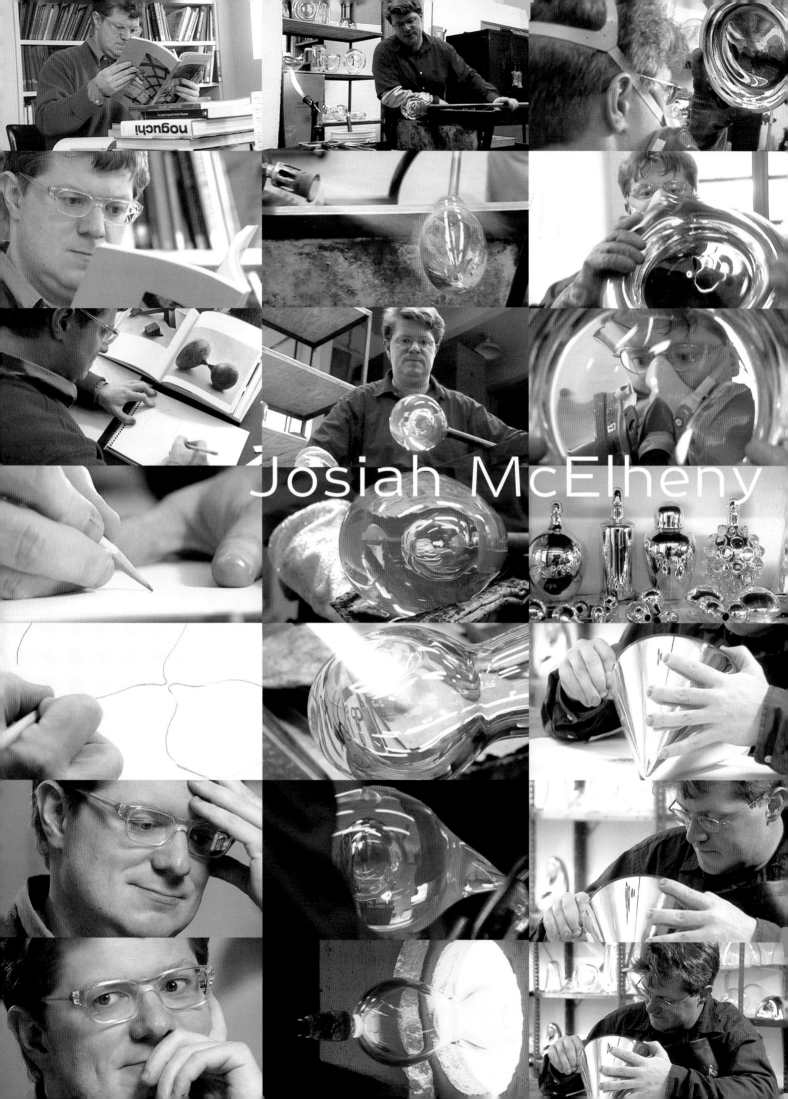

Josiah McElheny

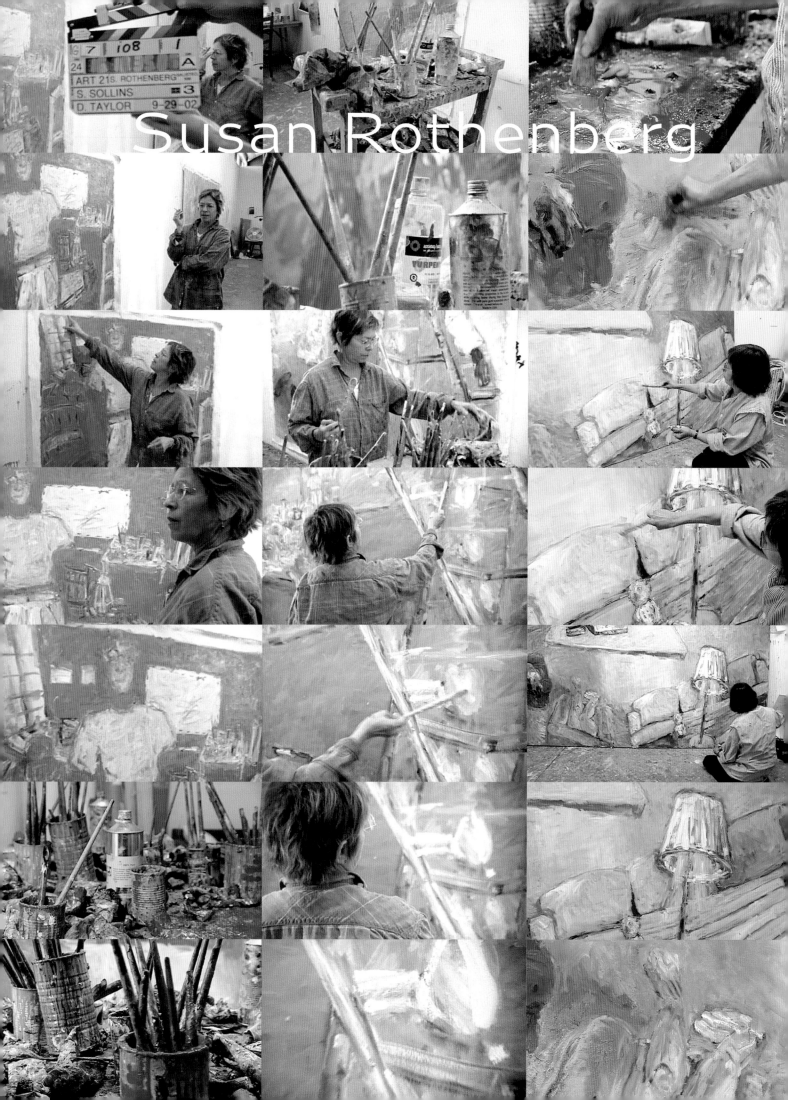

Susan Rothenberg

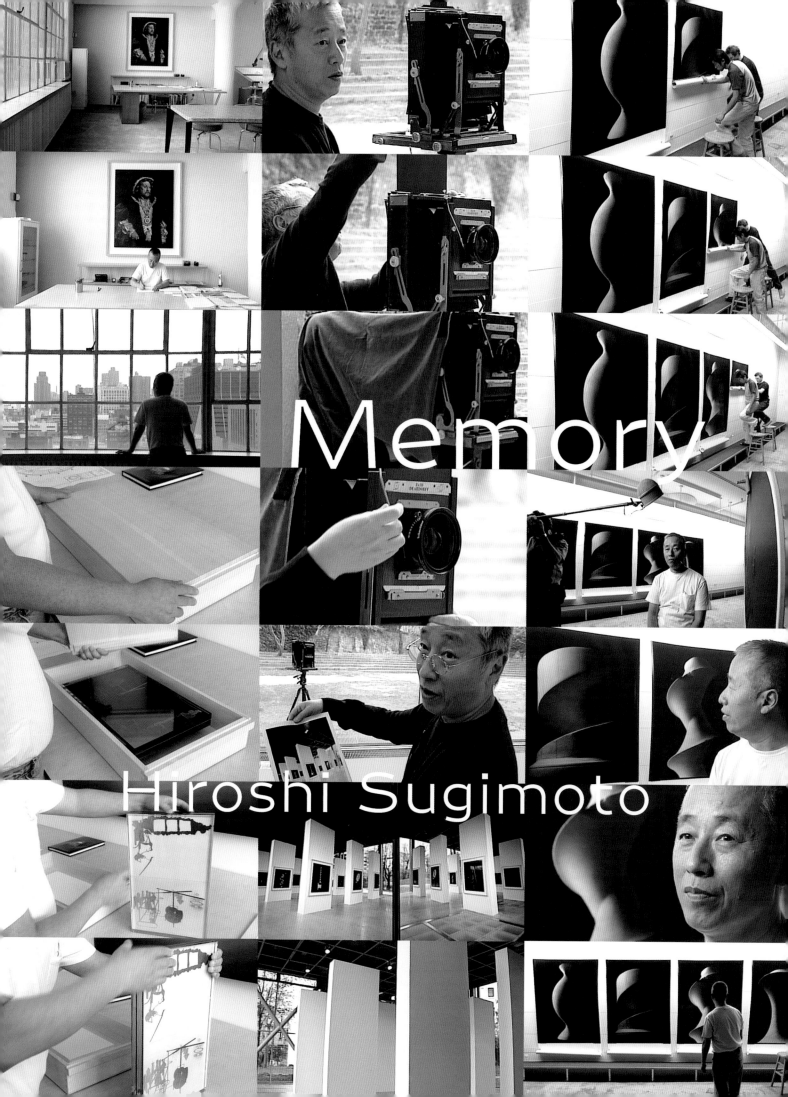

Memory

Hiroshi Sugimoto

Mike Kelley

It's hard to differentiate between personal memory and cultural memory because, for example, a lot of what I use in writing is associative and it comes from my own experience. But it's very hard to disentangle memories of films or books or cartoons or plays from real experience. It all gets mixed up. So in a way I don't make such distinctions and I see it all as a kind of fiction. And if you read a lot about the literature of repressed memory syndrome the abuse scenarios are often very standardized. It's really a form of literature that's internalized and then voiced as reality. But it finds form in a variety of tropes. So if you have a religious orientation, it comes through Satanic-cult abuse. If you don't, it might come through alien abduction. Or a more typical one is family incest scenarios. And yet the stories are all quite similar—it's just the social bracket that changes. I see this as almost a kind of overarching 'religion' in which the rationale for almost all behavior is the presumption of some kind of repressed abuse. . . . The basic premise is that it's all based on trauma culture, and that's a contemporary motivation—like a basic motivational idea. And I have to undermine that. I think having something be somewhat ridiculous is a way of undermining that notion that life is just about trauma. This is also something that is very much embedded in a lot of modernist work. Expressionism, and existentialist artworks—that kind of heavy artist-as-sufferer. I have no interest in that.

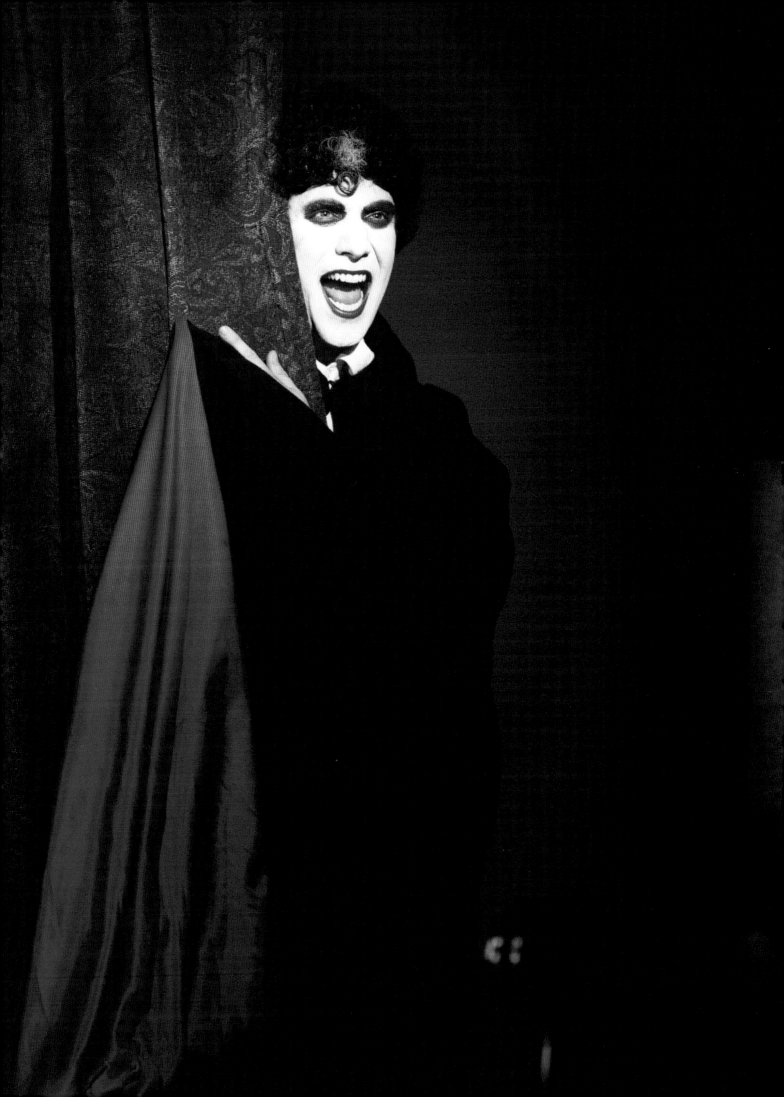

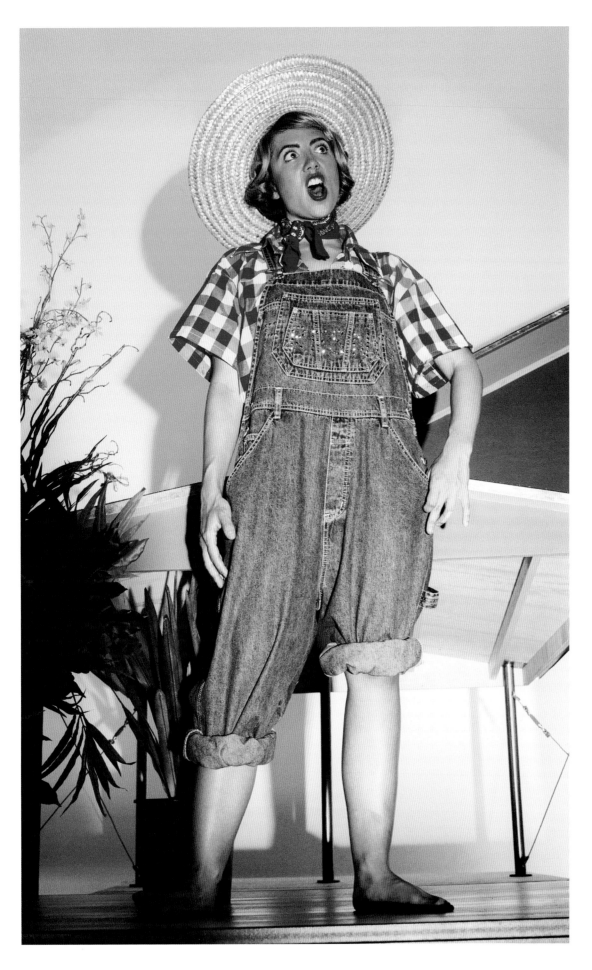

Mike Kelley

LEFT AND OPPOSITE
*Extracurricular Activity
Projective Reconstruction
#s 2 through 32
(Day is Done)*, 2004–05

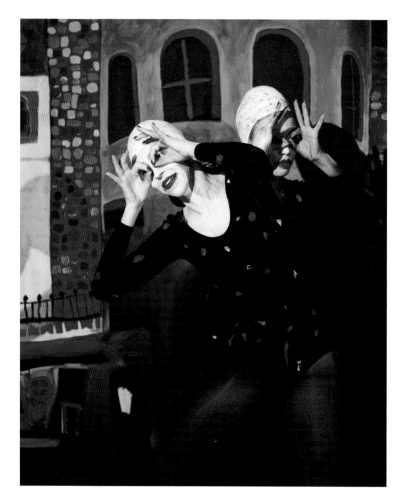 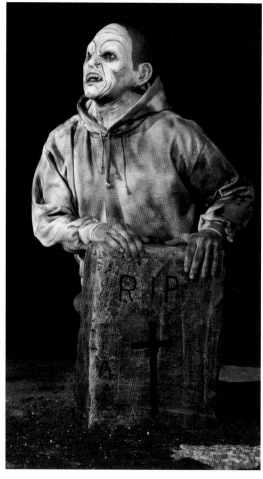

All the scenarios for *Day is Done* (2004–05) are based on images found in high-school yearbooks in this particular case, though I've also done a whole collection of similar kinds of images from the small-town newspaper of the town where I grew up. The particular categories had religious ritual overtones, but outside of the church context. They all looked like they were done in public places, or they had gothic overtones. So I said, "Okay, I'm going to work with these particular groups of images and develop a kind of pseudo-narrative flow." The rituals run the gamut from something like dress-up day at work to St. Patrick's Day or Halloween, to a community play or an awards ceremony. So all I have is this image, and then I have to write a whole scenario for it like a play, and then do the music and everything. Each one is just based on the look of the photograph that tells me what style it has to be done in. My dream is to perform it live in a 24-hour period. So

the day stands for the year. And at midnight there would be a grand finale spectacle—a donkey basketball game. Because I think the donkey basketball game is one of the greatest examples of American carnivalesque. It's all about inversions of power . . . which is very typical of folk forms that perform carnivalesque functions—where you get to break the mold of how you're supposed to act or look. In that sense, it's analogous to the traditional social role of art in the avant-garde, but it's a very restrained one. And I'm just trying to show that relationship between the traditional avant-garde and the carnivalesque social function of these folk rituals, as I guess you'd call them.

Day is Done is built around the mythos that relates to *Educational Complex* (1995) and the history of a kind of symbolist attempt at uniting all the arts. I know that people don't look at art like that, and I don't expect people to know any of this stuff. And I don't care if they do

or don't, because you have to make an artwork so it can be enjoyed on the most surface level, but I want for the more dedicated art viewer to be able to get the secondary and third levels of meaning. It has to operate on multiple levels: it has to be available to the laziest viewer on a certain level, and then on a more sophisticated level as well. So using that as a model where there's an architecture, that architecture needs various kinds of art forms—like a grand spectacle. I was thinking of the Russian composer Scriabin who, at the time of his death, was working on a grand spectacle that would last for a week. And there was a different thing for each day, and that was linked to some kind of broader natural system. So I'm using the year (a series of 365 video tapes) just as a given system, the rationale tying it to this history of works that relate to natural cycles, like symbolist artworks. But I don't expect to get to 365.

Mike Kelley

BELOW AND RIGHT
Educational Complex, 1995
Synthetic polymer, latex, foam core,
fiberglass and wood, 51 x 192 x 96 inches
Whitney Museum of American Art,
New York; Purchase, with funds from
the Contemporary Painting and Sculpture
Committee 96.50

Educational Complex is a model of every school I ever went to, plus the home I grew up in, with all the parts I can't remember left blank. They're all combined into a new kind of structure that looks like a kind of modernist building. I started to think about this structure through the *Gesamtenswerk*, the 'total artwork', of Rudolf Steiner, where he tries to combine all the arts and develop a kind of rule system according to which every art form is related. So the architectural relates to the dance relates to the music relates to the writing. But it's also a kind of religion. And so my religion for this structure is repressed memory syndrome. The idea is that anything you can't remember, that you forget or block out, is the byproduct of abuse and that all of these scenarios are supposed to be filling in the missing action in these blank sections in this building. It's a perverse reading of Hans Hofmann's push-pull theory.

Mike Kelley

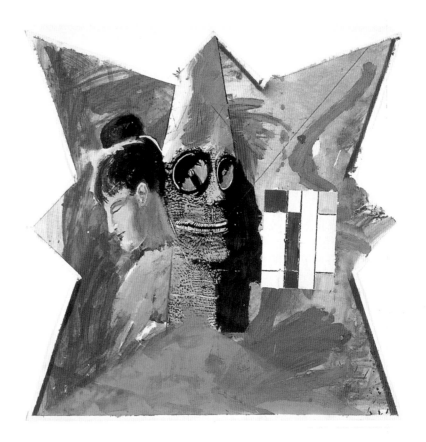

My own abuse was my training in Hofmann's push-pull theory. All the formal qualities in the organization of these works are patterned on that kind of formalist visual-art training which I see as a kind of visual indoctrination. So I'm recovering that. Another aspect of this—besides my video project of *Day is Done*—is paintings and drawings done in the manner of my student works. Hofmannesque push-pull theory is also the base organizational principle of the buildings in *Educational Complex,* and even the sculptures that attend them. Everything else is a kind of social gloss added on top of that, taken from various cultural categories.

When I went to undergraduate school I studied to be a painter and I was taught mostly by GI-bill artists who studied with Hofmann or other modernists like Léger. But Hofmann was the primary theorist for compositional ideas in painting. That's what I was taught, but I always had this perverse kind of version of it. And it was already kind of perversely being done by the early pop people like Rauschenberg—obviously still painting in a Hofmann manner. I just replaced the kind of blander everyday image that Rauschenberg used with more overtly perverse kinds of imagery because I was looking to the more sub-pop Chicago-school artists. I was more interested in the kind of popular material that they were working with, which was the lowest of the low, rather than New York pop art which tended to be more mainstream, like Warhol's Campbell Soup cans and very standard Americana kind of imagery. I was more interested in that kind of 'sub-stuff'.

I decided to go back to my originating trauma—my student training—and I took all these drawings, which are perversions of Hofmannesque compositional principles that I did in college, and I re-learned to paint that way. So I did this series called *Missing Time* because in trauma literature the part you can't remember or the time of trauma is called *missing time*, and then you recover it. So I re-learned to paint in this manner and also did a series called the *Thirteen Seasons* (1994) in this regressive manner. It's one more than the twelve seasons so it's eternal—eternally occurring abuse. The paintings are oval; I broke from the rectangular form because the oval has no end.

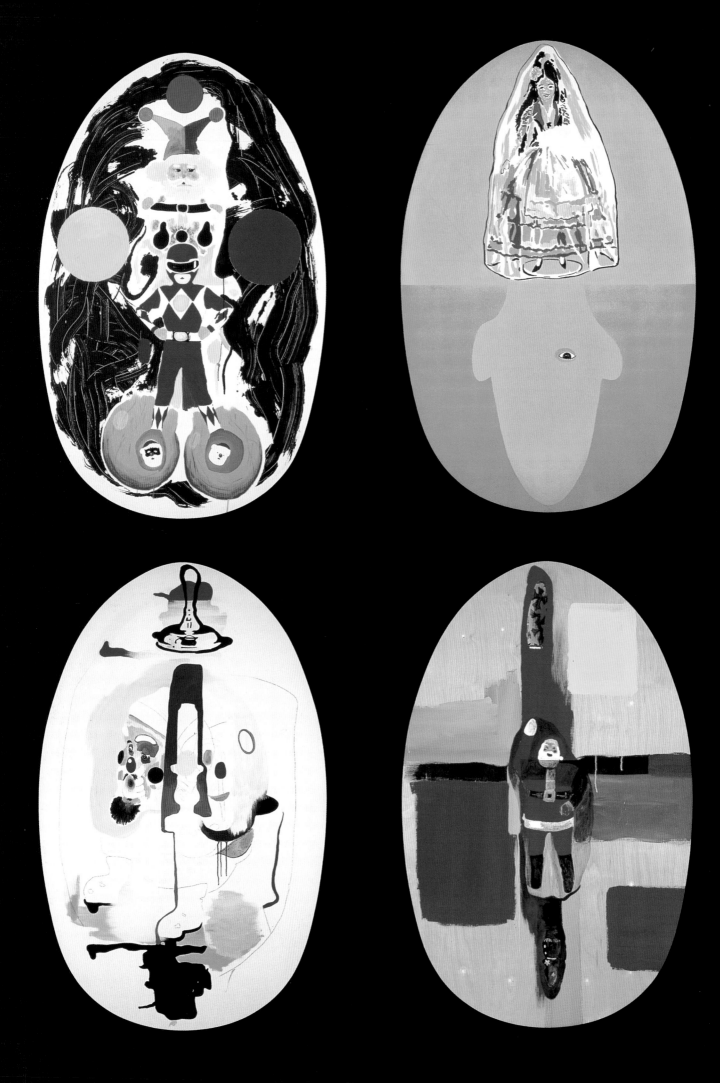

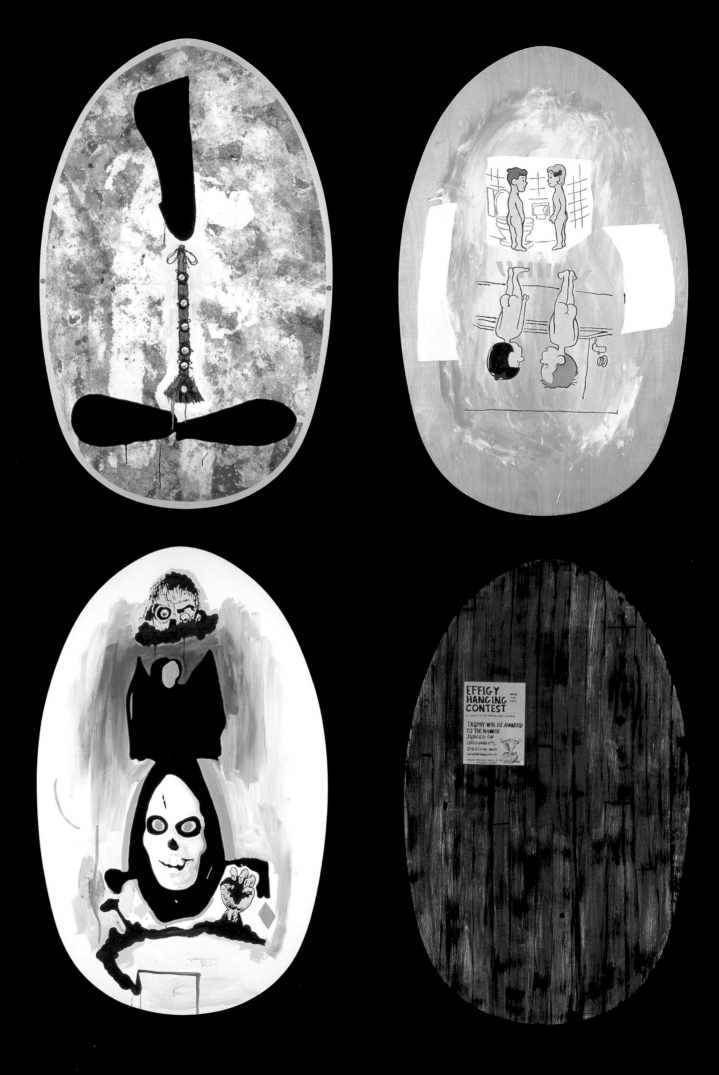

Mike Kelley

BELOW
More Love Hours Than Can Ever Be Repaid and *The Wages of Sin,* 1987
Stuffed fabric toys and afghans on canvas with dried corn; wax candles on wood and metal base, 90 x 119¼ x 5 inches
Whitney Museum of American Art, New York; Purchase, with funds from the Painting and Sculpture Committee 89.13a-e

OPPOSITE, ABOVE
Hanging stuffed animals and deodorizers, 1991
Installation view at Jablonka Galerie, Cologne
November 15–December 21, 1991

OPPOSITE, BELOW
Dialogues, 1991
Installation view at Jablonka Galerie, Cologne
November 15–December 21, 1991

I knew by the time I was a teenager that I was going to be an artist, there's no doubt about that. There was nothing else for me to be. I didn't even want to be the other things that at the time were outside general culture. I didn't want to be a rock musician; I wanted to be an artist. And I think the reason I chose it was that at that time it was the most despicable thing you could be in American culture. To be an artist at that time had absolutely no social value. It was like planned failure. You could never be a success. And the fact that I'm now a professional artist? At that time it seemed like a contradiction of terms. I came from a milieu in which artists were despised, whereas rock musicians and drug dealers were—you know—hipster culture heroes.

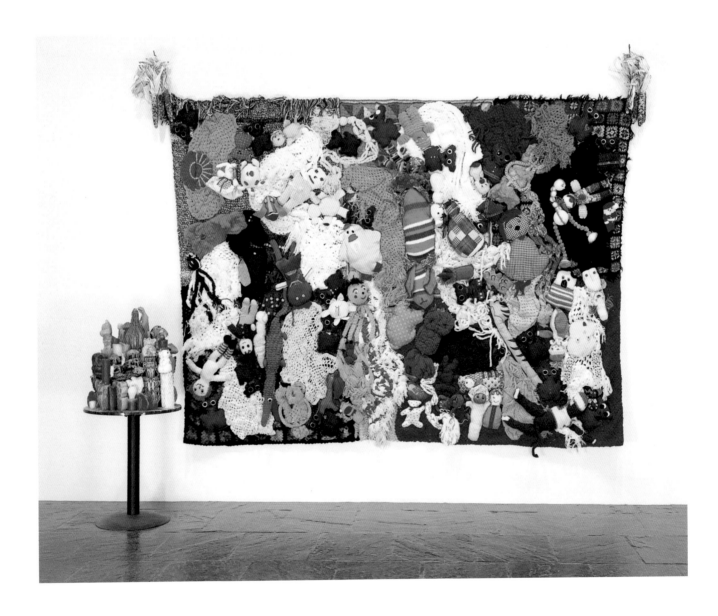

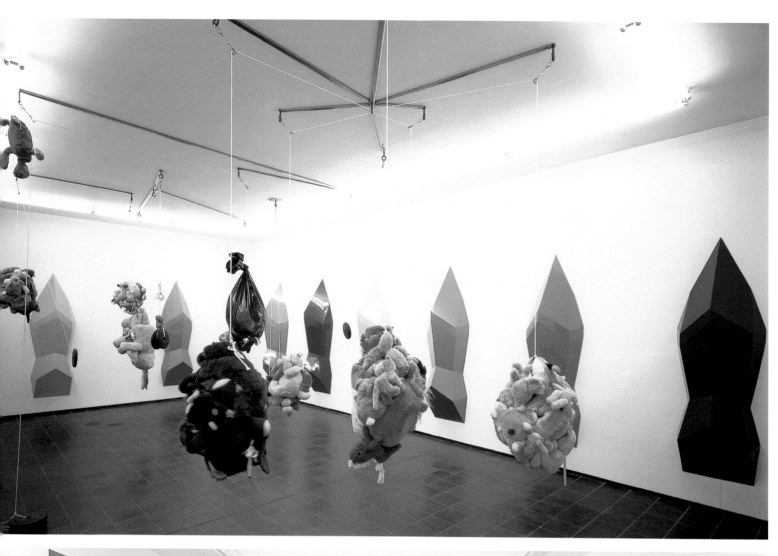

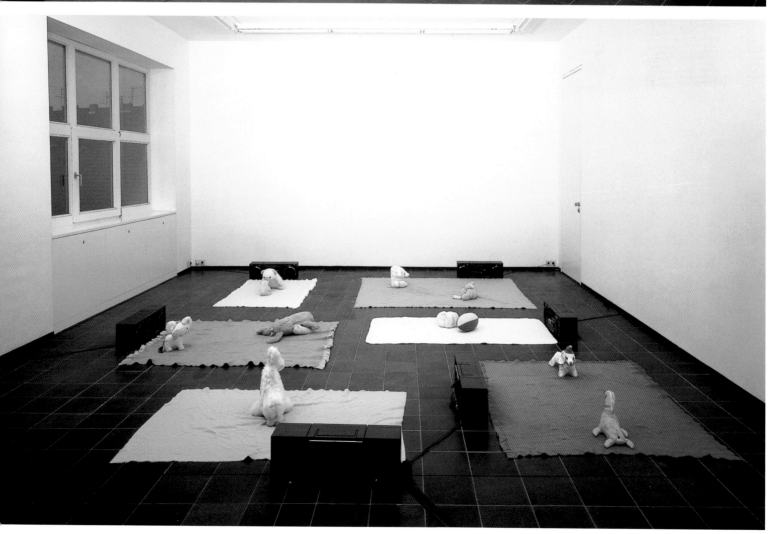

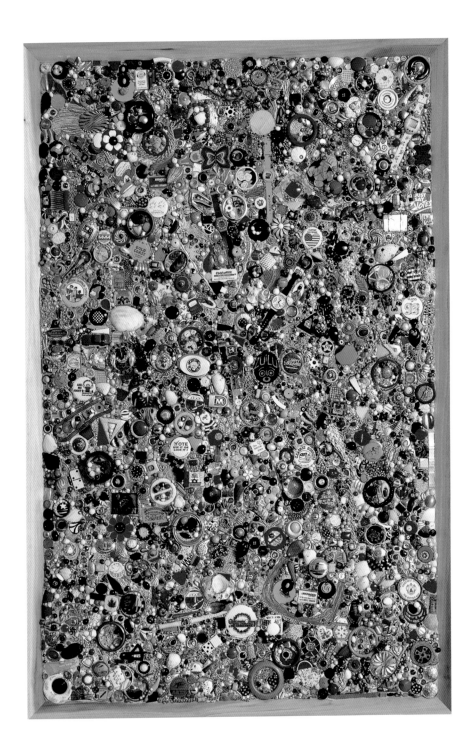

I'm more of a Marxist than a symbolist. Always, my interest in popular forms was not to glorify them—because I really dislike popular culture in most cases. I think it's garbage, but that's the culture I live in and that's the culture people speak. I'm an avant-gardist. We're living in the postmodern age, the death of the avant-garde. So all I can really do now is work with this dominant culture and flay it, rip it apart, reconfigure it, expose it. Because popular culture is really invisible. People are really visually illiterate. They learn to read in school, but they don't learn to decode images. They're not taught to look at films and recognize them as things that are put together. They see film as a kind of nature, like trees. They don't say, "Oh yeah, somebody made that, somebody cut that." They don't think about visual things that way. So visual culture just surrounds them, but people are oblivious to it.

Mike Kelley

ABOVE
Memory Ware Flat #13, 2001
Paper pulp, tile grout, acrylic, miscellaneous beads, buttons, and jewelry on wooden panel, 70 x 46 x 4 inches

OPPOSITE
Balanced By Mass and Worth, 2001
Foam, paper mâché, wood, brass, paper pulp, tile grout, acrylic, miscellaneous beads, buttons, jewelry, 2 parts, 27 x 134 x 15 inches each

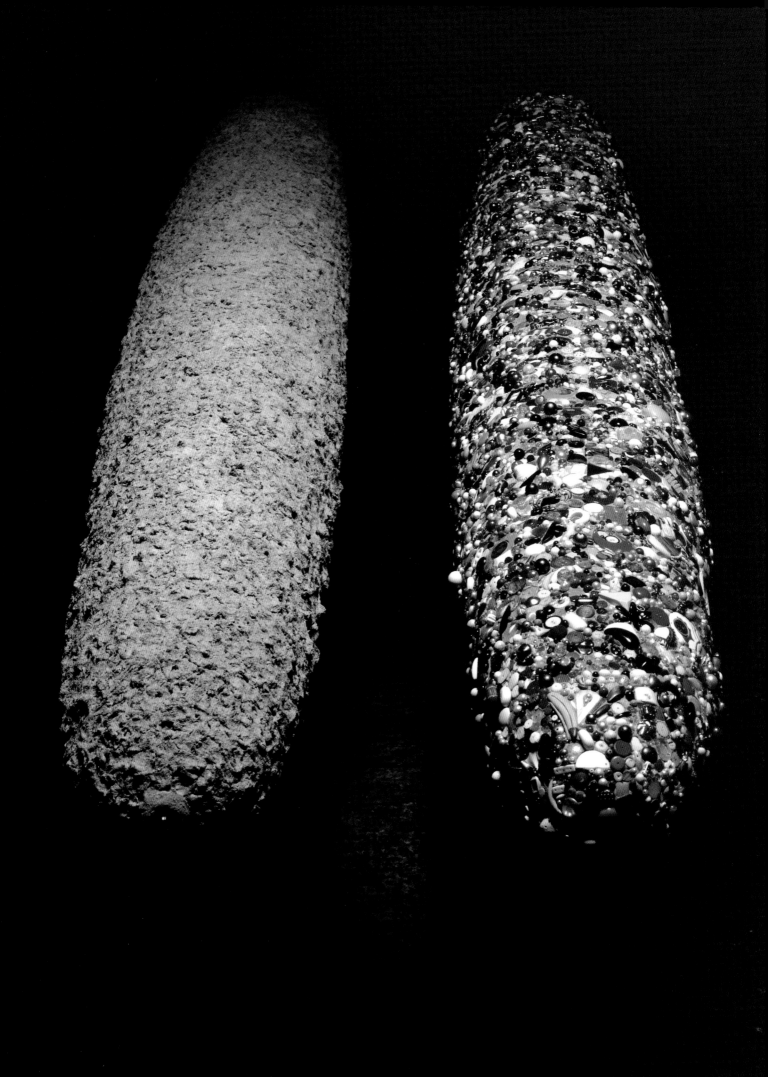

Josiah McElheny

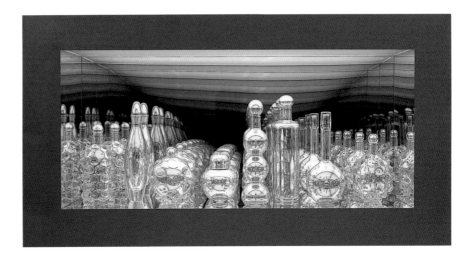

I don't really believe in history. And I think that at some level that's one subject of some of my work—the fact that history is mutable, which is essentially denying history. So either you can believe there is this thing called history which is a linear narrative or in some general sense a linear narrative with a definable kind of thrust to it, or you could say that there's just a lot of different stories. And if you believe that, which I would argue I believe, then you can't really break with them. You could only reassemble them, possibly in some other way. Or you could add your own. I am interested in the past because for me it seems like a very rich thing to try to understand, especially because art is essentially a physical remnant of a moment.

Because glass is both special and difficult, and also because it's easy for it to imitate other things, it's always been in flux. The people I studied with were actually very much involved in the invention of mid-century modernism. In one sense they were very, very far from the deep past. In another sense they were very close to it because the way they were working was essentially unaltered for hundreds of years. But they were in connection with famous architects, designers, and artists, and they had been instrumental in figuring out a way to adapt this tradition to make modern objects. What they did was collaborate with designers to try to figure out what was possible with this material, with this process, in line with the ideas of the day. So they responded to what the process naturally did and, in so doing, helped invent this vocabulary of form.

Some people have asked me whether I have any desire to do something original. I often explain that a lot of my work, all of my work, is derived from some previous source at some level and that what I'm doing is re-imagining something or shifting or transforming it slightly but always very much in connection to its source. I'm of the generation that doesn't really believe in originality. It's never occurred to me—this idea of, quote-unquote, *originality* being important.

ABOVE AND OPPOSITE
Modernity circa 1952, Mirrored and Reflected Infinitely, 2004
Mirrored blown glass, chrome metal, glass, mirror, electric lighting, 30½ x 56½ x 18½ inches
Collection Milwaukee Art Museum, Milwaukee, Wisconsin

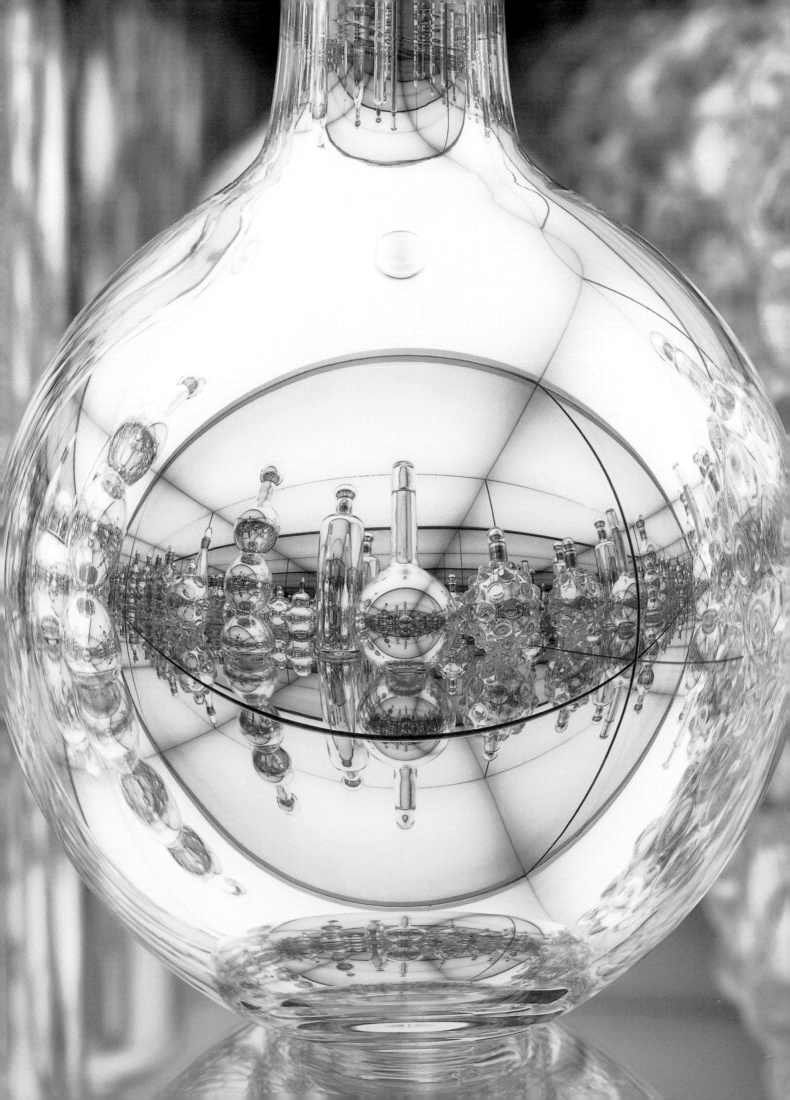

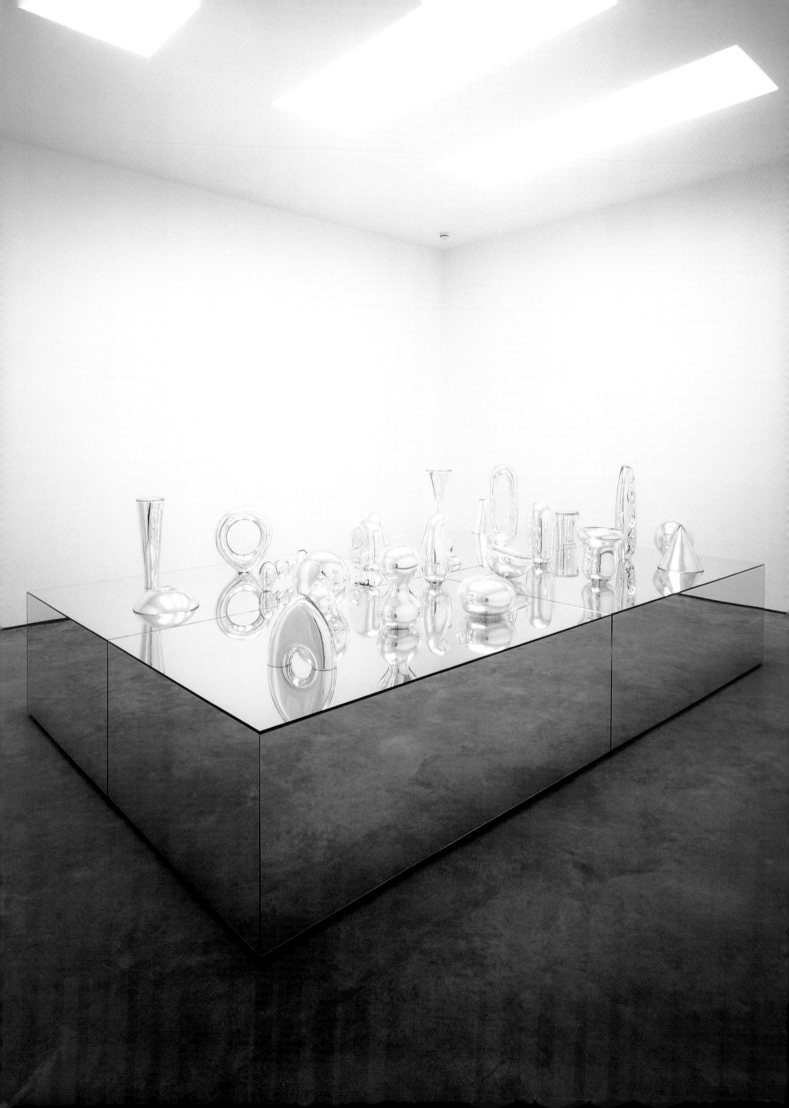

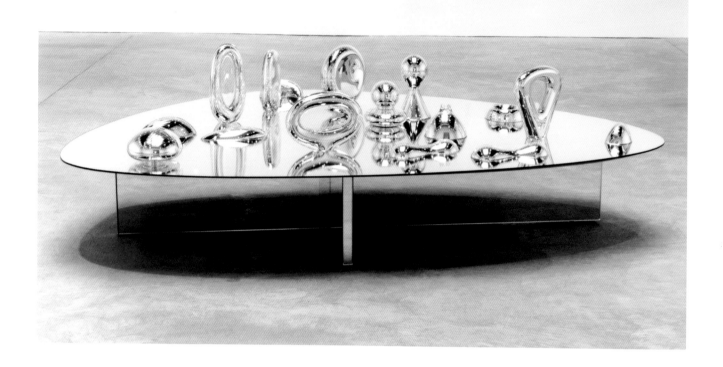

Josiah McElheny

OPPOSITE
Model for Total Reflective Abstraction (after Buckminster Fuller and Isamu Noguchi), 2003
Mirrored blown glass, wood and mirror,
49 x 144 x 88 inches
Promised gift to the de Young Museum
of Art, San Francisco, California

ABOVE
Landscape Model for Total Reflective Abstraction, 2004
Mirrored blown glass, wood and
mirror, 28 x 87 x 57 inches
Collection Dallas Museum of Art, Dallas, Texas

One of the things I've been thinking about a lot in my most recent work is making models. And so I made a series of works about a conversation between Noguchi and Buckminster Fuller—an aesthetic proposal from 1929—in which they talked about a kind of sculpture or sculpture abstraction that could exist without any shadow. They said it would have to be a perfectly reflective sculpture in a perfectly reflective environment—the ultimate aesthetic utopia where the context and object are unified completely. And so I've been fascinated by the idea and I've been making some models of it—like Noguchi's landscape model sculptures—trying to turn those into a manifestation of this idea. What I'm interested in is artists showing another way of looking at something, proposing a model for something that's impossible to realize by saying, "Okay, this isn't a plan, this is a model, a way of going forward." How can we go forward? Well, stop making plans. Say this is just a model and it can only be realized in your mind.

For this particular project, I wanted to use the technique of silvering the inside of the glass so that it's totally reflective to take advantage of the natural property of the glass, creating this perfectly smooth surface. None of these pieces are perfect. They're not like telescope mirror. They're still relatively handmade objects and they have imperfections, but at the same time the whole point is just to demonstrate this utopian idea of reflectivity. And so I want it to be as close as it can to perfectly reflective.

The forms are all based on adaptations of specific forms that Noguchi either created as sculptures or modeled in some way for his unrealized and realized ideas for landscape design. And so each object that I made in the glass foundry was envisioned as what its final part in the whole installation was going to be. Some of the forms involved cutting, and most of them involved grinding and polishing to get them to mold into the surface of the landscape or the ground of the installation, which is sort of a landscape model or an abstract landscape model.

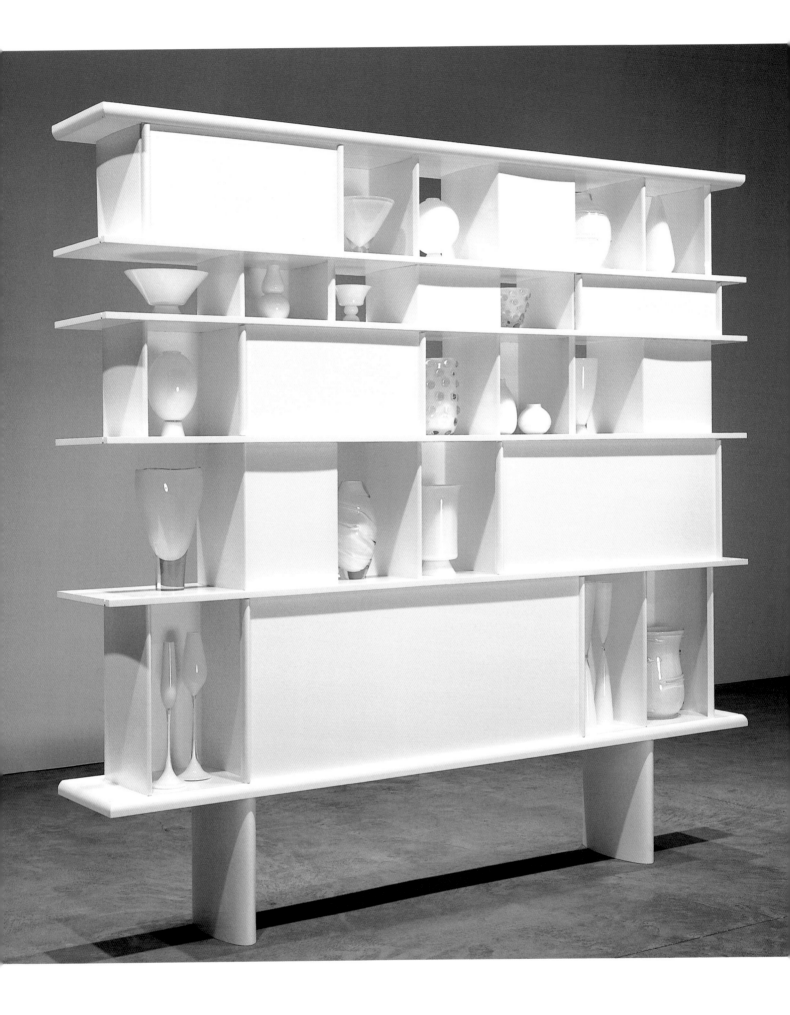

Josiah McElheny

OPPOSITE
Charlotte Perriand, Carlo Scarpa, others (White), 2000
Blown glass, wood and metal shelving
Case dimensions: 89½ x 93½ x 18 inches
Collection of Linda Pace

RIGHT
Adolf Loos' Ornament and Crime, 2002
Blown glass, wood, glass and electric lighting
Case dimensions: 49 x 60 x 10½ inches
Collection of the Detroit Institute of the Arts, Detroit, Michigan

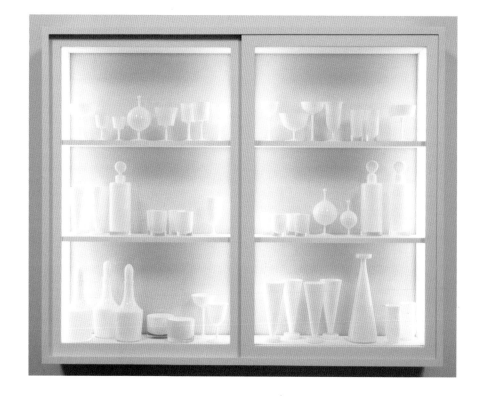

I made a series of works where I took some classic mid-century modern furniture and decorative art objects—famous design objects—and had them all remade in white. There's an element of it being a kind of display or history or a whitewash (whatever you want to call it), and it's also supposed to be very seductive. Behind the whole thing is my notion that the ideas of our modern era are applied in, or infect, everything we do so that even an idea of aesthetic beauty is not free from those associations. So my idea of this whole series of white works is that you come in, and it's this very luscious, beautiful place to be.

I guess I'm afraid that those pieces just function to seduce you to look at them. But then it doesn't seem to me to actually take a lot of thought to look at them and say, "Well wait a minute, all this perfection, this aesthetic utopia, it's impossible to maintain." It has terrible implications, even just how you keep it clean. Who keeps it clean? And you know right there that you have a huge problem. At some

level even simple aesthetic decisions in the world have both beauty (in a sense that they could be beautiful gestures, i.e., deeply 'pleasureful') and at the same time imply a kind of denial of the grayness of life. So I've always been sort of afraid. . . . Will people see that, or will it just be too seductive?

I'm also interested in the idea that a specific material quality can have information about metaphor in it. I've done this all-white stuff and all these reflective things, and both are about metaphors. In the all-white work, it's interesting if you think about black. The color black allows for a lot of range. There are many whites, but with white—one little piece of something else and you've ruined it. But things are still black if they have a little bit of imperfection—a little bit of brown or a little blue, or whatever. And it's interesting—actually, metaphor is in the material. Or the material aspect of the color black is that it has a much more forgiving and open-ended quality, whereas white—trying to make these 'utopic' white pieces—it's

almost impossible. You just look at it and it gets dirty, and you've ruined it. And I think that was inherent in my intention: white is this perfect theory—this perfect theoretical state—and it's quite horrible in that sense. Whereas black is very welcoming in comparison. . . .

If you actually read Adolf Loos's "Ornament and Crime," which is one of the founding essays of modernism, it's where this whole Mies van der Rohe idea of 'less is more' comes from. It's about making the world white in some way. It says, really directly, that primitive people are the people who decorate, and that the natural course of progress in man is to remove this decorative impulse from our psyche, and that if you provided, quote-unquote, *primitive* people with the opportunity not to ornament their bodies or whatever, or you offered workmen the opportunity not to ornament their work, they ultimately would want to do that—which is a really strange idea. I think all of it is very colonialist and racist and sexist and fascistic.

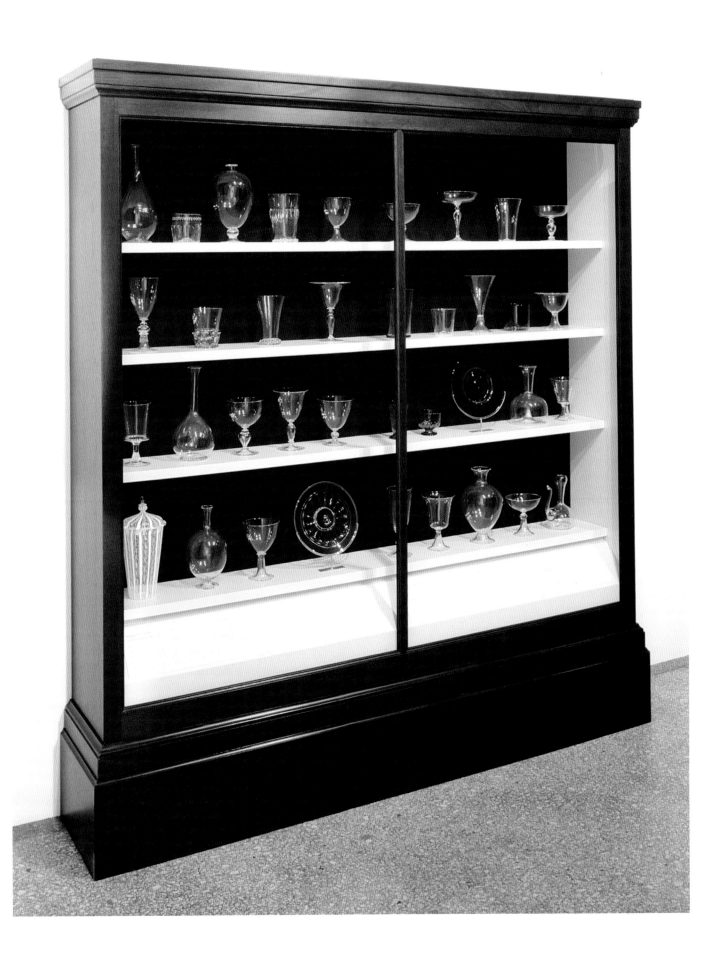

Josiah McElheny

OPPOSITE
*Verzelini's Acts of Faith (Glass from
Paintings of the Life of Christ)*, 1996
Blown glass, text, wood and glass display case
Case dimensions: 78½ x 72½ x 14¾ inches
Collection Yale University Art Gallery, New
Haven, Connecticut

ABOVE
Halo After Botticelli, 1998–99
Blown glass with 24-karat gold, metal
and wood wall mount, framed color
photograph, 17½ x 30 x 5 inches
Edition of 10

The word 'display' plays a particularly important role for me. I have used the language of exhibitions, expos, trade fairs as part of my work because it implies ideas being connected to objects. This language is familiar to generally everyone, so using specific elements of it gives the viewer a starting point to begin to experience the sculpture. I think of display in a broad sense: texts, documents, drawings, photographs, the objects, the physical presence, atmosphere, and style of display furniture. The total physical experience of all of this can be used to tell a story if you want to follow that path. You can enter the room, recognize that here is something that looks like an exhibition within an exhibition, accept it as such or not, examine the elements or not, read the text or not. Each stage of looking offers the opportunity to add more pieces of a narrative or instead invent one's own because the whole thing is suspect. What's this *exhibition* doing here?

Josiah McElheny

ABOVE
Recreating a Miraculous Object, 1997–99
Blown glass, wood and metal wall
mount, framed reproduction of a fresco
in Padua, 21 x 35½ x 7 inches
Edition of 10

OPPOSITE
Studies in the Search for Infinity, 1997–98
Blown glass, wood, fabric, metal
display, text, 20 x 144 x 8 inches
Collection of the Museum of the
Rhode Island School of Design,
Providence, Rhode Island

FOLLOWING SPREAD
From an Historical Anecdote
about Fashion, 2000
Blown glass, wood, metal and glass
display case, five framed digital prints
Display case dimensions: 72 x 120 x 28 inches
Digital prints: 18 x 25½ inches each
Collection Whitney Museum of American Art,
New York

When I think about an artwork, in its totality from the beginning, usually I'm thinking about certain ideas, a narrative, or a notion. I don't really start making artwork until I can figure out what it looks like for the person coming upon it for the first time. How do you enter it? How do you allow somebody to come into it? And I think of all the aspects of display or style or, quote-unquote, *beauty*. Not of the word 'beauty' per se but of elegance—of its specific visual nature, or humor—so that you want to look at it. It's a way of bringing people into the work—and then there are ideas or experiences for them to find.

You can have every idea that you want, but when you have to actually create some lasting thing you bump up into reality. So you have to translate your ideas somehow. And that creates art. As an artist I'm interested in how art works—that art has lots of ideas behind it and they somehow get embedded into the object. It's not a question of deciphering what the original ideas are, but it's letting those ideas be useful for me now in another way. That's a big subject in my work—how ideas are contained in objects, and how the idea and the object can't be disentangled. My belief is, there is no such thing as the idea *or* the object. There is only a kind of fusion of the two.

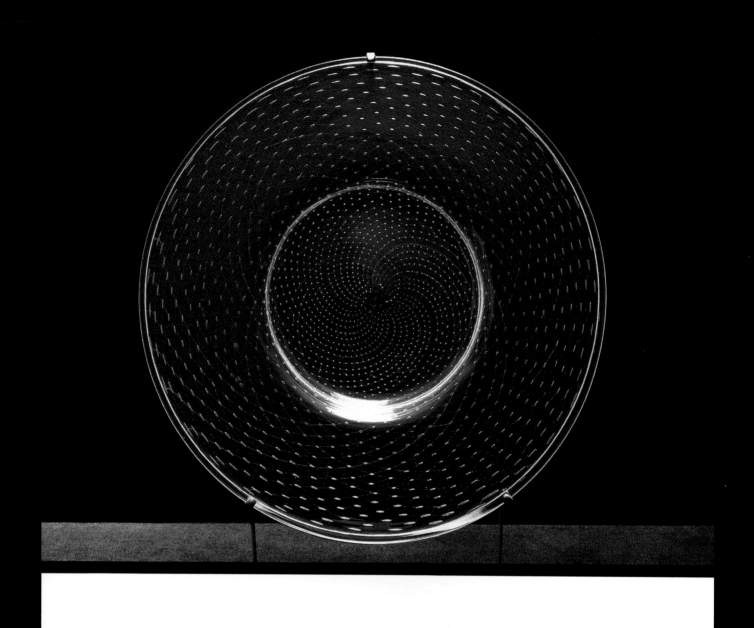

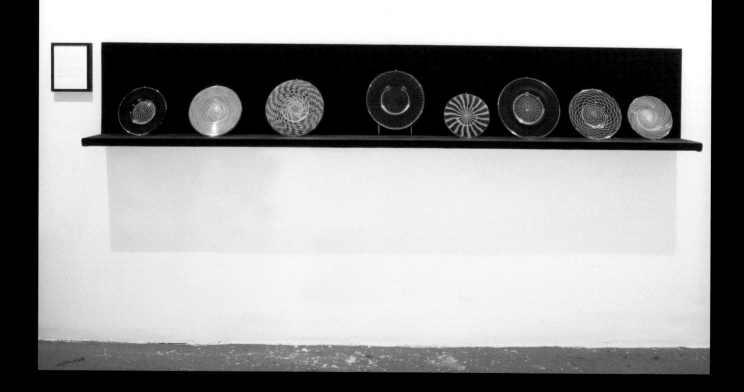

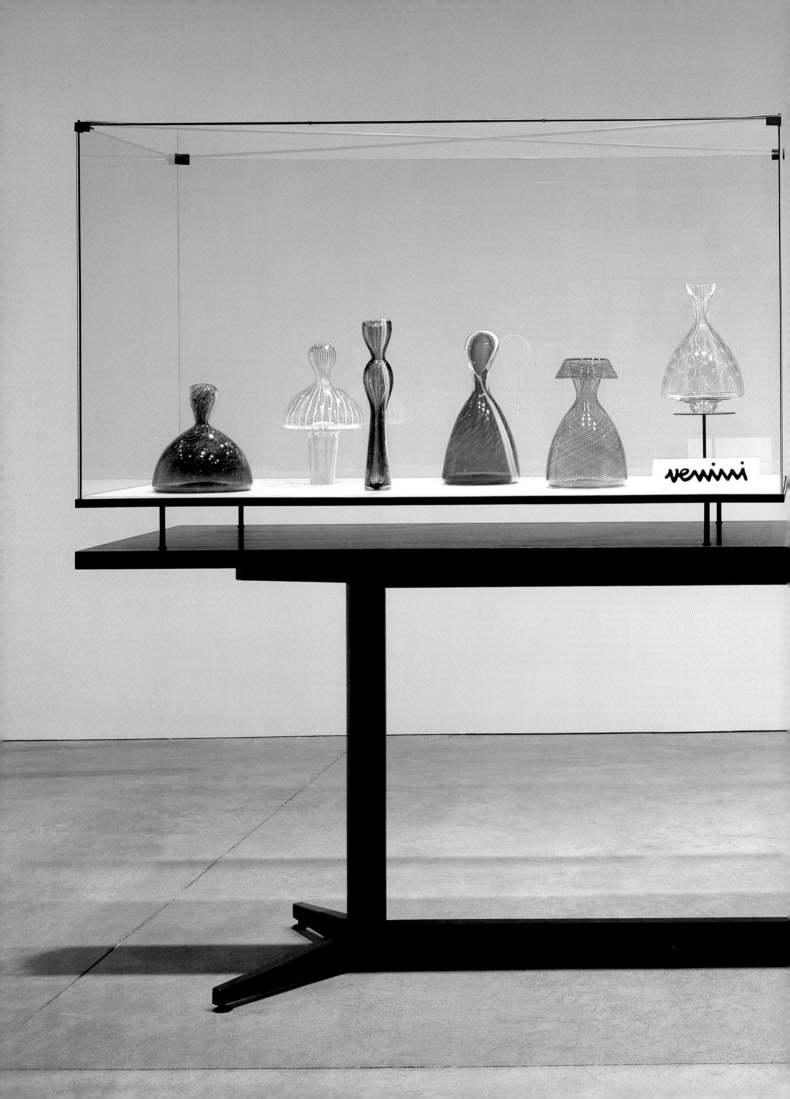

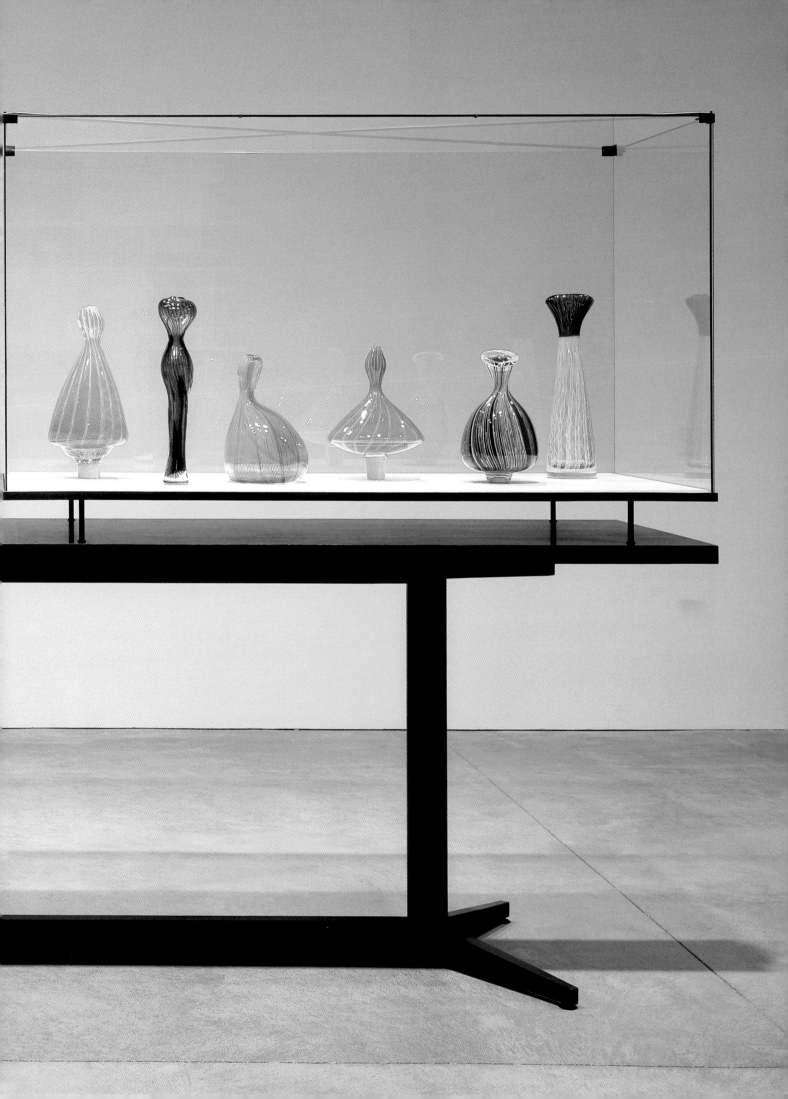

Susan Rothenberg

I'm pretty interested in this idea of looking down at a scene, getting distance from it and looking down upon it. I'm almost positive it's from my walks and the geography here—the creek bed and the arroyos. Sometimes I'm above, and sometimes if I'm walking in the creek I can't see the clouds because the cliffs cut them off. And I can't wait sometimes to get up, especially in the monsoon season. Then I see these tower-of-power clouds. And other times I'm on the top walking along, looking down into these bays, these meadows that have happened through erosion in the creek bed. So I've taken what I learned outside and brought it into these paintings. And now that's pretty much what I want to do with them. So I have the sense of where I'll be going but I don't know what the image will be. I want the paintings to become less lucid.

I hate limits. And lucidity means limits to me. So they're going to have to start being about something, and then they're going to have to kind of self-destruct for the sake of the painting. It's about the fragments too, the fragments of bodies. Let the mind do something! It doesn't all have to be painted out, or laid out. I'm not really a less-is-more person, but I figure a hand on a table suggests a human being. But I don't feel like getting into who the human being is, what the dynamic is. And I don't, I don't want to get too literal about things, I just don't think I need to. I want the viewer to be able to do the work, too.

RIGHT
Galisteo Creek, 1992
Oil on canvas, 112 x 148 inches
Collection the Metropolitan Museum
of Art, New York

OPPOSITE
Falling, 2001
Oil on canvas, 84 x 72 inches
Collection Dar Reedy
Dellwood, Minnesota

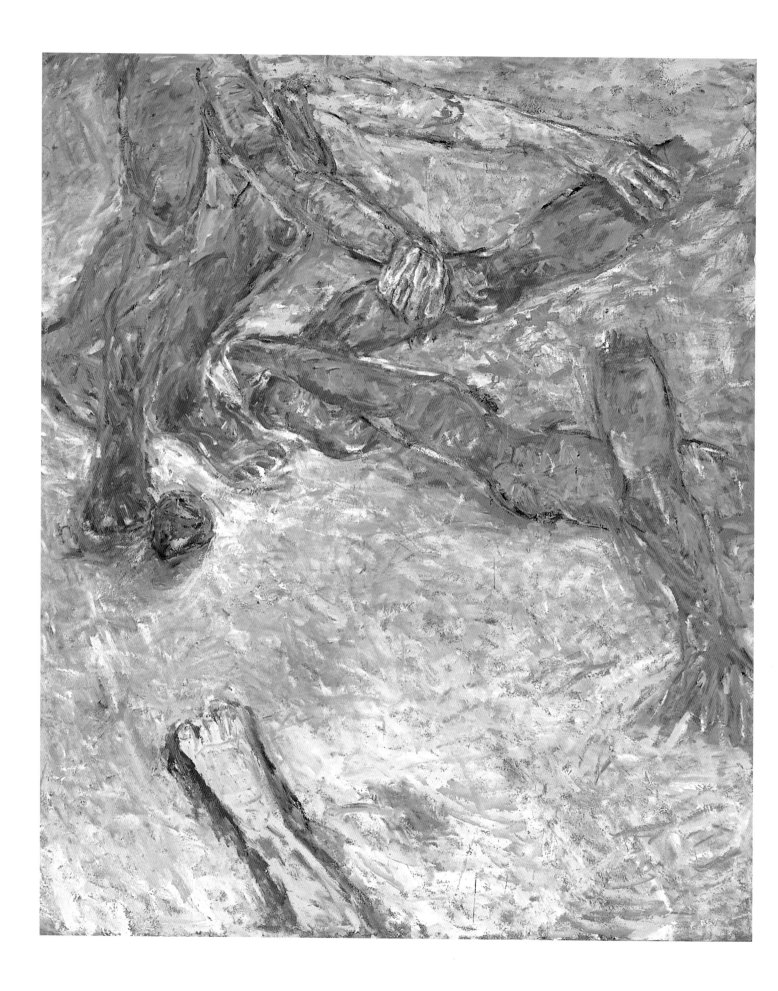

Susan Rothenberg

Red Studio, 2002–03
Oil on canvas, 63 x 58 inches
Private collection

I had been looking at Matisse and reading a book about Picasso and the relationship of his paintings to his studio. And I thought (since I wasn't locked into any subject at this moment and I didn't want to enter a work stoppage and be sitting around here in an empty room), "I'm going to try painting my studio, but I'm going to try painting it red à la Matisse. It won't be the same—it won't be subject to the same symbolism, because I'm not a symbolist. It's simply some of the elements which exist here. Dogs, tables, bare canvases, rolls of paper, and me." It's the second self-portrait or attempt at a self-portrait I've ever done. The other one had paper tabs as in a paper doll mask, and this one apparently has no neck or arms—just clothes and shoes. But I wanted to be in there in my studio. It's me barely present, me there—not working, not sitting down reading, not messing with the dogs. Just my presence, which is as much or as little physicality as that bare canvas in the background or that table or that stretcher bar. It's just me in my studio and a self-portrait. A presence of myself in here, where I always am.

I started with drawing. I think in this case I was a little scared. I was pretty timid, so I started with a pencil and then I quickly got into a dirty brush till I got where the window is. I didn't know how to paint this table, but I painted the table anyway. And then as quickly as I could, I laid in this ocher tone to begin to find out what reds I was using. I used a dirty red tone. And then I used eighteen differ-ent reds and grays and some purple. But I laid down the tone that I knew the painting was going to have. And I figured out then what was going to be white and what was going to be yellow, and how much color the painting could carry and still be the red studio. And it just evolved over the days. You see dead spots and you enliven those. And then that makes that spot maybe look a little dead there, so you put some orange up there and it all responds to what you've done. I think Jasper Johns said, "Do something and then do something else to it, and then do something else to it." And there you go, you're painting.

I can't use the word 'abstraction'. I'm a very literal-minded person. I know my paintings. I know this isn't a real figure, because it doesn't have any arms. At one point it had hands in the pockets without arms attached. And I thought, "Well, are you doing a figure or are you doing this presence? You're doing the presence." So I let go of whatever I needed to, and I kept what I wanted. And I do a lot of that in making painting. I edit. "Is that doing anything for me? Is that carrying its weight in that part of the canvas?" And if it's not, it's scraped out.

I think artists almost always end up turning to what's around them, what's in their environment or outside their window. Not all artists, and certainly not abstract artists. . . . But I spend a lot of time in this room. It's not red. It's white. But I wanted to give it the vivacity of a special and heated-up kind of place. I've never painted a painting like this. . . .

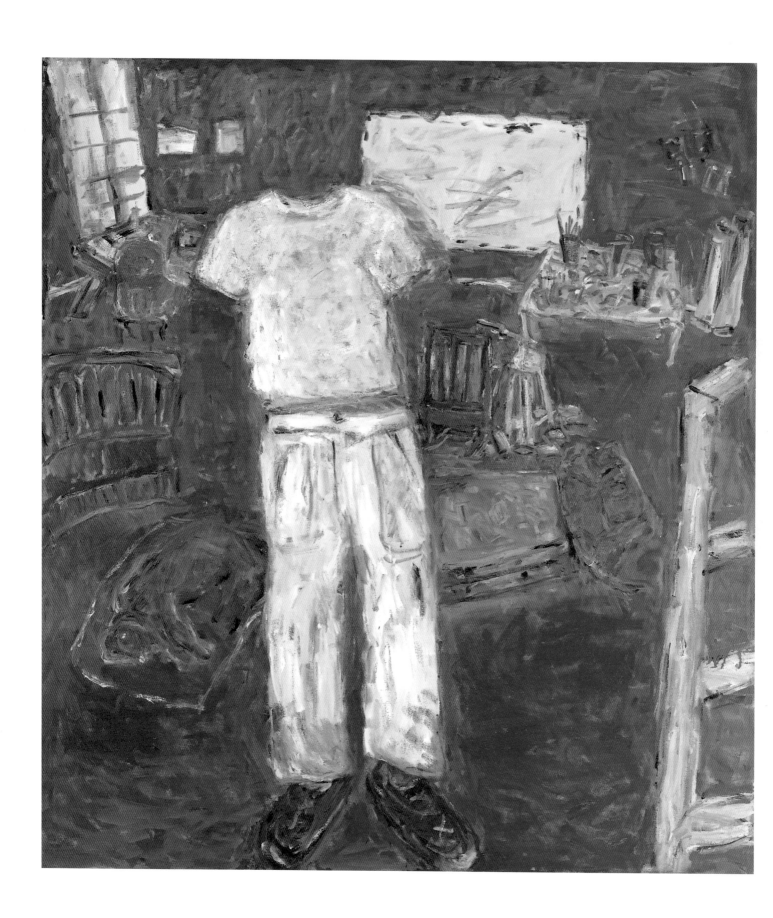

Susan Rothenberg

I love red. I use a lot of red. I use innumerable tubes of white. I try to dirty down most of the colors that I use, rather than use them pure. Cobalt blue always gets a hit of something else to twist it out of its sharp, bright coldness. But this studio painting became extremely green. That was out of the preceding body of work, the Domino paintings, where I felt free to take green right out of a landscape context into any operation I cared to. Green became a very exciting kind of event for me. And to use green out of context felt quite fresh. I mean, what's green? A tree, a grass, a leaf—but not in my work! So I've had that kind of a take— that "Hey, this is a color that you don't usually see in this context." I love to work with twenty different colors of green.

You squeeze a tube of color, and you see this bright green and it's just frightening. It's this pure color that somebody mixed up, and you just have to immediately get after it and make it fight with orange or something. Somebody taught me to mix orange with green to dull it down, and even black with green. And I never change my turp in my cans where my brushes are, so I have residue on every single brush and that'll gray it down pretty quick. Then you hit it up with white to bring it up a tone. . . . Every painting carries through the same brushes and the same moves as the last painting. And this particular turpentine, there's got to be traces of fifteen-year-old turpentine in those cans. But again, if I need a clear color and I don't see that any of my cans are going to give me anything but the dirty-down, I'll start a new can and actually, once in a while, wash a brush so it will be free of old colors. It's laziness, you know.

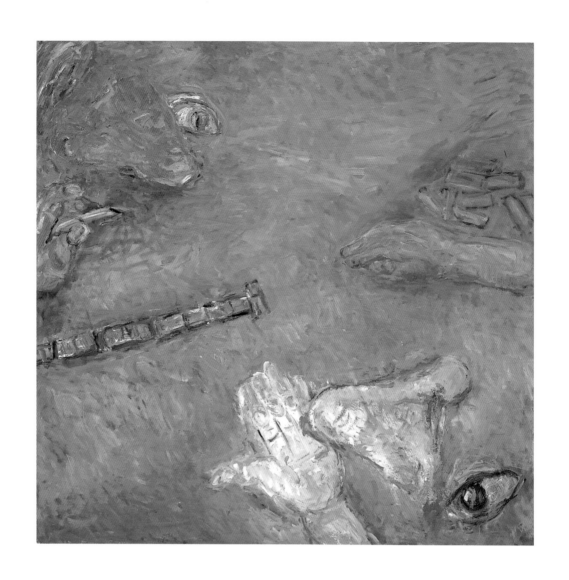

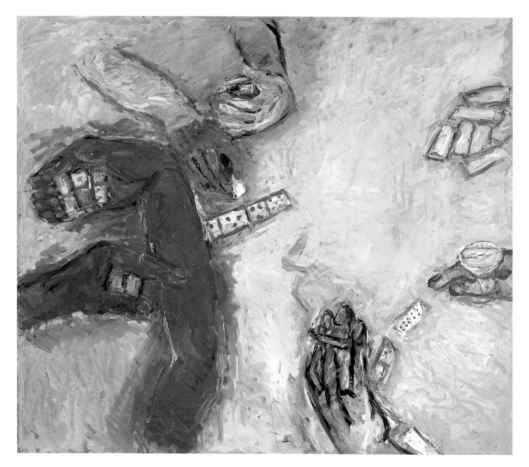

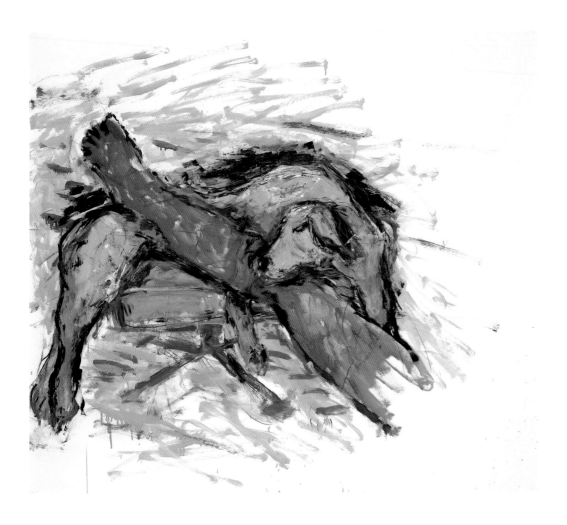

The gesture of drawing—it's very different from painting, and I've tried to bridge the difference by working with paint on paper as well as charcoal and pencil and graphite. One drawing I did on my stomach, kneeling and crouching over this big piece of paper, so that I couldn't have any perspective and so that I didn't have that back-and-forth space between me, my arm, and the wall. And it turned out quite distorted, but it's interesting. But the other way I'd like to think about drawing is cradling a board in my hand and drawing, without trying to emulate these big gestures that painting takes.

I think I care about beauty, but I don't go for it. I hope it sometimes might be in there. I think, maybe, more in terms of a beautiful moment than trying to figure out what beauty is or what people respond to. I hope that my paintings can be emotional moments for people. In the paintings where there's tenderness I work for it. I'm not afraid of it. And I care very much about what I care about—and when I choose to. And there's not that many tender moments that can bring up that response in me. A lot of my work is about melodrama. I wait for Bruce to fall off a horse and then I go, "Oh, okay, the horse's legs were there, the fence post was there, his hat flew off there." I was going, like, "Oh my God . . . there!" Or, "The dogs are killing a rabbit!" I wait for these things and then I pounce.

Susan Rothenberg

ABOVE
Untitled, 2004
Charcoal and oil on paper, 42¼ x 48 inches
Private collection, Wynnewood, Pennsylvania

OPPOSITE, ABOVE
Dogs Killing Rabbit, 1991–92
Oil on canvas, 87 x 141 inches
Collection Museum of Modern Art, New York
Partial and promised gift of UBS

OPPOSITE, BELOW
Accident #2, 1993–94
Oil on canvas, 66 x 125 inches
The Eli Broad Family Foundation,
Santa Monica, California

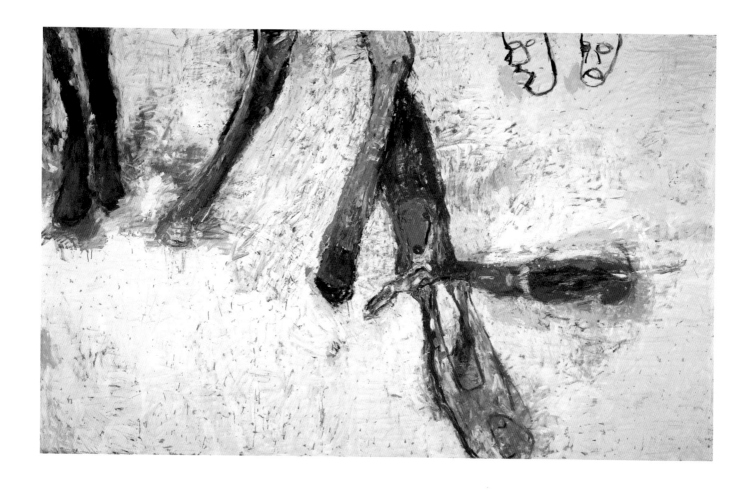

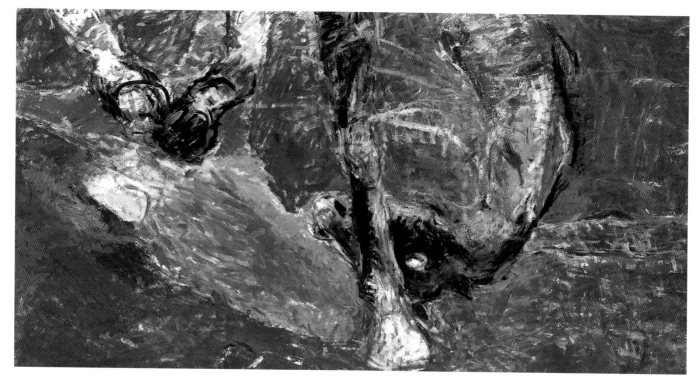

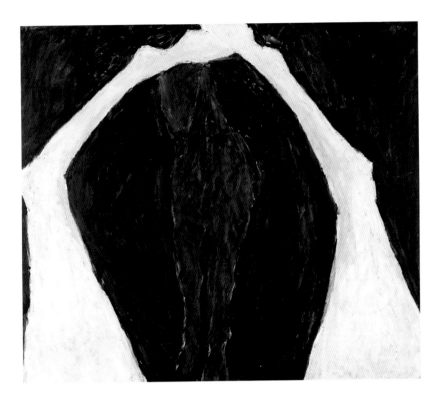

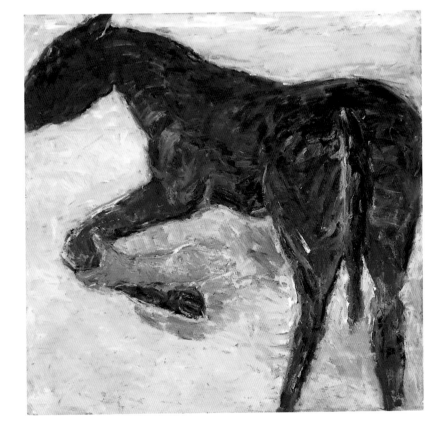

Susan Rothenberg

When I stumbled on the horse idea, I went, "Okay, this can be my Jasper John flag, my target. This can be nothing to me because I don't like horses. I can draw a line through it and make it flat." I could take all the things that I'd learned and negate painting as much as possible in terms of illusionism and shadow and composition and stuff. And that's what I guess I made my reputation on because they were acceptable as paintings and acceptable as not going backwards. They were acceptable as objects in some way.

I can't explain how the work comes. The work comes and goes. What makes me continue to make paintings? I don't know how to do anything else. If you don't know what you're doing out here in the Southwest—in this kind of isolation— if you don't understand that you're supposed to have work and a purpose to every day, you're going to float off into the stratosphere, or move very quickly back to an urban center. You have to commit to your work. And you have to find things that interest you, and interesting ways of rendering them—and fight yourself at every turn so that you're not repetitive or taking an easy solution.

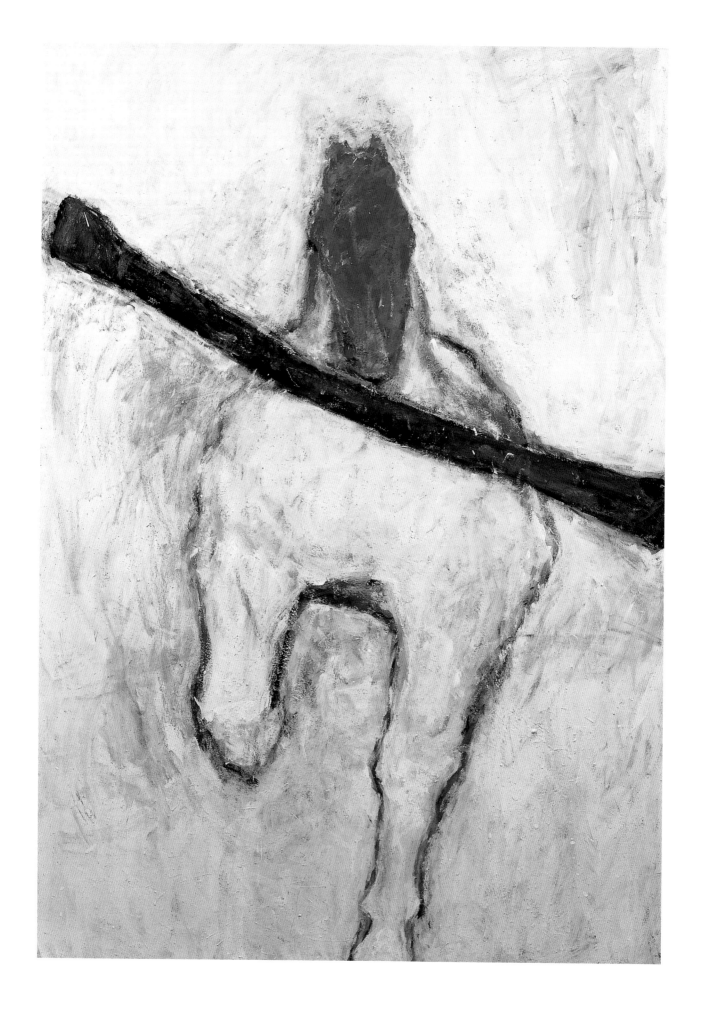

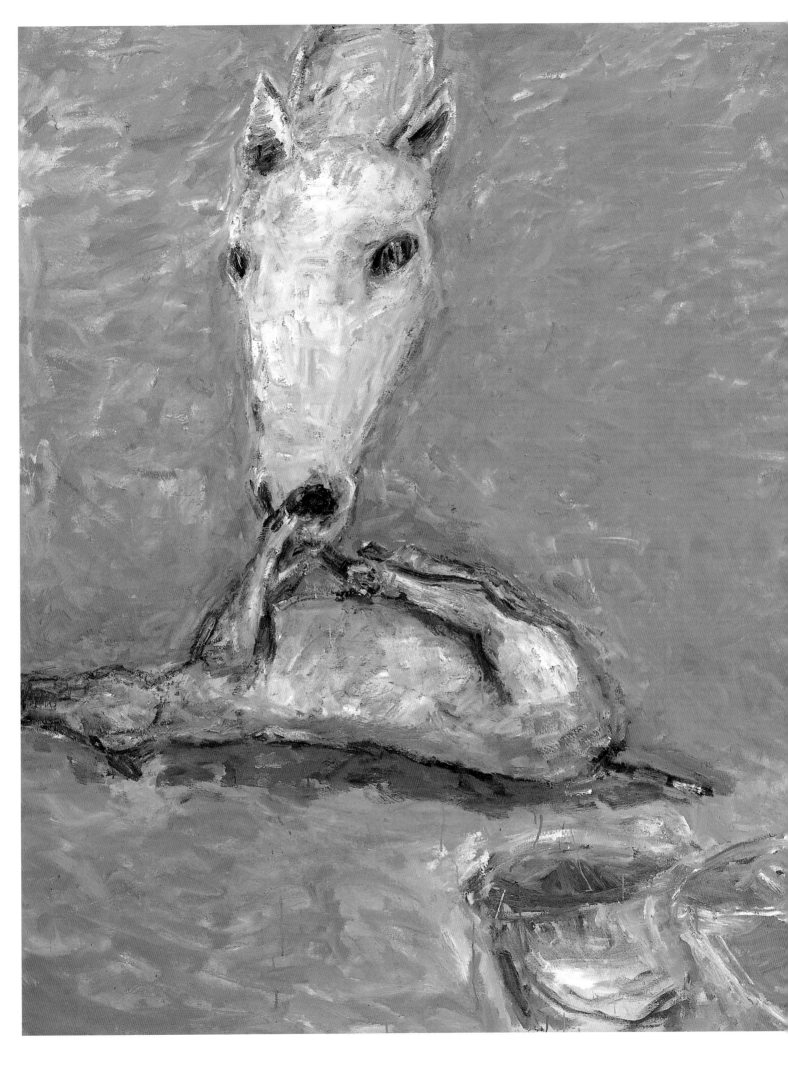

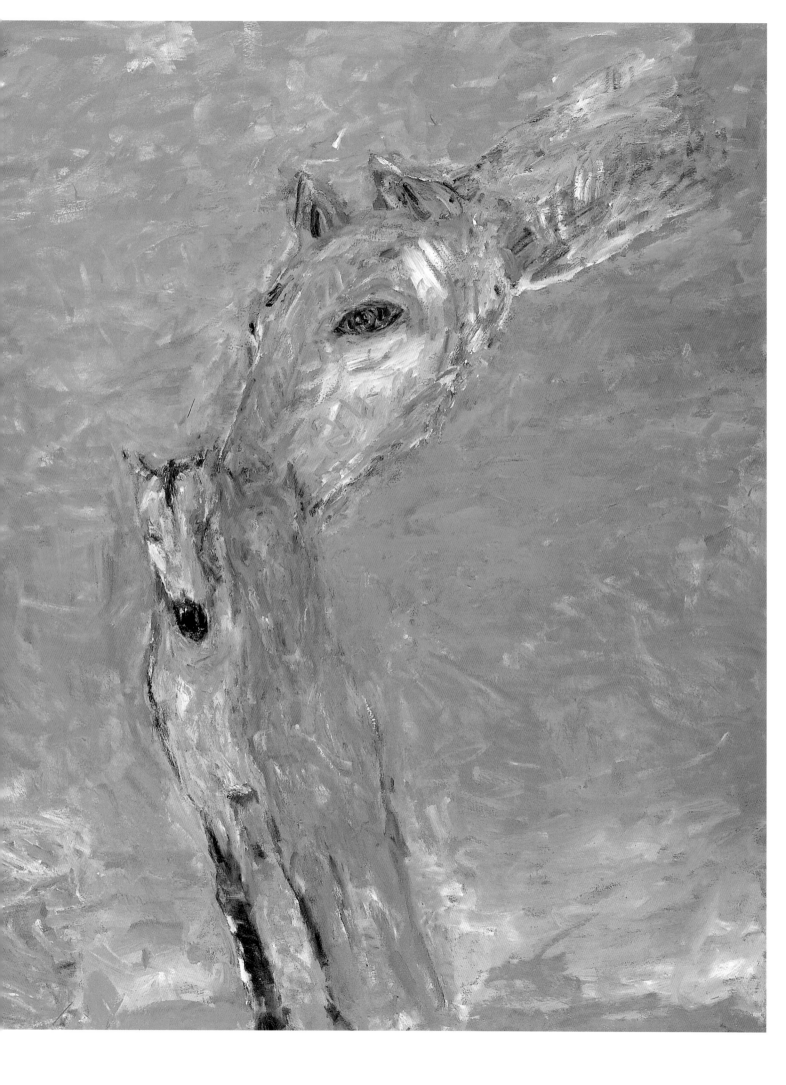

Hiroshi Sugimoto

I grew up in Japan. I was interested in art, and probably the first influence on my art was the declaration of Surrealism by André Breton. That was the first translated book I read, probably in high school. And that made me quite interested in Surrealism and the Dada movement.

It is exactly thirty years ago since I first saw Duchamp's *Large Glass*. At that time I wasn't aware that Marcel Duchamp's works somehow related to the artwork that I was going to make. I had no sense of close relationship. I didn't have any sense of being influenced by Duchamp. But now, I have a very strong feeling of a kind of power I received from his work. I recognize it and am more and more aware of it.

There are four replicas of *Large Glass*—two in Stockholm, one in London, one in Tokyo. I've been photographing the replica in Tokyo, spending so much time with the replica that facing the original is a very strange feeling. The original has an enormous power compared to the replica. A replica is a replica, it's a copy—a duplicate. Duchamp's concept of a copy was that the copy is as important as the original. But it's not true. The original has its own Duchamp spirit in itself, even though he might say, "Well, this is not

special at all." He probably didn't believe in spirits. But I do feel it.

My intention was to make a replica of a replica. So mine is a third-generation copy of the original, but mine is even smaller. I used my 8 x 10 camera and photographed the upper part and bottom part, made a negative, and a contact print out of the negative. I made negative and positive prints sandwiched with very thick glass.

Memory, and replica. Photography is a system of saving memories. It's a time machine, in a way . . . to preserve the memory, to preserve time. That's something I learned from the Duchamp concept. Probably it was Duchamp's intention to have glass that's transparent. It's very hard to concentrate on the image—everything is in the surface. So for my piece, the Tokyo version, I think I betrayed his wishes. I covered *Large Glass* with a huge black tent so that the image is clearly visible because it's against the black background. Then I photographed it so it's very transparent. And then my negative serves as a positive because it's just black background. As a negative, it's pure transparent glass. So mine is back to the original, even though it's reversed, negative and positive.

La Boîte en Bois (Wooden Box)
(Replica of Duchamp's "Large Glass"), 2004
Glass, gelatin-silver print and two
sheets of 8 x 10-inch original negative
Glass: 16 x 10 x 1⅜ inches
Box: 17⅞ x 11⅝ x 3 inches
Edition of 35
Commissioned by the New Museum
of Contemporary Art, New York

Hiroshi Sugimoto

ABOVE, LEFT
0001 Helicoid: minimal surface, 2004
$x = a \sinh v \cos u$
$y = a \sinh v \sin u$
$z = au$
$(0 \leq u < 2\pi, -\infty < v < \infty)$
Gelatin-silver print, 58¾ x 47 inches
Edition of 5

ABOVE, RIGHT
0012 Diagonal Clebsch surface,
cubic with 27 lines, 2004
$x_0 + x_1 + x_2 + x_3 + x_4 = 0$
$x_0^3 + x_1^3 + x_2^3 + x_3^3 + x_4^3 = 0$
$(x_0 : x_1 : x_2 : x_3 : x_4) \in \mathbf{R}P^4$
Gelatin-silver print, 58¾ x 47 inches
Edition of 5

OPPOSITE, LEFT
0026 Worm gear, 2004
Gelatin-silver print, 58¾ x 47 inches
Edition of 5

OPPOSITE, RIGHT
0028 Regulator, 2004
Gelatin-silver print, 58¾ x 47 inches
Edition of 5

I found this form in Tokyo in a complete set of German-made cast models for the study of mathematics. It's a very artistic sculpture, but actually it was made to show students that three-dimensional theories can be seen in three-dimensional models. It's such an irony that mathematicians made more interesting sculpture than artists!

This is the image of a mathematician's thinking. No such thing actually exists in nature; it's purely what the human mind comes up with—this kind of theory. I don't know whether these carry emotions for mathematicians, but as an artist I project my own vision onto these mathematical, purely abstract forms. You know, we want to see things the way we want to—so this is the beginning of the art here, and we can shape . . . how we want to see.

I was very bad in mathematics when I was a high-school student. I found that I was a visual person. I had to confirm everything by eye, not by abstract thinking. Once a mathematical theory got abstract, my eyes couldn't visualize it. So I just gave up trying to understand perfectly. I could sense with my brain, "Maybe this functions . . . ," but I just felt uncomfortable not having confirmed it with my visual understanding. So I became more like a visual artist, not an abstract thinker. Now, I again encounter that my way of understanding mathematics is purely visual. The formula itself is very conceptual and it looks beautiful, but it never gives me a solid visual understanding. Now, finally (thank you, Marcel Duchamp, for giving me this idea and hint!), this is my way of presenting

mathematics and formulas in visual form.

As a photographer, I have already envisioned how I wanted to see this object. So probably I am looking at this the way I want to see. Actually, Man Ray did a series of photographs using the same cast model (not the very piece I found in Tokyo, but the one that belongs to the Poincaré Institute in Paris). It's been published. I found that out after I started to do this. I am quite convinced that I'm looking at these objects in a very different way from Man Ray.

It's just like sculpture. I feel like I'm carving this out of conceptual form. The figures were made without artistic motivation, and I'm trying to make them artlike. So that's photography! People tend to believe that photography can just record scenes, but this is more like using my

camera and then projecting my own imagination onto the surface of this 'sculpture'—these models. So I think I feel more like I'm shaping the forms using a camera instead of chisel. It's sculptural form using my camera as a tool. And between chisel and camera, there's no difference to me. . . .

What I'm photographing here is a nineteenth century–made machine. I'm trying to make it present as art or sculpture. So my interest—curiosity—is if the non-artist made object can be presented in a way that it can keep the power of art itself, without artistic intention of its making. I think it's very conceptual. Marcel Duchamp invented this readymade concept. So I'm definitely borrowing. I cannot escape his influence.

Toward the end of the nineteenth century the technical aspect of photography—

how to make beautiful black-and-white photography using a large format camera—peaked. And people may never understand that in old-fashioned photography, with large-format camera, you can adjust the image, or the size, and the perspective the way you want to—the way you wish to see. The small camera . . . you just shoot. And then you automatically get the image. But with this large-size photography, I can change so many things that I wish to change. So don't believe photography! If you actually saw what I'm photographing, you would be amazed—it's so different. For instance, this piece, it's small, but I can make it look like a gigantic sculpture. There are many technical aspects that I applied to make it look like art, or look like a sculpture. I just want you to be aware of that.

Hiroshi Sugimoto

LEFT
Henry VIII, 1999
Gelatin-silver print, 58 3/4 x 47 inches
Edition of 5

BELOW, LEFT
Diana, Princess of Wales, 1999
Gelatin-silver print, 58 3/4 x 47 inches
Edition of 5

OPPOSITE
The Music Lesson, 1999
Pigment print, 53 5/8 x 42 inches

The mathematical models are very fragile pieces, so I set up my small studio in the Tokyo University Art Museum and we spent a couple of weeks, bringing them in one by one. The lighting is very primitive, straightforward, against the black background. These white, cast models floating in the darkness. This is very similar to what I did for the wax figures in London. Most of the wax figures look very waxy and fake . . . but I brought a dark black background. It's *life* in front of my camera, against black, black background.

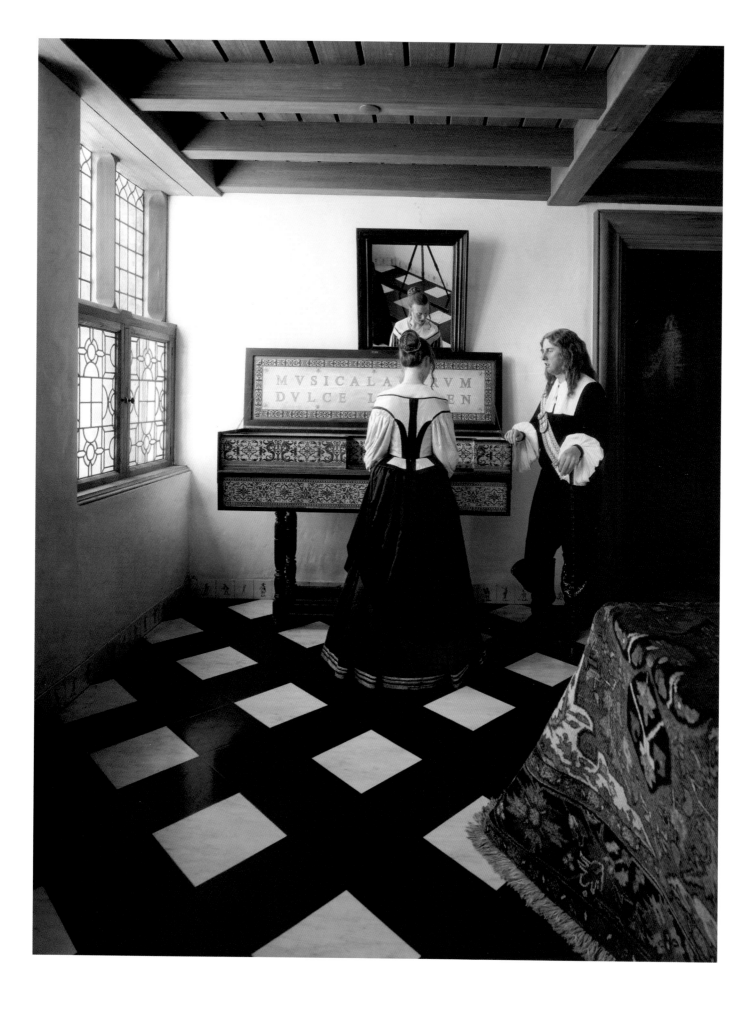

Hiroshi Sugimoto

TOP TO BOTTOM
Caribbean Sea, Jamaica, 1980
Lake Superior, Cascade River, 1995
Seto Inland Sea, Yashima, 2001
Gelatin-silver prints, each 47 x 58 ¾ inches
Each in an edition of 5

OPPOSITE, ABOVE
Devonian Period, 1992
Gelatin-silver print, 20 x 24 inches
Edition of 25

OPPOSITE, BELOW
Permian Period, 1992
Gelatin-silver print, 20 x 24 inches
Edition of 25

In *Seascapes*, my subject matter is water and air. Stillness. . . . I'm not intentionally promoting it, but most people see it, and it's very quiet and serene. That's something that just naturally, automatically comes out through my work. . . .

Fossils work almost the same way as photography . . . as a record of history. The accumulation of time and history becomes a negative of the image. And this negative comes off, and the fossil is the positive side. This is the same as the action of photography. So that's why I am very curious about the artistic stage of imprinting the memories of the time record. A fossil is made over four hundred fifty million years—it takes that much time. But photography, it's instant. So, to me, photography functions as a fossilization of time.

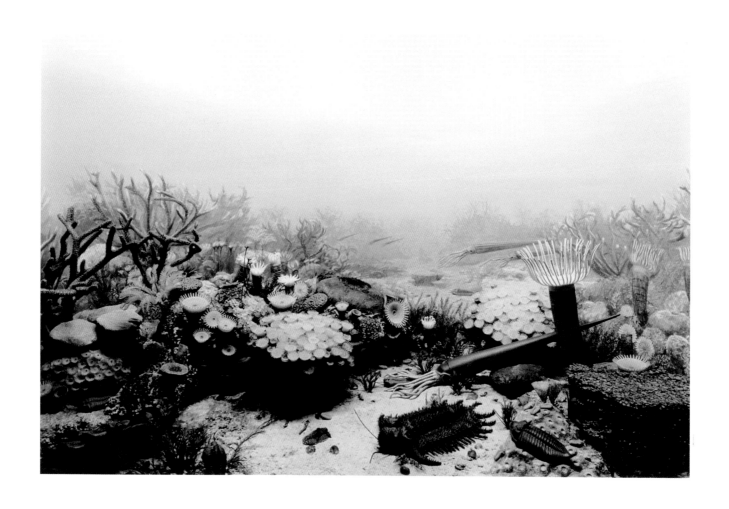

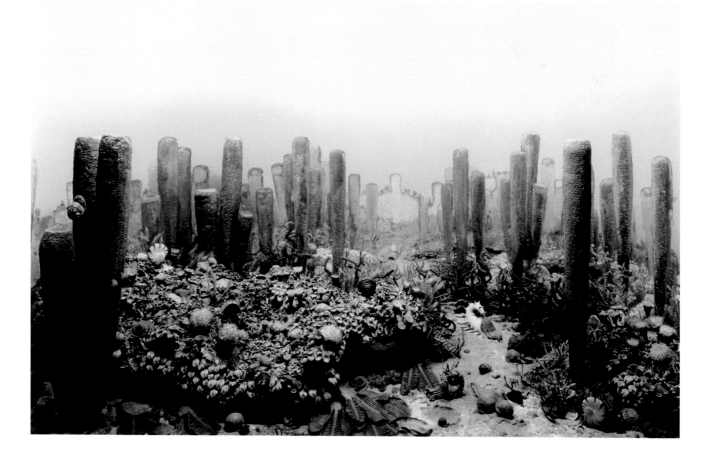

Hiroshi Sugimoto

ABOVE
*E.U.R. Palazzo Della Civiltà Romana,
Marcello Piacentini*, 1998
Gelatin-silver print, 47 x 58 ¾ inches
Edition of 5

OPPOSITE
Hiroshi Sugimoto Architecture
Installation views at the Museum of
Contemporary Art, Chicago, 2003

I developed my own style of printing. I tested many different methods—Walker Evans's method, Ansel Adams's. I also developed a sense to adjust gray tones, black tones . . . highlights, white. Even in the deepest shadow there's a tone that you can print on the silver surface. This involves studying the silver reactions, the colors of the metal as silver, and the surface of ink tones that make the images so rich. So in that sense I am a very craft-oriented person. But at the same time, I want to make something artistic and conceptual. In general, you know, the postmodern artist never paid attention to craftsmanship. That's something like a nineteenth-century cliché. But to me, I'm going the other way around. I really respect my craftsmanship and my hands. So even though I've lived

in this postmodern time, I probably call myself a postmodern-experienced pre-postmodern modernist!

Every museum show, I try to design the space. It's very important. It's not just a photography show; it's more like I'm designing the space. I just want to point out where exactly my piece has to be hanged, or against what color, what height, what kind of wall conditions. It's just like a space sculpture. It costs a lot of money to do it, but I put it as a condition to do a show. I have to be there to fill the space, the height of the ceiling, and then the height of the wall— how much space is between the ceiling and the top of the wall—and then just wide enough for the wheelchair people to go through. Many factors.

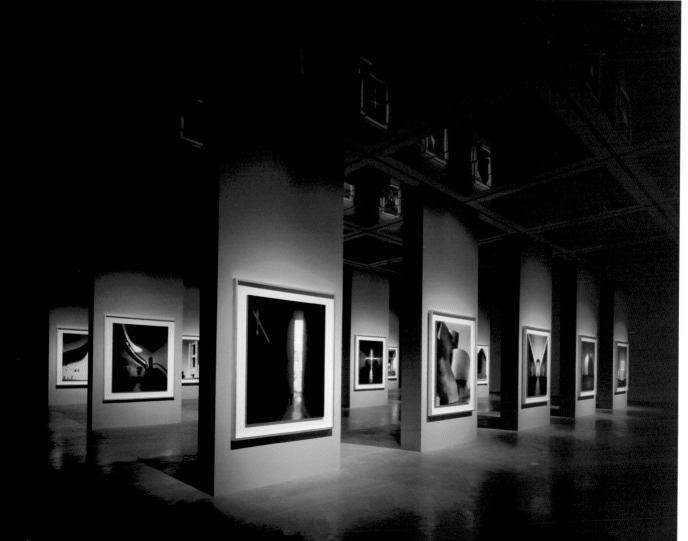

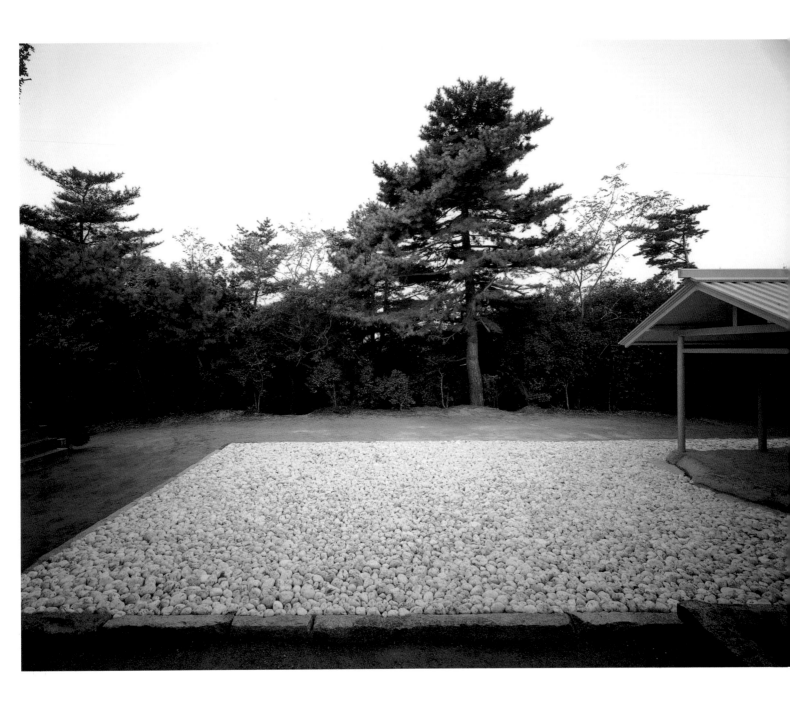

Hiroshi Sugimoto

ABOVE
Go-oh Shrine, 2002
Pigment print
View of *Go-oh Shrine* at
Naoshima, Japan

OPPOSITE
Go-oh Shrine, 2002
View of *Go-oh Shrine* at
Naoshima, Japan

When I was a college student in Tokyo, my study was in German philosophy and also Marxist economics, Hegel and Kant. I was trying to catch up on Western philosophy. Then, when I moved in the early 1970s to California, everybody was talking about Zen and Buddhism. I felt, you know, as Japanese, that I had to give them proper answers. So all of a sudden I rushed to study my Japanese background. I actually spent about three years in California studying Oriental philosophy to catch up on that.

About thirty years later, I was commissioned to build a Shinto shrine in Japan.

So I studied the history of Japanese religion, especially Shintoism. I found that it's very serious to pay attention to ancestors, how you worship your ancestors, and then also the old memories and families—the origin of families, the origin of life itself. So this is the most radical presentation of how we should pay attention to the ancestors. The concept of a Shinto shrine itself is an architecture—a case—but inside, there's nothing in there. It's an empty box. It's just purified space. Once it's covered, four sides and top and bottom, it's sealed. So that's the notion—for the god to descend. It's already purified space.

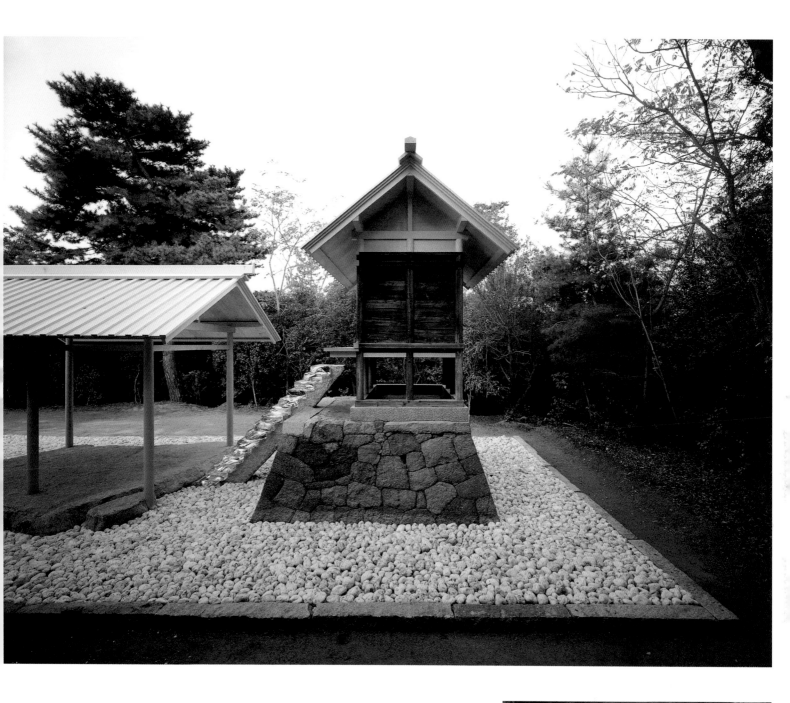

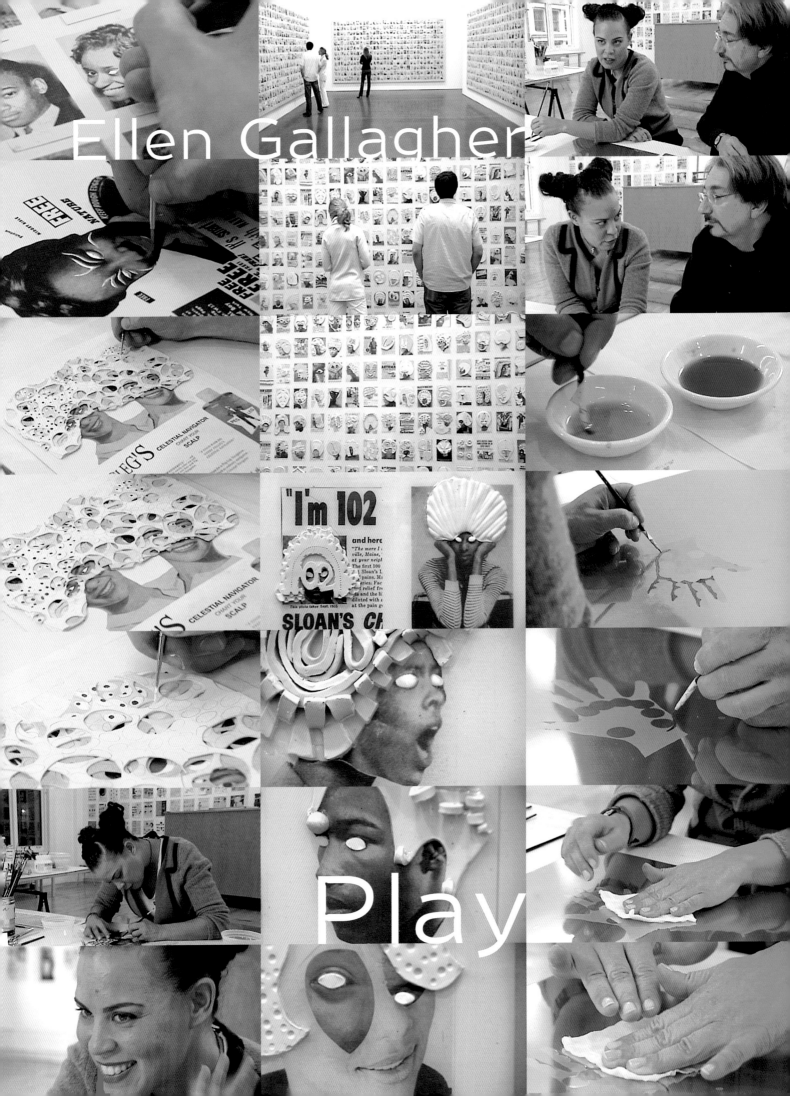

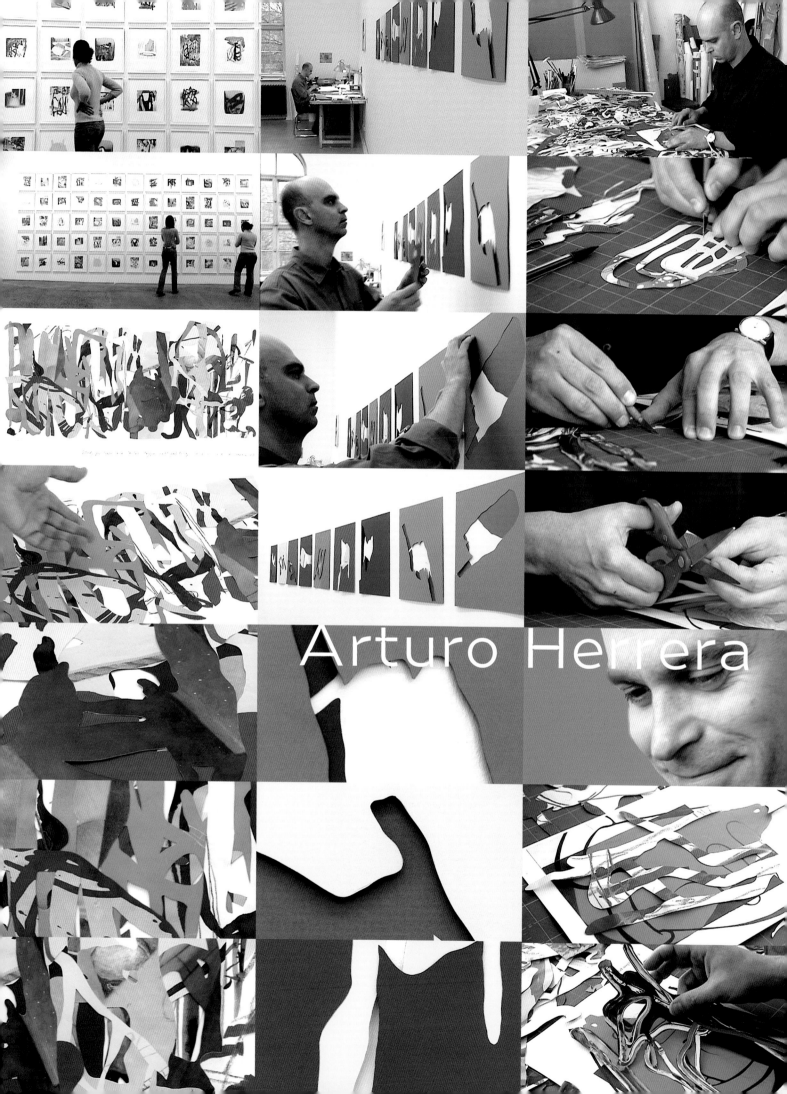

Arturo Herrera

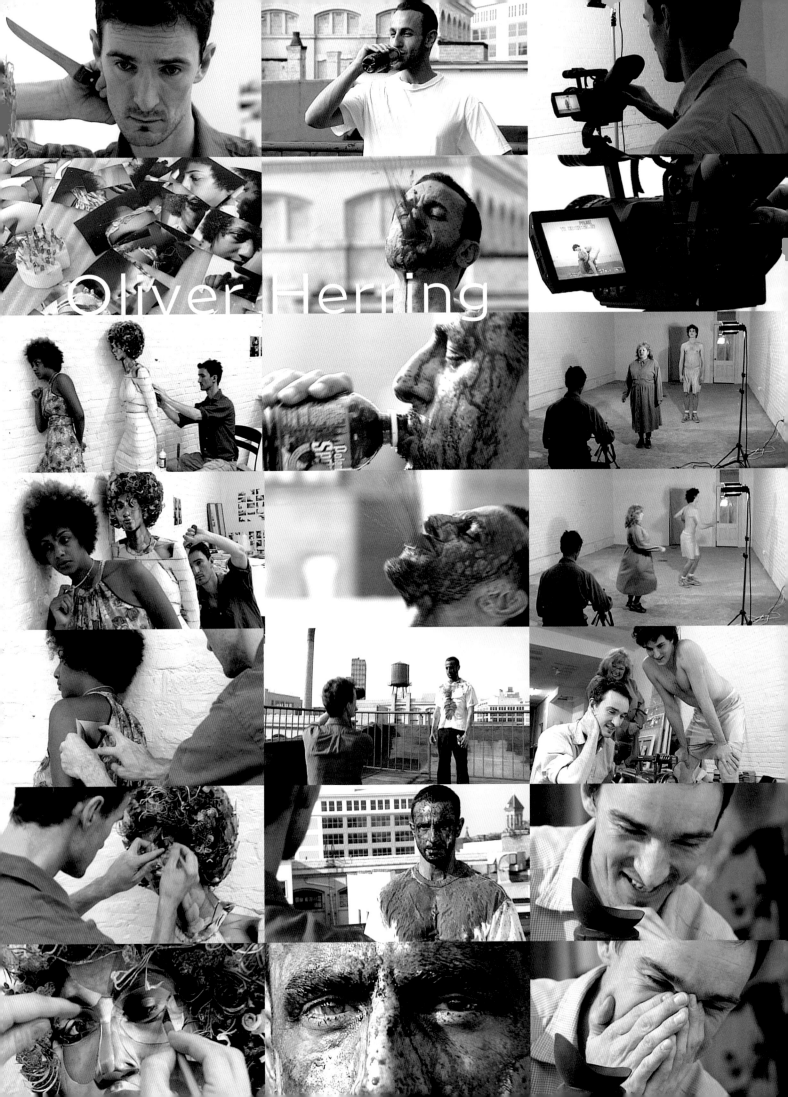

Oliver Herring

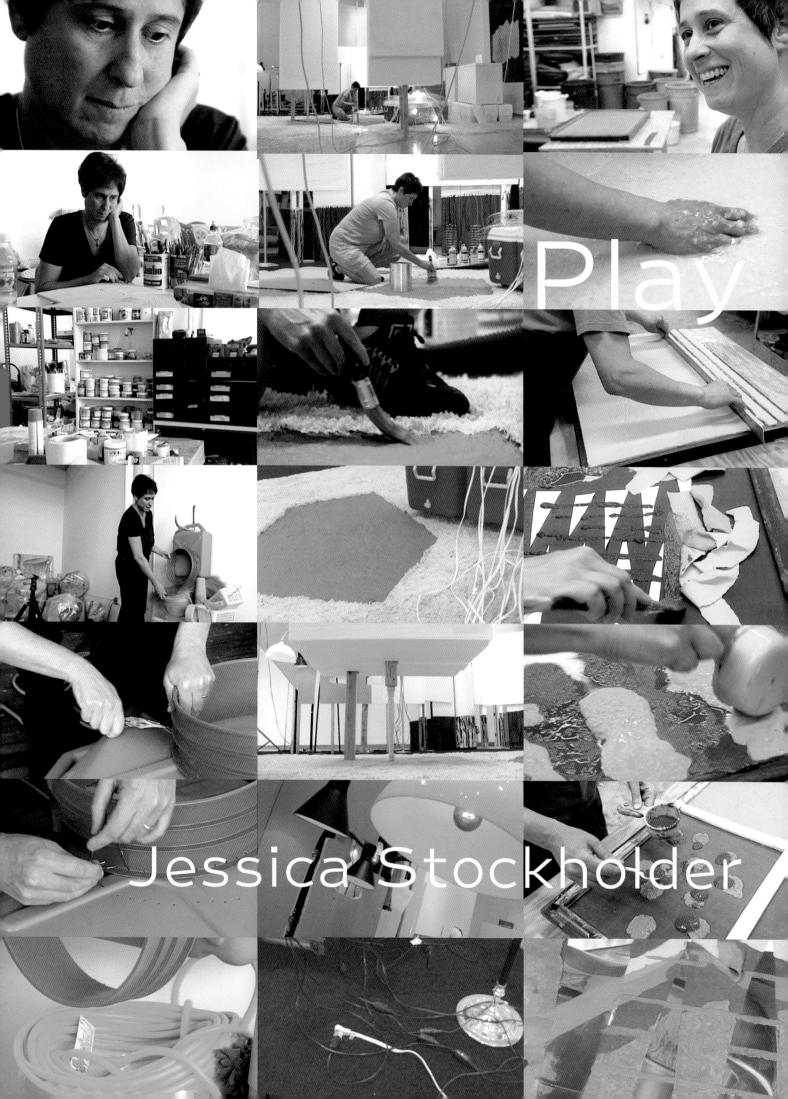

Play

Jessica Stockholder

Ellen Gallagher

BELOW
eXelento, Gagosian Gallery, New
York, September 14–October 23, 2004
Left: *Afrylic,* 2004
Center: *eXelento,* 2004
Right: *POMP-BANG,* 2003

OPPOSITE
eXelento, detail, 2004
Plasticine, ink and paper on
canvas, 96 x 192 inches
The Eli Broad Family Foundation,
Santa Monica, California

I've collected archival material from black photo journals from 1939 to 1972, looking at magazines like *Our World, Sepia,* and *Ebony.* Initially I was attracted to the magazines because the wig advertisements had a grid-like structure that interested me. But as I began looking through them, the wig ads themselves had such a language to them—so worldly—that referred to other countries, La Sheba . . . this sort of lost past. I started collecting the wig ads themselves. And then I realized that I also had a kind of longing for the other stories, the narratives, wanting to bring them back into the paintings and wanting the paintings to function through the characters of the ads—to function as a kind of chart or a map of this lost world. . . .

I think there is nostalgia in my gathering of this material, looking at this material and trying to hold it still for a moment in these paintings or in the films . . . even though in my attempt to hold something

still I'm always presenting it (however 'gridded', fractured) as a way of saying these are notes *toward* something. It's not just a nostalgia in terms of looking backward; it's a way of imagining forward, like the Greek word 'νοσ' that appears in the *Odyssey*—the idea of constant going forward as a way of constantly looking for home.

My grid (unlike the grid of the 1960s which was more mute and meant to map the work of art itself) is meant to refer to the grids of navigational charting or mapping, or to the world outside of itself. In the paintings, the grid of each page is a kind of reduction of the whole, so the parts themselves are not greater than the whole. The whole itself becomes greater than the parts, and the parts then are seemingly more simple or snapshot-like. But together, there is this kind of otherworldliness that happens when you have 396 together in concert.

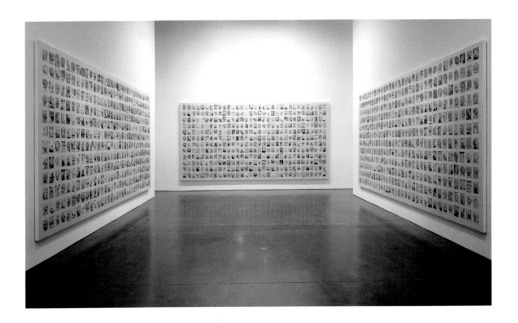

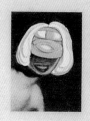
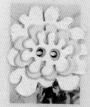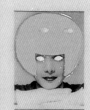

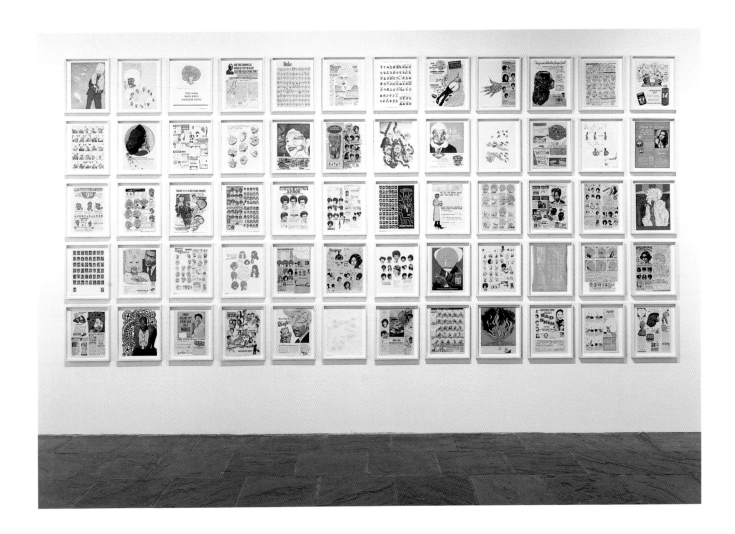

Ellen Gallagher

ABOVE
DeLuxe, 2004–05
Portfolio of 60 prints, edition of 20

OPPOSITE
Isaac, from *DeLuxe*, 2004–05
Lithography, tattoo engraving, laser-cutting,
crystals, gold leaf, velvet and plasticine,
13 x 10 inches
Edition of 20

Some of the same characters appear in the grids of the *DeLuxe* (2004–05) prints as well as the paintings. One thing that the works have in common is that I think of them as built paintings. There's very little paint ever in the work, but they feel very *built*. The seams are important, and where the seams don't line up is all very conscious and deliberate. That's the intent—that they're built. And the grid in *DeLuxe* works so that each individual page exists as a separate working part. Each is a kind of coda to itself and its own drama, or its own stage.

Using paper as support for printed material has always been central to my work, from the earliest penmanship paper works to *DeLuxe*, the print project at Two Palms Press where I'm working in collaboration with printmakers and people building alongside of me. . . . What was exciting for me here was that what happens as whimsy in the drawings or as a decision made with an improvisational spirit (for example, when I would make a choice to blindfold characters or obliterate names underneath characters) would have to be structured so that it could be repeated twenty times. And it was exciting to see, repeated as a language, something that was usually a one-to-one experience. I would make these little squares and they would then be hand-cut and traced, so each sort of whimsical obliteration or recovery would be created into a kind of structure or language, back and forth. That was really exciting, in terms of looking at my work and my language, and having it mean something even in its refusals to be completely readable. . . . There's this call and response that you actually feel directly as you're working in this kind of collaboration.

Ellen Gallagher

My mind is also activated by the resistance of the material. . . . The signs from a page of *Ebony* come with their own specificity and undeniable drag—their inability to be fully woven into my world. (Some model actually modeled these wigs in 1939!) The way they resist me, even before I manipulate them, or even after I blot out their original stylings with my own plasticine blobby wigs, is that I know I'm looking at someone who was eighteen in 1939, as opposed to somebody who was eighteen in 1970. And even though all the signs have been uniform, or they're now wearing my plasticine form and their eyes have been whited out and they are actually reproduced only in a kind of snapshot form and not the full advertisement itself, there's a way in which their specificity is undeniable. And I find that really moving.

There's a way in which the work *isn't* read in terms of mood, and *is* read as if it should be seen as political. What's seen as political in the work is a kind of one-to-one reading of the signs as opposed to a more formal reading of the materials, how it's made, or what insistences are made. I think people get overwhelmed by the super-signs of race when, in fact, my relationship to some of the more over-determined signs in the work is very tangential. What I think is more repeated than that in the work is a kind of mutability and moodiness to the signs. And that's more what I think the work is about than a one-to-one reading of the signs, however over-determined they may be. You may think that's what you're supposed to be translating. In fact, it's this other thing, which requires a kind of confidence that you have to enter that realm. And I think that's where you can talk about race in my work. That idea of the abstract 'I' . . . what it means to look at somebody who was eighteen in 1939 . . . whatever she was. That's specificity. It's impossible to know who that was. But try anyway to have some kind of imaginative space with that sign.

FILL OUT THE COUPON ABOVE
AND I WILL RUSH TO YOU...

**FREE NURSES BOOKLET
AND SAMPLE
LESSON PAGES**

LEARN PRACTICAL NURSING AT
HOME IN ONLY 10 SHORT WEEKS

THIS IS THE HOME STUDY COURSE
security, independence and freedom
good times

accept your case

YOUR AGE AND EDUCATION ARE NOT IMPORTANT common sense
desire

future
now!

HUNDREDS OF ADDITIONAL PRACTICAL NURSES WILL SOON BE NEEDED
opportunity

happiness, contentment and prestige

BUT THE IMPORTANT THING is to get ___ FREE

FREE FREE

ROOM 12R81

Sa-a-y this is
terrific!

Johnson's *Ultra Wave* will make you really proud of your hair.

Yes sir! You'll find that Johnson's
Ultra Wave not only straightens your
hair, it "culture-grooms" it. You'll find
your hair becomes wonderfully natural
looking and lots easier to manage.
Follow the lead of well-groomed men
everywhere—*insist* on Johnson's Ultra

Wave Hair Culture. Just follow the
simple directions and you'll be truly
proud of the way your hair will look.
Today is a good day to try Ultra Wave!

*Nearly all good drug stores carry Ultra Wave.
If you know one that doesn't, please write us.*

JOHNSON PRODUCTS CO., INC., 8631 South Green Street · Chicago 21, Illinois

100% Human Hair

The riots in Harlem last August left scenes like this after many violent nights. Police personnel, such as Captain
Lloyd Sealy, were found to be heroes in helping maintain law and order in the strife-torn Harlem 28th Precinct.

THE MAN
WHO KEPT
HARLEM COOL

MAKE NEGRO A DAY AND MORE!

NURSE

Clip and mail this coupon for your 10-page...

FREE 1ST LESSON ON NURSING

EARN $70.00
weekly ... as
Graduate
Practical
Nurse

Ellen Gallagher

ABOVE
Watery Ecstatic Series, 2001
Watercolor, ink, oil, pencil, cut paper on
paper, 17½ x 22½ inches
Collection of the artist

Ellen Gallagher
and Edgar Cleijne

OPPOOSITE, ABOVE
Monster, from *Murmur,* 2003,
a suite of five 16mm films

OPPOSITE, BELOW
*Murmur: Watery Ecstatic, Kabuki
Death Dance, Blizzard of White,
Super Boo, Monster,* 2003
Five 16mm film projections,
dimensions variable
Installation view at Gagosian Gallery,
New York

The way that these drawings are made
is my version of scrimshaw, the carving
into bone that sailors did when they were
out whaling. I imagine them in this over-
whelming, scary expanse of sea where
this kind of cutting would give a focus, a
sense of being in control of something.
Scrimshaw had three genre forms (one
was images of home). So, much like
scrimshaw, I'm cutting directly into the
thick stock of the watercolor paper, imag-
ining this place, but this idea of home
is more like the idea of constant return.
And the voyage itself becomes a kind of
origin myth . . . the Middle Passage itself
rather than some version of an origin
myth based on Mother Africa. It's the
passage itself, the concept of mutability,
that I'm referring to here. In 2001, I also
started making a sequence of films
called *Murmur,* from the *Watery Ecstatic*
drawings. The first film *(Watery Ecstatic)*
refers most literally to the drawings, in
terms of the way the paper is cut . . . and
the drawing over it. It's this moment of
being submerged . . . there's a marine

mountain and these heads bobbing up
and down in the waves. . . .

The films do what I would hope people
would do with the paintings in mind.
Go back to this idea of a collection of
materials that has been opened up and
spread out sequentially. Activate your
own sequence through it. The films are
also a grid where each frame erases the
frame before as you move forward, so
it's literally a projection of a grid in space.
But it's the same place over and over
again. And that is what I want you to
do with the paintings. It's about the idea
of travel or motion . . . descent into an
altered state. For me, each repetition is
about an inauguration of a character into
an altered state—a way to change that
character slightly or pull it further into
difference and change, and into my
language. I'm not the only artist who's
interested in repetition and revision. So
many women artists before me have
used that—Gertrude Stein in her insis-
tences, and Eva Hesse. And of course,
it's a central aspect of jazz.

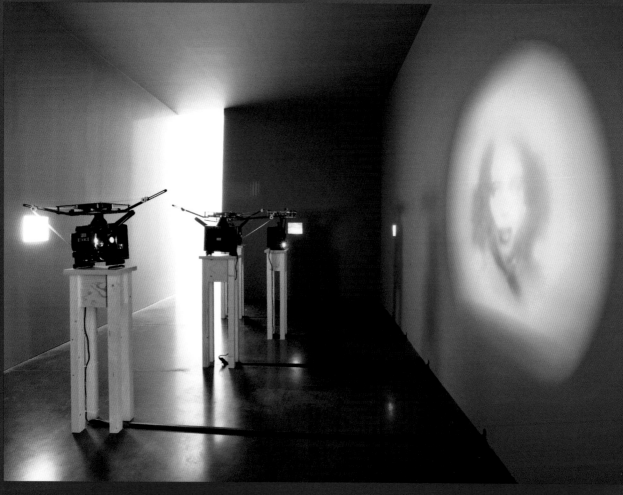

I didn't really come from a fine-arts background. I came from a carpentry background. So when I went to art school that was what I knew how to do, and that's the way I built my canvases. I built a latticework grid and over that laid down very thin plywood and stretched the canvas over that. That way I could sit on the canvas as I began gluing down sheets of penmanship paper from top to bottom, left to right. Then I began drawing and painting into the pages, after they'd all been laid down in a skin. And they really became something that can be read both

sheet to sheet and as an overall skin. The lines of the penmanship paper sort of line up and, from a distance, almost form a seamless kind of horizon line. But, up close, you see that it's a kind of striated, broken grid. So there's this push and pull between the watery blue of the penmanship paper lines and the gestural marks made inside and around them. Penmanship paper is the found material that I always see as a reference to how you make your letters—what height, and where you dot your *i*—so it's always been a sign of gesture for me.

Ellen Gallagher

OPPOSITE
Purgatorium, 2000
Ink, pencil, plasticine and paper on linen, 120 x 96 inches
Collection of the artist

ABOVE
Blubber, 2000
Ink, pencil and paper on linen, 120 x 192 inches
The Art Museum at Princeton University, Princeton, New Jersey

Ellen Gallagher

bling bling, 2001
Rubber, paper and enamel on linen,
96 x 120 inches
The Eli Broad Family Foundation
Santa Monica, California

I would say the concept of repetition and revision, like you have in jazz or jungle music—where a conductor might ask to have a phrase played and then repeated and there's this kind of call and response between the musician and the conductor, between the DJ and the audience—is central to my work. And what happens is that stackings develop between call and response. And the stackings never quite line up in the same way, so the repetition isn't ever quite a repetition. So even though I limit it to a class of signs—these lips, tongues, and eyeballs, or wigs, flipped wigs—they're always hand drawn. Even when they're printed, it's a direct mark through a mediated material, either a printed kind of carbon paper or a loaded-up sheet of ink. So the repetition itself isn't quite a repetition, and there's always a revision involved in each laying out. There's always your hand, or a gestural relationship, to the repetition. Where it will end up is never a given. Through this stacking, densities and gaps are created. And that's what's interesting to me. It's not the repetition itself—it's this 'disrupture' that happens in the repetition.

Arturo Herrera

I find abstraction satisfying because I can actually enter the work more easily. It is a preference of mine to be able to see work that is not telling me exactly what to think about, or what to do with it. Abstraction allows me to play within certain boundaries of interaction, and these boundaries are pretty intimate because the work is not telling me how to deal with them. I just bring my own history to them. It is a complex experience because we are informed with the language of abstraction from the past—and we're seeing it also *now*. Some people might find it frustrating, now, in this age; some people will call it irresponsible. I think there is a potential for these images to communicate different things to different viewers in a very touching way. But that experience is not a public experience. It's very, very private and it's very, very personal. I'm more interested in that aspect of the visual language, how an image can speak to you in a very touching way that is both charged with knowledge and with memory. It can trigger so many associations because it's not clear about what it's trying to say— but you actually attach yourself to the work, and it becomes experience.

Since there is no direction—usually no title—you're basically looking at this with your baggage of intellectual knowledge and your memories, desires, and emotional life all combined. So you make your own collage and then you bring it to the piece. You juxtapose yourself—attach yourself—to the image and then a new thing is created. You are fragmented, and the piece comes from fragmentation. And what I want is that this experience of the fragmented person and the fragmented image becomes a new whole, a hybrid experience. Nothing is ever sure in life. . . . So I'm playing with that idea of ambiguity and uncertainty. And I'm welcoming that.

Arturo Herrera

ABOVE AND OPPOSITE
Untitled, works from 1997–98
Mixed-media collage on paper,
12 x 9 inches each

Being Latin American, you're made up of so many fragments from different cultures. Venezuelan culture is extremely complex. And then you're part of Latin America, and part of America itself. The European tradition is part of you because you came from there. The way that you are fragmented inside makes you stronger. I see it as a positive thing. It just informs who I am. And being born in Latin America and living in the United States, you get accustomed to accents and the way people speak. Fragments of voice intonation, the way they pronounce and use words. I find it very rich to be able to identify those fragments of language. So maybe fragmentation and the way language gets transformed and recycled could be informative to my work . . . a correlation between the visual language I use and spoken language—the way we

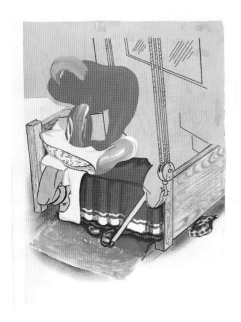

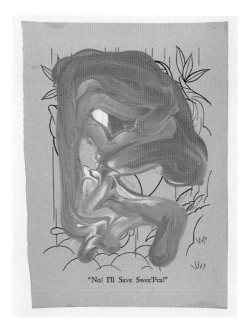

"No! I'll Save Swee'Pea!"

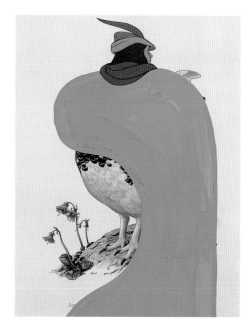

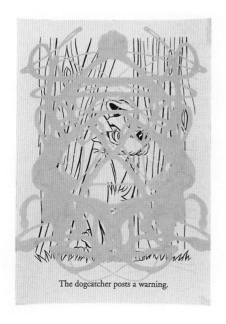

The dogcatcher posts a warning.

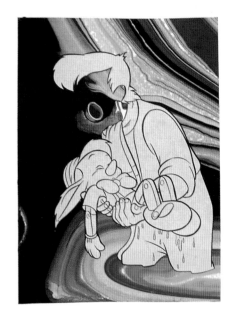

clearly identify a huge amount of information through very short gestures or intonation of voices or fragments of words. The visual fragment carries a lot of associative meaning in the same way.

You're on your own when you look at these images. Fragments offer a point of entry that you can identify in the piece. Once you're there, you are in a complete process of association. And that process is completely different to another person's process. So I'm not directing you towards a specific reading: you will be able to form whatever information you want from this image because it allows this field of abstraction—with some subjectivity—and then the objectivity of the image is there, too. So you shift back and forth without any kind of order or didactic direction from me telling you what to do, how to look at the image.

I'm interested in how an image that is so well composed and so clear and so objective—made out of these disparate fragments—can be glued, forced together to create an image that will have a different reading from what the fragments said. Both sides are part of the images' ambiguity, of not knowing exactly what I'm looking at, and then the clarity of the way it was composed. This is something intriguing to me.

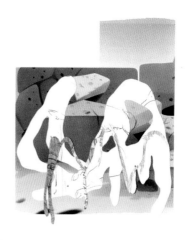

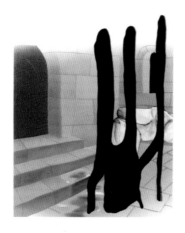

Arturo Herrera

OPPOSITE
Untitled, 2002
Collage (gouache on paper),
9¼ x 7 inches
Private collection

ABOVE
Keep in Touch (from set #4), 2004
Mixed media on paper, thirteen
parts, 18 x 17 inches each

The range of techniques is very open. I could pour paint directly on pieces of paper that have already been collaged, or stain the paper and then do the collage, and then do a drawing on top. It's a completely open process. Sometimes I use found, printed paper with images that I submit to a painter friend. I tell him to delete specific items out of this 'stage-set' (maybe the references are too didactic; maybe they're too clear), and he creates original paintings with a wash. So he deletes some elements, and then it becomes a complete abstraction and, now, something can be applied on top of this image. By deleting elements from a specific image, it allows me to get more involved in the creation of a completely different one that I hope will be much more powerful because of juxtaposing the painted background and the fragments that I glue on.

I'm trying to get away from specific content. Just by deleting that, it allows the viewer to enter the image, grab the references from the background, but not specifically identify them. So you're in a state of recognition but not objectivity. You recognize. You kind of remember. So this chain reaction of associations linking this flow of ideas and memories and desires and fantasies just comes to the center. . . .

Arturo Herrera

I decided to photograph my own drawings, not because I just want to photograph my own pieces, but because I'm trying to use the camera lens as a blade that cuts rectangular fragments from the originals. It's an unusual cutting technique because it's somewhat by chance, and it allows only a specific area to be fragmented. So it was interesting, after I did the photographs, to find that images that I thought were already finished (in paper and collage form) now have a completely different life. A couple layers have been eliminated—and now we have something else, but even more direct. It's like a layer of fat has been removed . . . or dissected with a surgical blade. Or something has been exposed. And this allows me to get closer to this language of abstraction.

Is there a possibility of abstraction now? These days, objectivity seems to rule everything. We need to have the meaning of this image; we need to have the content for that one. I'm interested in the other side. I want to *not* know what I'm looking at. . . . These images which come from my drawings and collages now have another life that has different associations that the collages didn't have. And that jumps them into another area that will hit different kinds of viewers in different ways. So I'm just thinking, "Could these be of interest to somebody today?" Yes. So that's what I'm trying to do—to see if they continue to activate viewers into a state of curiosity and intellectual questioning.

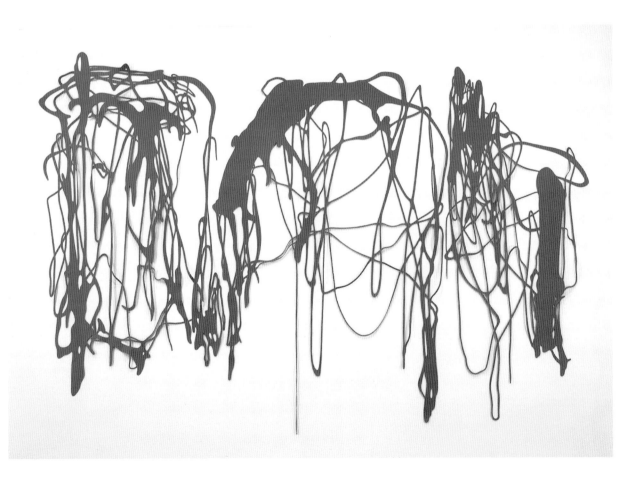

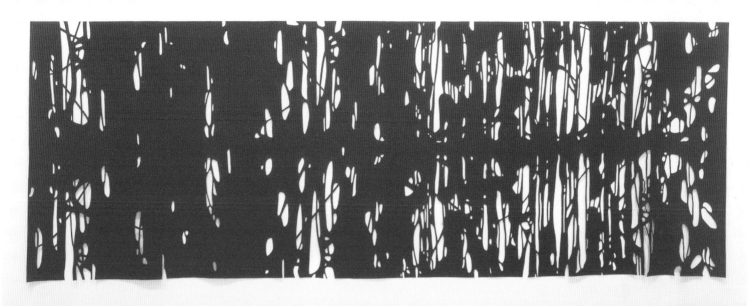

Arturo Herrera

OPPOSITE, ABOVE
Say Seven, 2000
Wool felt, 65 x 90 inches
Collection James Patterson

OPPOSITE, BELOW
Before We Leave, 2001
Wool felt, 84 x 144 inches
Collection Whitney Museum of
American Art, New York

ABOVE
I Am Yours, 2000
Wool felt, 64 x 192 inches
Collection San Francisco Museum
of Modern Art

These works are based on ink drawings that I did in large and then projected onto felt. It's compressed wool. It cuts very easily with no threads, it's pure pigment, and it behaves like paper. It comes in many, many colors and allows for the enlargement of any drawing into large scale. These pieces were made to respond to specific architectural areas—to be able, in a sense, to collage the piece of felt into a wall of artistic space. They usually hang from the top, and all the shadows are visible so the wall becomes part of the piece, too. The ink drawings are very intuitive. There's no planning for them so they're just like the collages. They're made in

series. And maybe a few of them will make it into a final state and be reassembled and photocopied. Once the process is done, they go further and further from the original version until they get to a state of editing that satisfies me to be able to cut and use them for a specific wall. So they're far removed from the original ink drawings. The pieces have a material aspect, connotations of felt and pure pigment on the wall. They're just drawings made out of felt. I mean, yes, they're like sculpture—and they're really like paintings. But they're drawings. And they just hang on the wall with two pieces of tape on the back. Drawings, cut with pure pigment of wool.

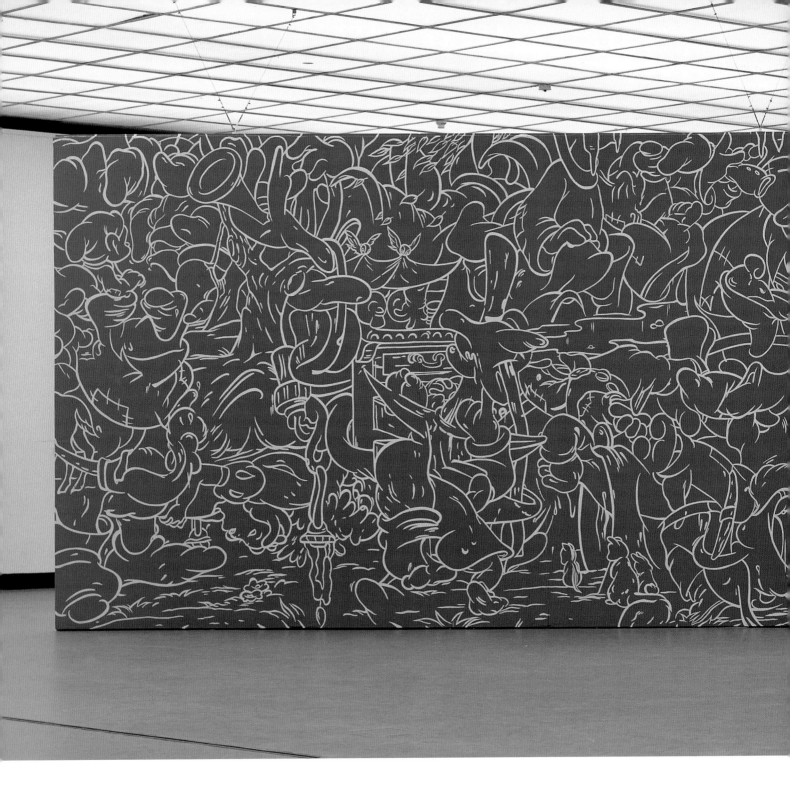

Arturo Herrera

All I Ask, 1999
Latex on wall, dimensions variable
Installation view at Württembergischer
Kunstverein, Stuttgart, Germany
Collection Rachel and Jean-Pierre Lehman

The first idea was to recognize in those images of dwarfs from *Snow White and the Seven Dwarfs* a very strong sense of connection with organic abstraction. It's like a ready-made modernist abstraction. Its round forms recall Brancusi, Arp. I took isolated fragments of these shapes from coloring books and I tried to unify them into an all-over pattern that would allow the viewer to take this image with an immediacy that, maybe, is not possible with the individual collages. Creating this all-over pattern made me also think about American abstract expressionism, where we're not confined with the limited space of the canvas or the window frame. It was a slow process of melding and blending to be able to create a seamless kind of narrative with no specific content. . . .

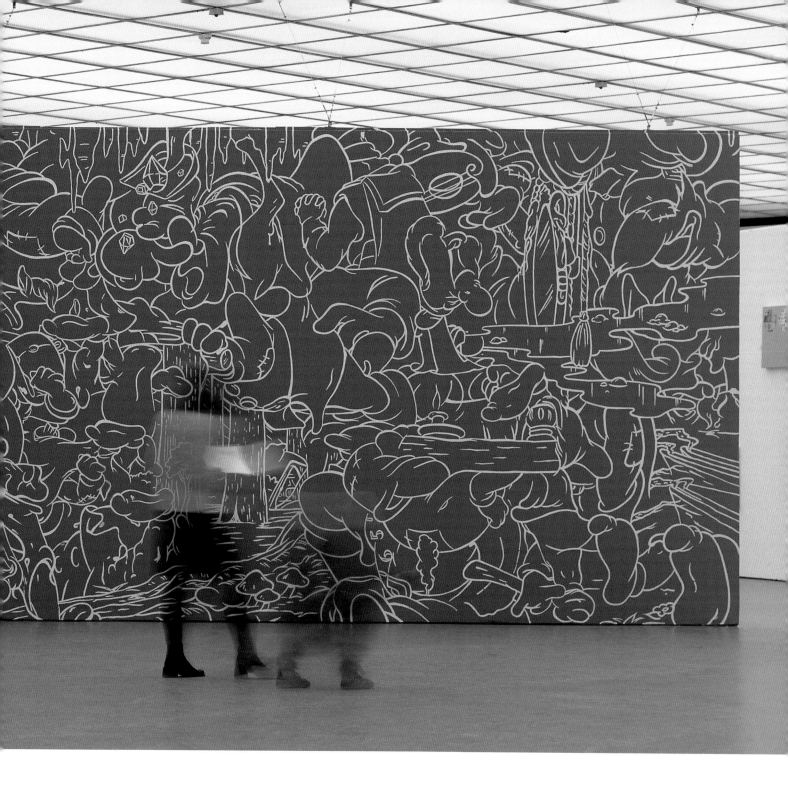

Music is related to the way of thinking for what I do—because music offers no solution. It has no content. It's just total subjectivity. So it lasts for a limited time, and it's gone. Unless somebody plays it, it's just non-existent. This experience of making it happen and then disappear—the transient nature of music—is fascinating to me. I'd like the visual images that I'm trying to do to be nonobjective, just like music.

Wall paintings also have this inherent aspect of being transitory, being exposed to weather or architecture . . . houses decaying. So it's just part of the process. Most of my wall paintings have actually been destroyed already. It doesn't bother me. They could be remade eventually, but then I would have to rethink where, how, and so on.

Oliver Herring

ABOVE
*SHANE AFTER HOURS OF SPITTING
FOOD DYE INDOORS*, 2004
C-print, 41½ x 62½ inches
Edition of 5 with 2 AP
Originally commissioned by Artpace,
San Antonio, Texas

OPPOSITE
*CHRIS AFTER HOURS OF SPITTING
FOOD DYE OUTDOORS*, 2004
C-print, 41½ x 62½ inches
Edition of 5 with 2 AP
Originally commissioned by Artpace,
San Antonio, Texas

I just popped the question, "Do you want to do some art-related project?" He wanted to know more, and I said, "Why don't you come tomorrow, whenever . . . let's do something simple, just spit some food-dye. . . ." And that perked his interest and he was gung-ho.

If somebody actually just walks up to you and says, "Hey, do you want to do something out of the ordinary?" there might be a little reluctance at first. But deep down, you want to do it. It's adventure. That's what brings people in front of the camera.

Once I gained the confidence to just play with the unexpected, and the more chance I could incorporate into the work, the more my work grew because I couldn't predict what would happen. And that chance element, combined with working with strangers, became the heart of my work.

I still think of myself very much as a sculptor or a painter. The idea of a director seems too hierarchical. I can't relax into that at all. And maybe that's also why these things become very collaborative. While I call the shots, I do it under disguise. I don't really know what my role is and perhaps that's a good thing because it keeps me fluid and changing—behind the camera or in front. It leaves doors open. I don't like roles, actually. In the end, these things are collaborations. I don't think of the people I work with as models or actors. They are people who are willing to sacrifice their time for me. Of course there is something in it for them, too: the experience is intimate and unusual. But it's the same for me. Although I know more what to expect since I usually work with strangers, there is still a whole new world that enters my studio with whoever comes in. It's very adventurous.

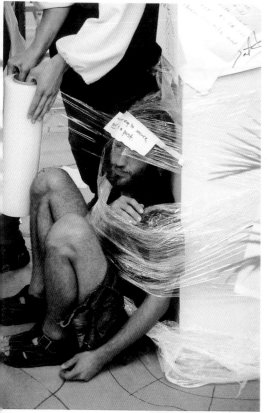

Oliver Herring

TASK at the Former Federal Security Bank,
Lake Worth, Florida, 2003

A public performance like *TASK* (2003) is almost a game—a reality game. I set up basic rules, such as 'don't leave the parameters of the stage'. I provide a bunch of props. In the case of *TASK*, I write a bunch of simple tasks in order to get the performance going. Each one goes in an envelope and is put in a task pool, and the performance starts with each participant taking an envelope, opening it, and trying to fulfill that task. Once they're done, they each write a new task, put it back in the task pool, grab a new task, and go on with business. After the first five or ten minutes, the performance is entirely self-perpetuating. You don't know what's going to happen. The rules that I start with are not binding. Anybody could just walk out, or break the rules. But that never really happens. I'm always surprised that there's no real anarchy—only staged anarchy. Anarchy can definitely happen in a piece of art. I haven't seen it happen in my work, but it's possible. I'm setting the rules for there to be anarchy, not in the larger sense but within the confines of the game. You can break the confines of the game. You can stop it, break it up entirely. It's just a creative possibility—to

take something to the extreme—which I think is creatively very interesting. That's what we try to do as artists. We try to push something to the point of breakage but stop just before. Sometimes we fail— we break the thing, we've gone too far. It's important to learn where that breakage point is in order to set the parameters of what's possible. Once you know your parameters, you know what to play with.

In the case of my performances it's about choice and interpretation. If you find meaning in that, you might also find meaning in similar situations in your life. You might just look at life slightly differently. You might not look at a mundane situation as mundane; you might see it as holding potential to turn into something more beautiful or meaningful, or something with which you can communicate to another person. I think that's what these performances do. Maybe it takes rules and structure to define something as an unusual situation. So it really becomes about bending those rules or defining them on your terms. That determines whether it's art or not, whether it's a special situation or a mundane situation. It's about choice.

The Day I Persuaded Two Brothers to Turn Their Backyard into a Mud Pool

Printed at Hare & Hound Press, San Antonio, TX. for the exhibition **Oliver Herring** at ArtPace, San Antonio, TX.

Davis Thompson-Moss
Palmer Thompson-Moss
Money (Dog)
Crown Hights, Brooklyn, NY

Edition: / / ○

Sunday, November 23, 2003

A/P: ○

Oliver Herring

THE DAY I PERSUADED TWO BROTHERS TO TURN THEIR BACKYARD INTO A MUD POOL, 2004
Color inkjet prints on Kitakawa paper with base, 4 ¾ x 28 x 33 inches
Edition of 10 with 2 AP
Originally commissioned by Artpace, San Antonio, Texas

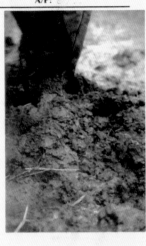

Oliver Herring

ABOVE
GLORIA, 2004
Digital C-Print photographs, museum
board, foam core and polystyrene,
72 x 40 x 40 inches with vitrine
Private collection

OPPOSITE
PATRICK, 2004
Digital C-Print photographs, museum
board, foam core and polystyrene,
51 x 37 x 37 inches with vitrine
Promised gift to Blanton Museum
by Michael and Jeanne Klein

When you look at these sculptures, you don't really get how they're put together. You might conceptually understand that they're made from photographs, but you don't really get the in-between stages. There are two separate mediums here: the Styrofoam structure, and the added photographs. They constantly struggle against each other. There have to be adjustments made in order for this to look real. It's a make-believe thing, a composite of many different poses at different times, at different light conditions.

What makes working on these figurative pieces so weird is that on one hand, it's incredibly tender and gentle, sensual and intimate, yet at the same time there is something very violent about the act of cutting into the photograph of a person . . . something brutal in the making of these figures. When I'm working on an eye I have to almost operate with a scalpel. There is a 'tactileness' and intimacy between me and this object, this fictional character. At the same time, the photographs sort of communicate

that better than the figures themselves. I'm just totally fascinated by what things look like, that weird translation from three-dimensional to two-dimensional space. It's mysterious because you can't quite gauge it. I don't know how to look at it and maybe that's the challenge. I know how to see the world through my own eyes, but with these things I just don't completely know how to approach them. . . . There are times when I see them as two-dimensional, as photographs, and then I read a

different kind of space and reality into them. But then I flip again back to the other way of looking at it, and I find it unsettling.

In these photographic pieces, I'm working with a person for two or three months, and that leaves a huge margin for things to happen and change. The person changes—things happen—and change gets incorporated into the piece. I take thousands of photographs. It feels very deconstructive. Then I try to bring it back together again, and that's the

restructuring process. Still, even these finished pieces are unsettling because you really don't know what you're looking at. Is it a portrait? Is it a summary of the time we spent together? Is it two-dimensional? Is it three-dimensional? It's disturbing. Maybe it's the times we live in. Things are very difficult to gauge. . . . Maybe the perfect object, the perfect shining object, seems way too utopian. Maybe something that's fractured, deconstructed, and reconstructed just seems more truthful.

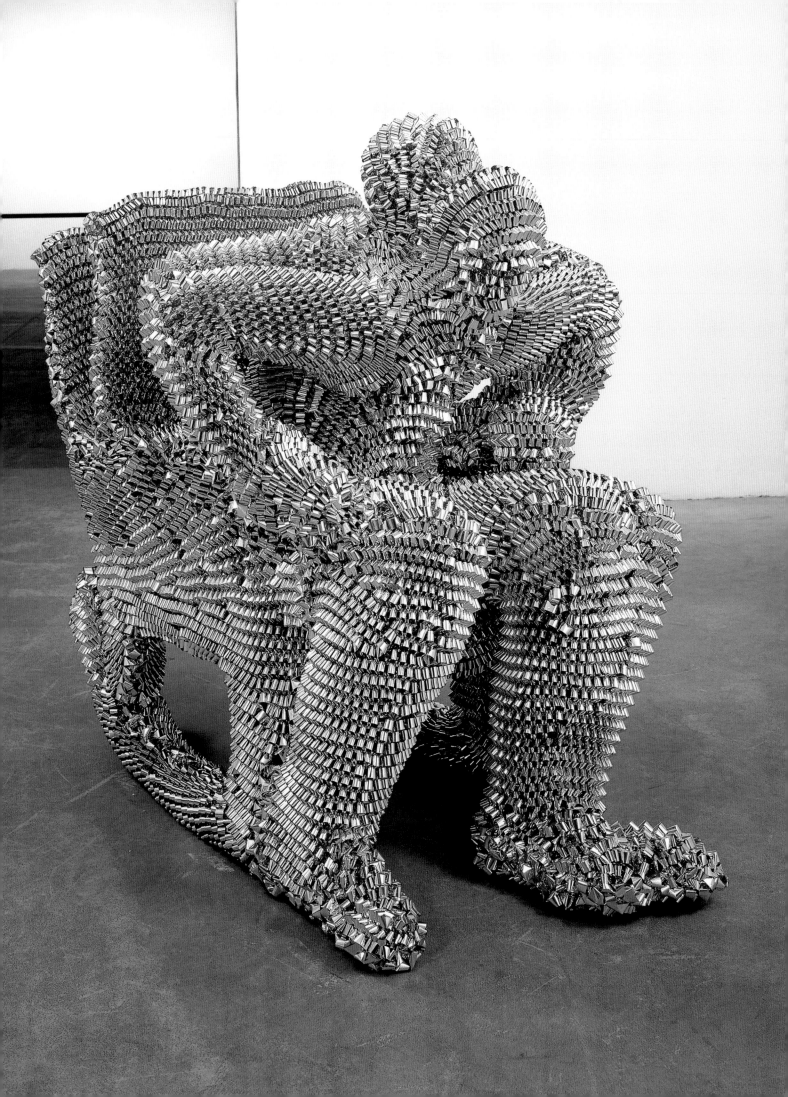

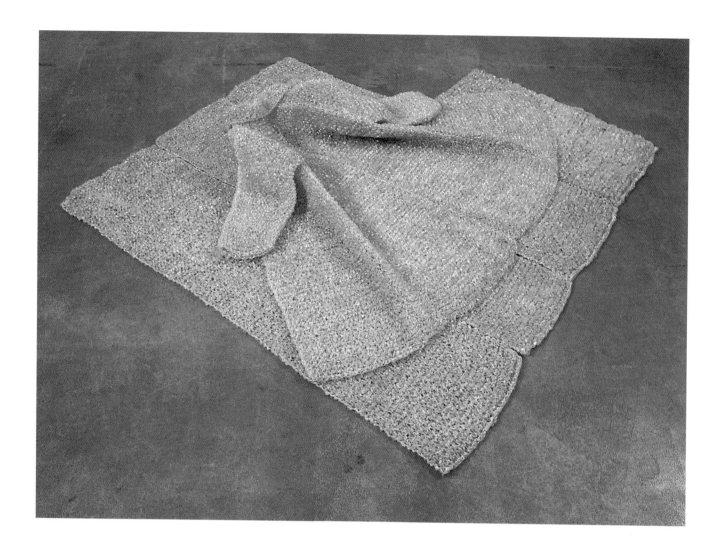

Oliver Herring

OPPOSITE
Double Rocker, 1999
Knit silver Mylar and wire,
44 x 24 x 50 inches
Collection of Kent and Vicki Logan

ABOVE
*Untitled (A Flower for Ethyl
Eichelberger)*, 1991–92
Knit transparent tape, 85 x 85 inches
Private collection

Every person I've ever met had, at least
for an hour, an interesting story to tell.
It's just a matter of finding the right ques-
tions, or tapping into that little hidden
something that unlocks somebody. In the
moment, that's more interesting to me
than to unlock that in myself. I'm always
aware that art can be very self-indulgent.
I started to knit in relation to the death
of the artist Ethyl Eichelberger. It was an
hommage, but at the same time it was
a way for me to resolve issues that I had
with mortality. I was frightened. That
was about me, about me in relation to
that death, me in relation to the world.

I was a painter, and my work up to that
point was very colorful and expressionistic.

From one day to the next, I took all the
color and all of that expressiveness out
of my work. I subjected myself to this
rigorous, monotonous discipline to push
myself in a direction that I wasn't familiar
with, to experience something that I hadn't
experienced before. As I knitted (it wasn't
a conceptual decision; it was emotional), I
learned that what I opened up through the
process was to allow myself time to think.
Time was the crux of the matter, lack of
time for Ethyl Eichelberger and the time
that I had to reflect. Once you sensitize
yourself to understanding that even the
narrowest thing is explorable—infinitely—
it's liberating. I did this for ten years, and
I could have done it for another ten.

Look at my videos as a continuation of my work in general. My work has always been very stripped down. It's always about generating something with a very simple and accessible material, or with what's around me. And perhaps the more 'operatic' video pieces were a reaction to my knit sculpture, which kept me isolated for so long in the studio that the videos were a way for me to be social and flamboyant and to change my mind all the time. Because when I did the knit pieces, once I committed myself to a piece I was locked into an idea and the only thing that could really move was my mind. The early video pieces were a way for me to express what was going on in my mind.

I advertise for people to come to my studio to make a video. The idea is not to prepare myself in any way. I try to keep my mind as empty as possible and base whatever we do on the personalities of the people who show up. Most of the time I have no idea who, how many, will show up, what gender or race, what expectations. The

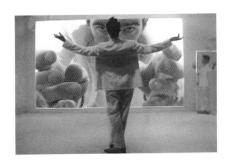

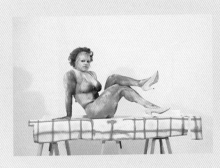

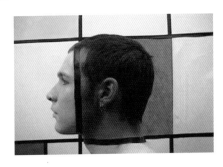
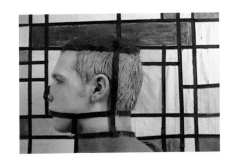
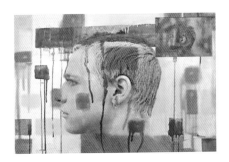

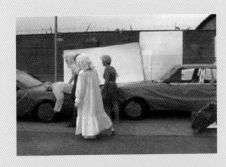
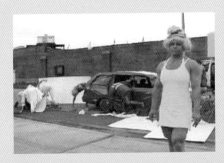

The premise is to make a video but that can mean a lot of different things. Perhaps it sounds much more glamorous to some people than it is—especially the videos that I make, which are stop-motion. I repeat a lot of movement, and whatever we end up doing, because I don't know where it is going. I try to take my cues from the personalities of these people. So if I have two people whom I know where you enjoy it, where you're not self-conscious, where personalities come through. At some point you reach a point of saturation where you're so tired and exhausted that the last little bit of guardedness falls away and something really pure comes out. That's what gives these videos humanity. And that's what I'm shooting for. All the action—all the motion—is really just a decoy to get to that.

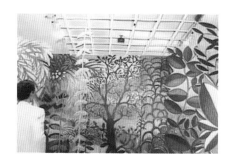
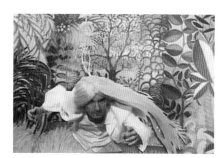
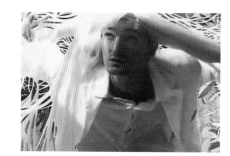

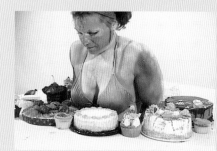
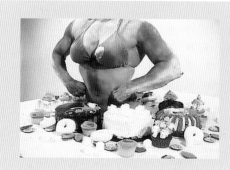

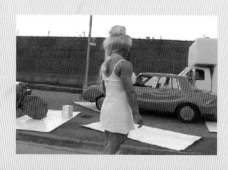

Jessica Stockholder

Sam Ran Over Sand, or Sand Ran Over Sam. The title? Dr. Seuss immediately comes to everybody's mind. Dr. Seuss is very playful with sounds of words as well as their meanings—the way words sound and play with each other internally is as important as what is being told. That resonates with my work: I'm as interested in formal play and how that intersects significance as in what things mean. So I do like that reference in the title. But it's also descriptive of something I am thinking about in my work generally—and in this work—about how things have character. I don't think it's fair to say that my work is just formal. I don't think anything is *just* formal; I think formal things have significance. And the word narrative isn't the right word to use in relationship to what I do. I don't construct narratives.

I haven't found the right word, but there is some kind of storytelling, for lack of a better word. There are evocations—floating significances—that combine in a poetic way. That title posits Sam as a character, and the sand as a character. Things have character. So I'm interested in how the character of things might function as a protagonist in what isn't a narrative here.

What I find most interesting about people is that the structure of meaning and significance that each of us lives with isn't easy to articulate. That's why storytelling is so important—and art making—because in those forums, as opposed to something like an academic essay, we create structures that are difficult to pin down and we accommodate floating kinds of significance.

I'm always playing with the way that things are pictorial from certain points of view, and then more physical. So it's less about picture making, though I don't think that disappears entirely, and more about your body—this orange color kind of floating onto your body and filling the air, and how that's similar to light generally filling the air—and the feeling of the Styrofoam, the weight of the Styrofoam next to that weight of that color. The green is flat; the Styrofoam is white but not flat. But that green has an illusion of volume or space. I like to put together those things that have illusion of weight and space with things that have real weight and space. So here we have a real rectangle of orange and white, a volume of it, sitting next to a flat kind of illusionistic volume of green. And red and green. Generally I've used a lot of red and green. When I first started painting and drawing, almost everything was red and green. There's a kind of optical buzz between them. And I think there's something very charged and almost sexual about red and green.

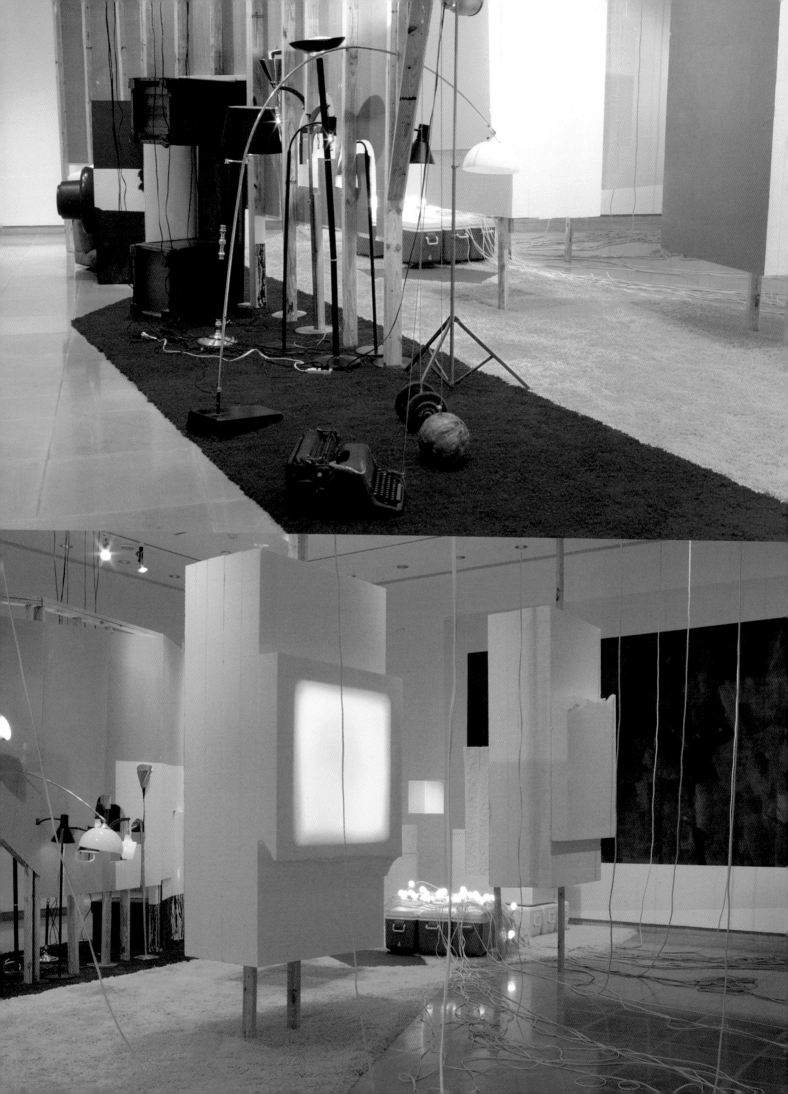

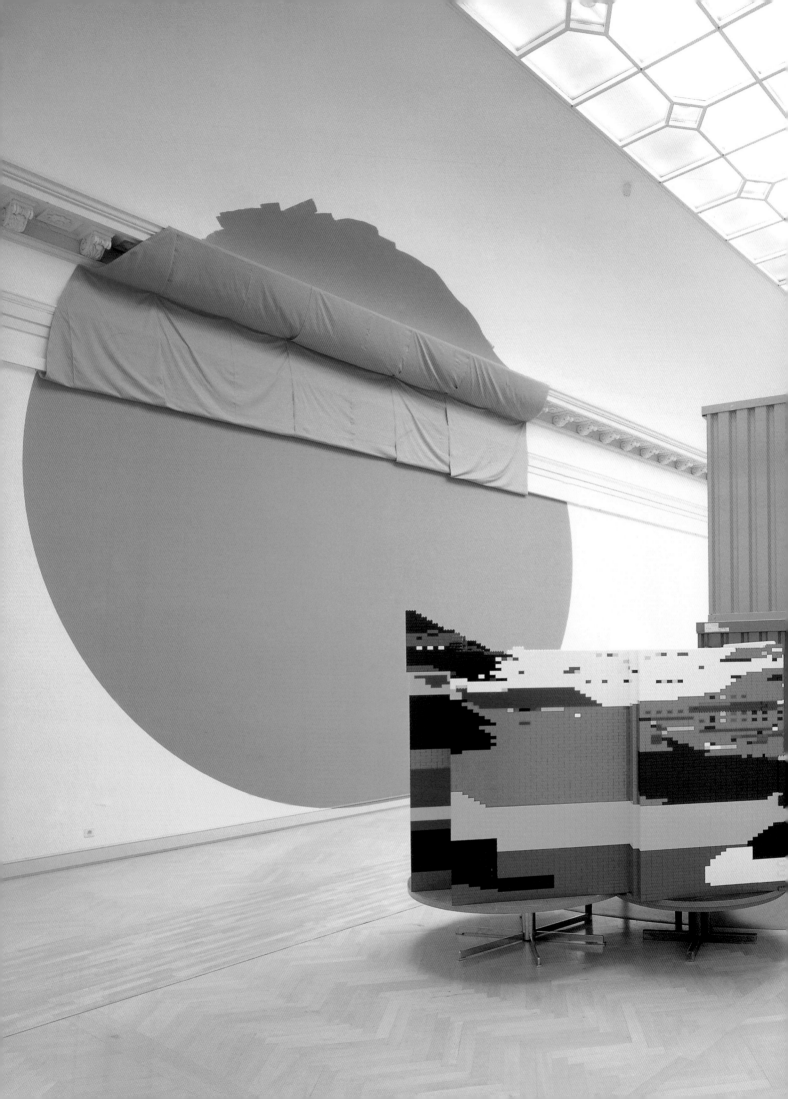

Jessica Stockholder

*Vortex in the Play of Theatre with Real Passion:
In Memory of Kay Stockholder,* 2000
Installation at Kunstmuseum St. Gallen
Duplo, theatre curtain, work site containers,
bench, theatre light, linoleum, tables,
fur, newspaper, fabric and paint,
dimensions site-specific
Collection Kunstmuseum St. Gallen, St. Gallen,
Switzerland

The title came after I made this piece. My mother studied Shakespeare, but she also loved drama and theatre in her life, and in all the senses. So this is a theatre. This piece wasn't made to illustrate my mother or be a portrait of her but, in retrospect, the theatre of the piece was interesting for me in relationship to her. I'm also interested in theatre . . . how sculpture has become theatrical. Having taken it off the pedestal, which separated it from the space of the room, it now sits in the room with you—and you move in the same space as it. So you become an actor in the room, alongside the actor that the sculpture is.

The wood-grain linoleum attaches to two doorways . . . so that's kind of like a runway that you can walk through, and then this theatre light points at the wall. There's some very faint expressionistic roller-painting of pink on the wall that the theatre light points at. So it's this self-conscious highlighting of that sort of "expression." I put it in quotation marks— but people *are* expressive. Art's expressive. But it's not that fact that's so important. It's rather what we make of all that expression. And there's a kind of stillness in the work. It's like the light is pointing at something that's still. Everything in there is still, but you can move through.

My mother died a couple of years before this work. That statement, "fixing things in the headlights," makes me think of the theatre light like fixing things in the headlights, catching things and keeping them. This work is a bit like a photograph that way. It catches a moment or a sort of nostalgia or a memory. For that reason it seemed appropriate to name it after her.

Jessica Stockholder

Lights plug into the wall and call attention to the electrical wires that are in the wall. It's static to look at these light bulbs. They don't do anything. It's a static, still image that the lights present. But it is an event because electricity moves, and the electricity is active in the wall. So, conceptually, I like it that the stillness of the work is disrupted. I'm very much in love with the work being still—and picture making is about still things. I'm interested in still pictures, but the electricity isn't actually still. So I like that disruption. And also I like plugging these things into the wall. They are sited. They're attached to the wall in a very particular way.

I like the wall. The wall being part of the work matters to me a great deal—not taking for granted how these things are in space and in the world. A painting is a conventional form, a rectangular thing that hangs on the wall. It's a convention that you can then forget about, and then just look at what's inside the painting. And a sculptural pedestal—that's another form where you put the thing on the pedestal and then sort of forget how it's in the world. You just look at this thing on the pedestal. It seemed to me that those conventions of how things are in the world, how they are in relationship to us moving around, and how they are in relationship to buildings, is part of their content. So with each one of these works, I kind of invent a slightly different way for it to be attached to the architecture.

Jessica Stockholder

1995
Wicker chair, plastic tub, light fixture with bulb,
synthetic polymer, oil paint, plastic, fabric, con-
crete, resin, wood, wheels, acrylic yarn, glass
and cookie in resin, 71½ x 63 x 50 inches
Collection Whitney Museum of American Art,
New York; gift of the Jack E. Chachkes Estate,
by exchange, and purchase, with funds from
the Peter Norton Family Foundation and Linda
and Ronald F. Daitz

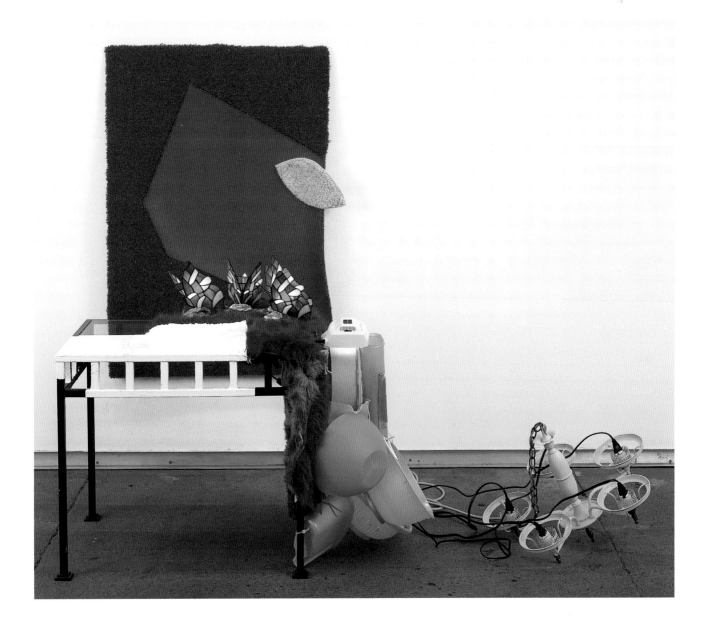

Jessica Stockholder

2003
Carpet, metal coffee table, four butterfly
lamps, chandelier, various green plastic
things, aluminum/tar flashing, oil and
acrylic paint, green extension cord,
56 x 64 x 45 inches
Collection of the artist

I'm interested in abstract expressionism.
Through my life, that's been kind of taboo.
Abstract expressionism has been debunked
and sneered at—the idea that expressing
oneself is interesting to anybody else has
been laughed at. And I understand the rea-
sons for that but I think, nevertheless, that
each one of us has personal reasons for
making things and that the work wouldn't
be interesting or powerful if we didn't. Each
one of us is a subject, a person. And each
one of us does have handwriting. You
know, we have a way of making marks and
that's not uninteresting. I don't think my
person is what's interesting about my work,
but what I make of my person, how I think
of my person and manage my person in
relationship to the culture we share, is of
interest, because we all have to do that.
Everybody has to manage their person in

relationship to others. And so this drip
and the hand of the brush and everything,
it's my handwriting, mark making. It's very
self-conscious.

I find something very lacking in mark mak-
ing on a flat surface with the hand—without
objects—when it's just a flat surface and my
hand. There's something disturbing. So in
my studio, I bring in objects. With installa-
tion work, I work in relation to the site and
the particularities of the space—thinking
about being in the space and mapping out
what's of interest in the space for myself.

And when I work on flat things, bringing
in a photograph is very helpful. The photo-
graph is crisp and has all kinds of scale and
information that aren't about my hand. To
have that be a foil to whatever my hand
does is very helpful.

Jessica Stockholder

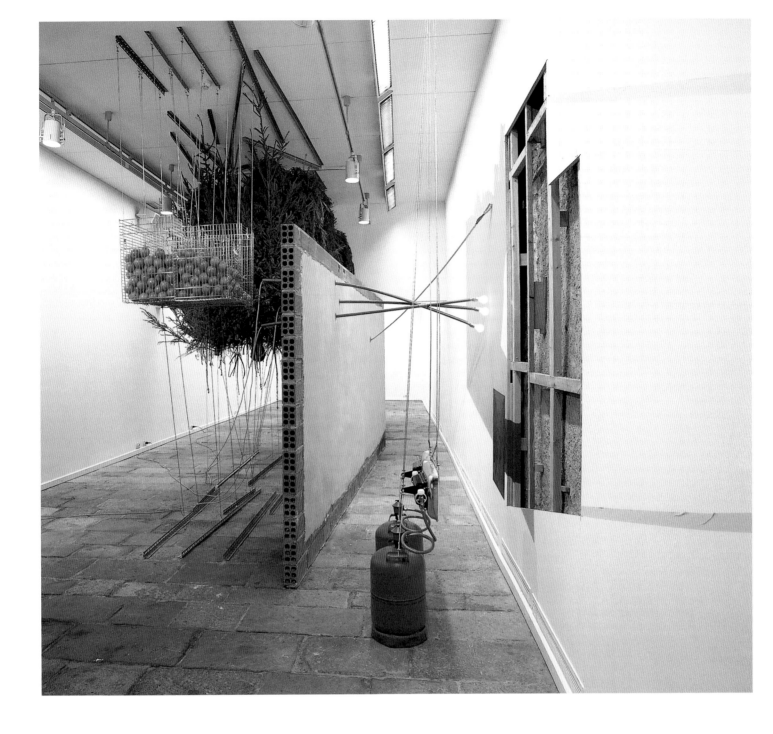

Jessica Stockholder

Sweet for Three Oranges, 1995
Installation at Sala Montcada de la
Fundacio la Caixa, Barcelona, Spain
Paint, approximately 40 Christmas trees,
oranges, 4 bird cages, brick wall, air
craft cable, butane heaters, rope, roofing
paper and roofing tar, lightbulbs, yellow
electric cord, pvc piping and angle iron,
1108 square feet overall

I used a lot of oranges because they're
orange! Here they were in this birdcage.
And I like that they're orange and they
have a beautiful color and that they're so
luscious—almost a cliché of beauty and
sexuality . . . still lifes and Cézanne. Oranges
immediately bring all of that up. And for
me they are also like electricity on the walls.
Though they're participating in the work
like a still life, in fact they're degenerating
and changing, and they're fluid.

How the pieces begin is a hard thing
to talk about. I like these pieces of plastic;

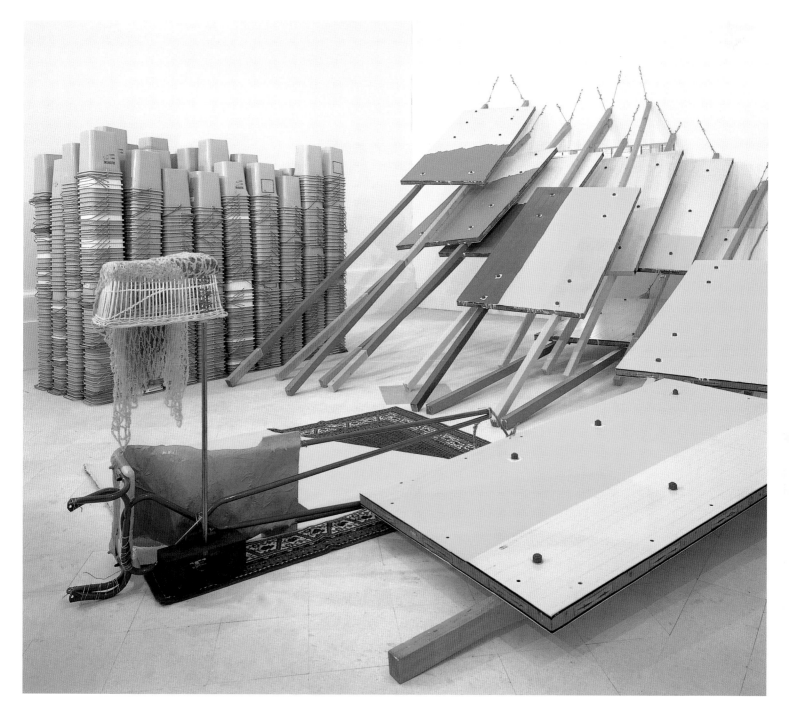

I like the color of the plastic; I like that they're inexpensive but gorgeous. And why are they so inexpensive and gorgeous compared to diamonds, which are so expensive and probably no more beautiful than these plastic things? I think these plastic things are stunningly beautiful. And they don't last long, not because plastic doesn't last long—it does—but because the objects themselves aren't strong, and people don't value them. You can see them in this process—from the store, into people's houses, to the dump. So they carry a lot of information with them as well as just being beautiful things to look at. I also just love color, and they're a really great vehicle for color. They embody color. They're colorful all the way through as opposed to having a skin of color, and I like that about them. So I've gathered them. But this jumble of things that I'm trying to make into a structure that can hold a fictive skin or a kind of a composition is more difficult to plan. I couldn't plan that. I have to discover that through putting things together.

Jessica Stockholder

Nit Picking Trumpets of Iced Blue Vagaries, 1998
Installation at Musée des Beaux-Arts de Nantes/La Salle Blanche, Nantes, France
Panels from a refrigerator room, 34 stacks of blue plastic buckets, lumber, cable, hardware, rope, enamel, oil and acrylic paint, carpet, basket, yarn, part from a swing set, paper mâché with paper and 55 lbs plaster, and pipe, dimensions site-specific
Collection Museum Moderner Kunst Stiflung Ludwig, Vienna, Austria

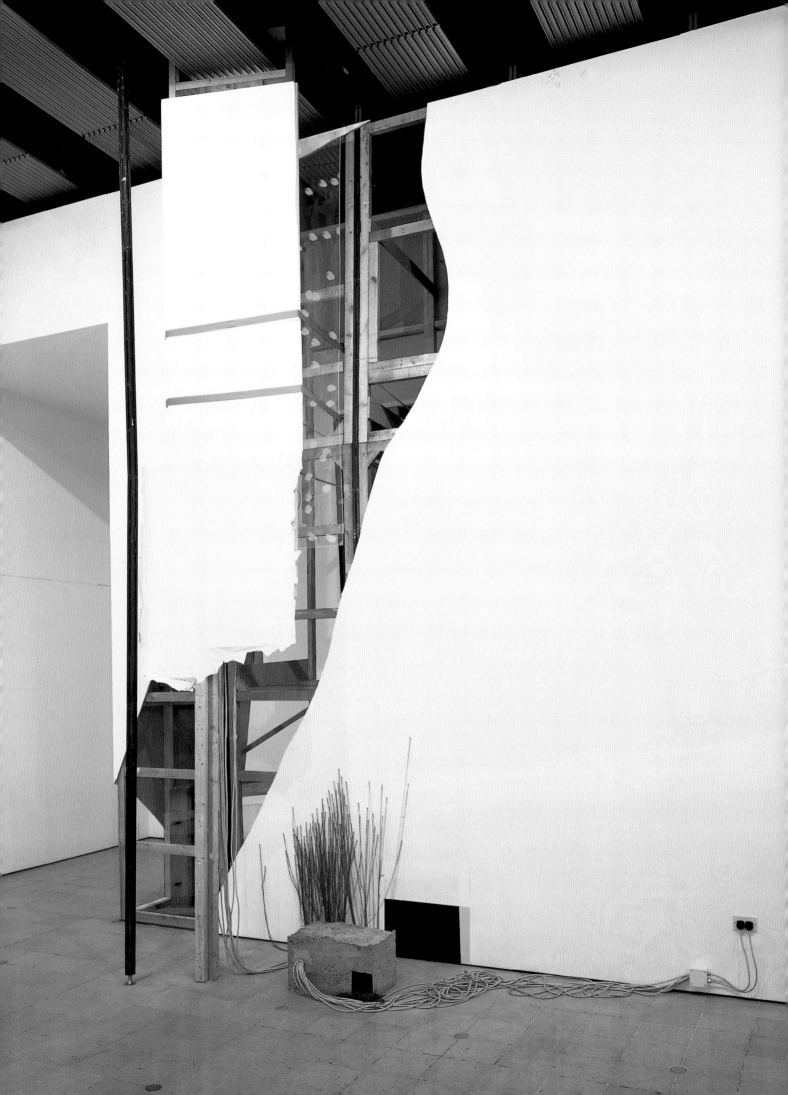

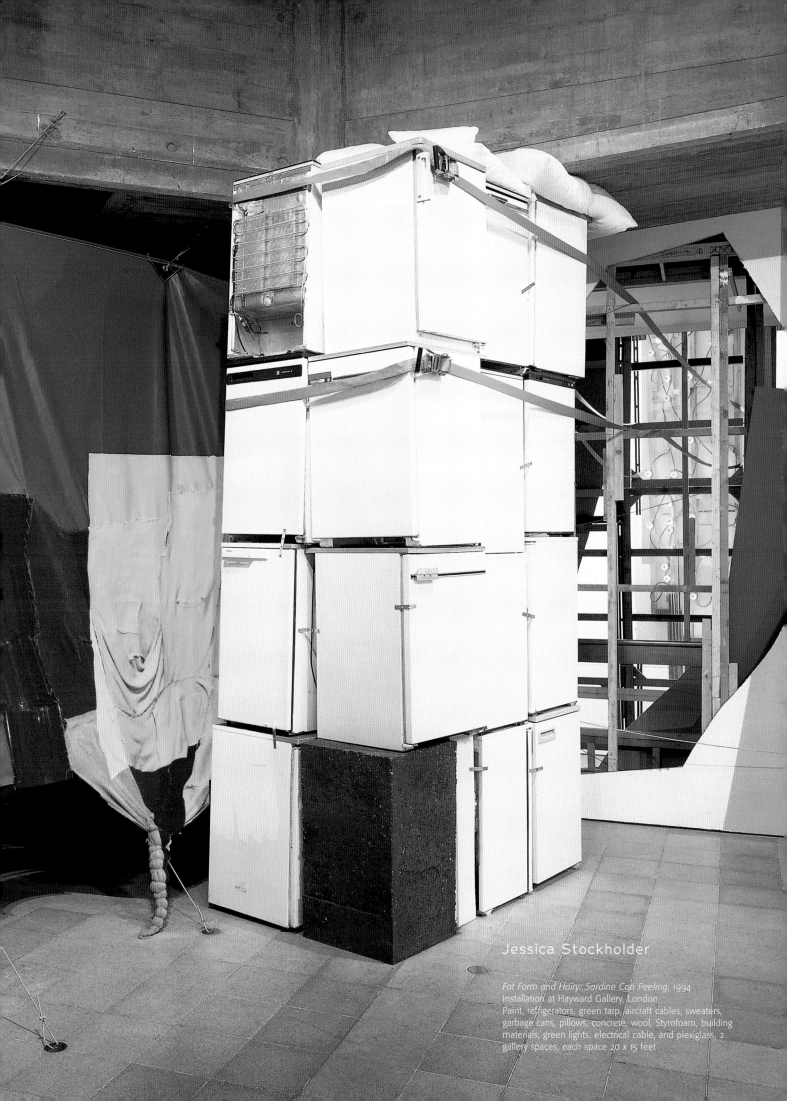

Jessica Stockholder

Fat Form and Hairy: Sardine Can Peeling, 1994
Installation at Hayward Gallery, London
Paint, refrigerators, green tarp, aircraft cables, sweaters,
garbage cans, pillows, concrete, wool, Styrofoam, building
materials, green lights, electrical cable, and plexiglass, 2
gallery spaces, each space 20 x 15 feet

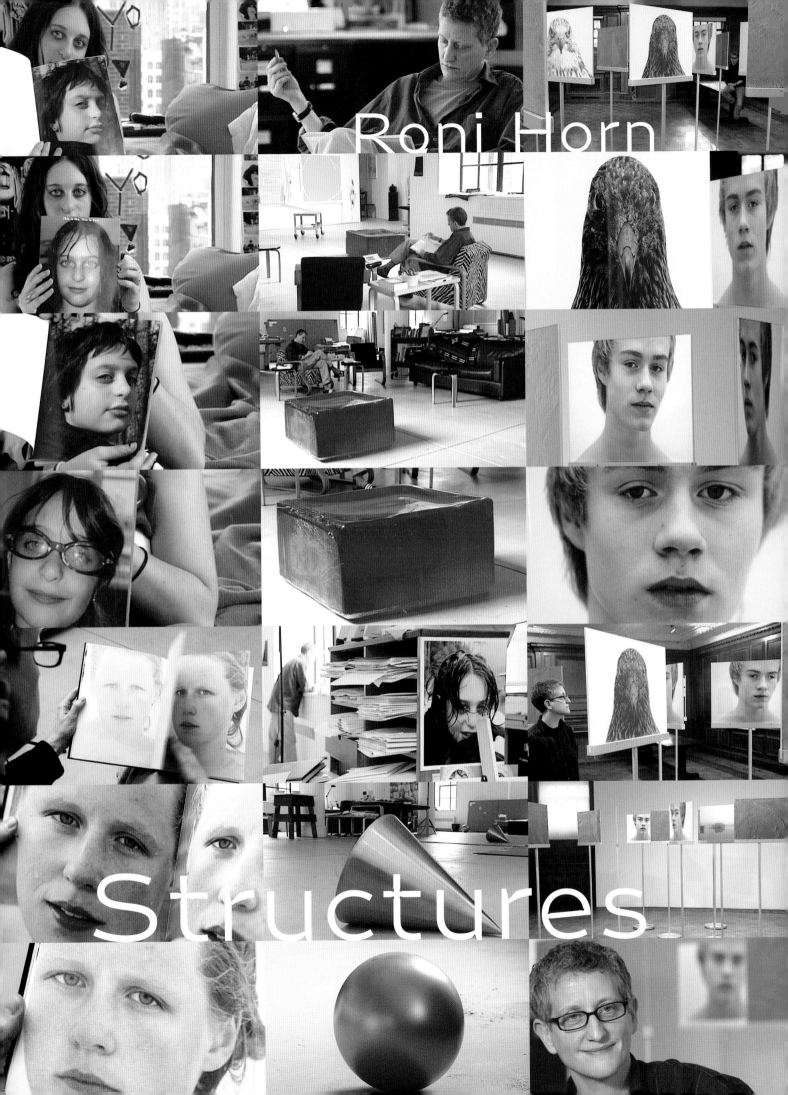

Roni Horn

Structures

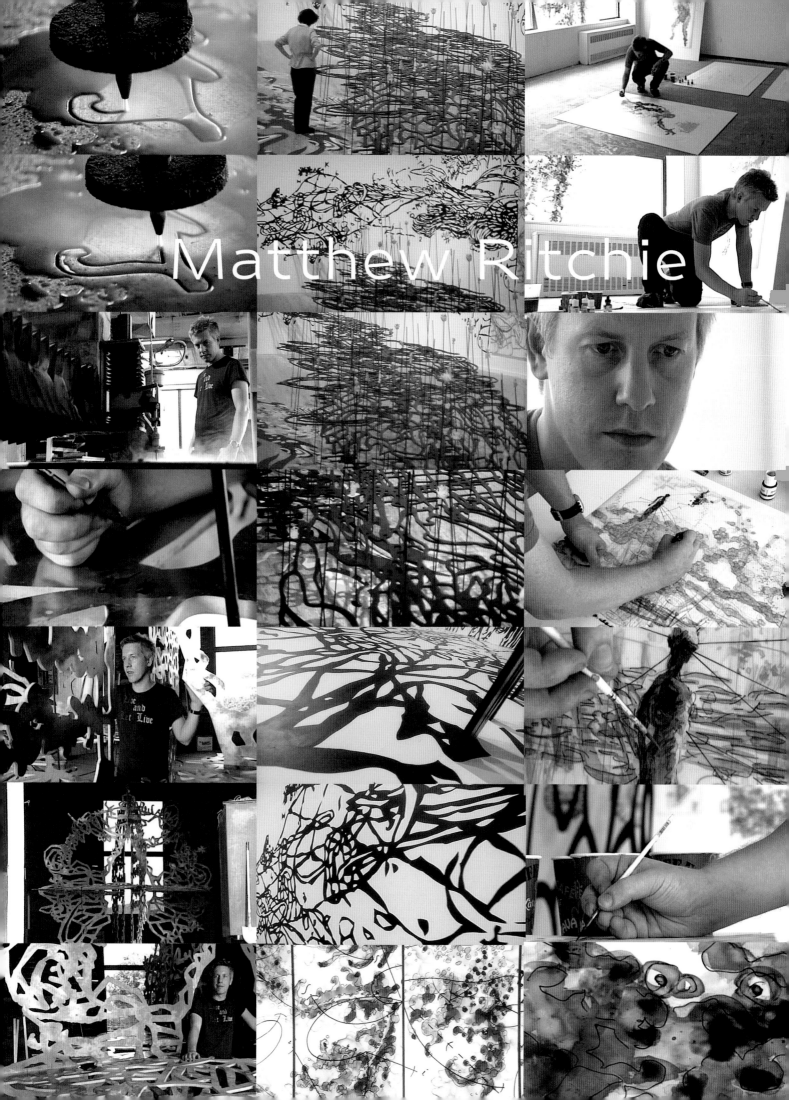

Matthew Ritchie

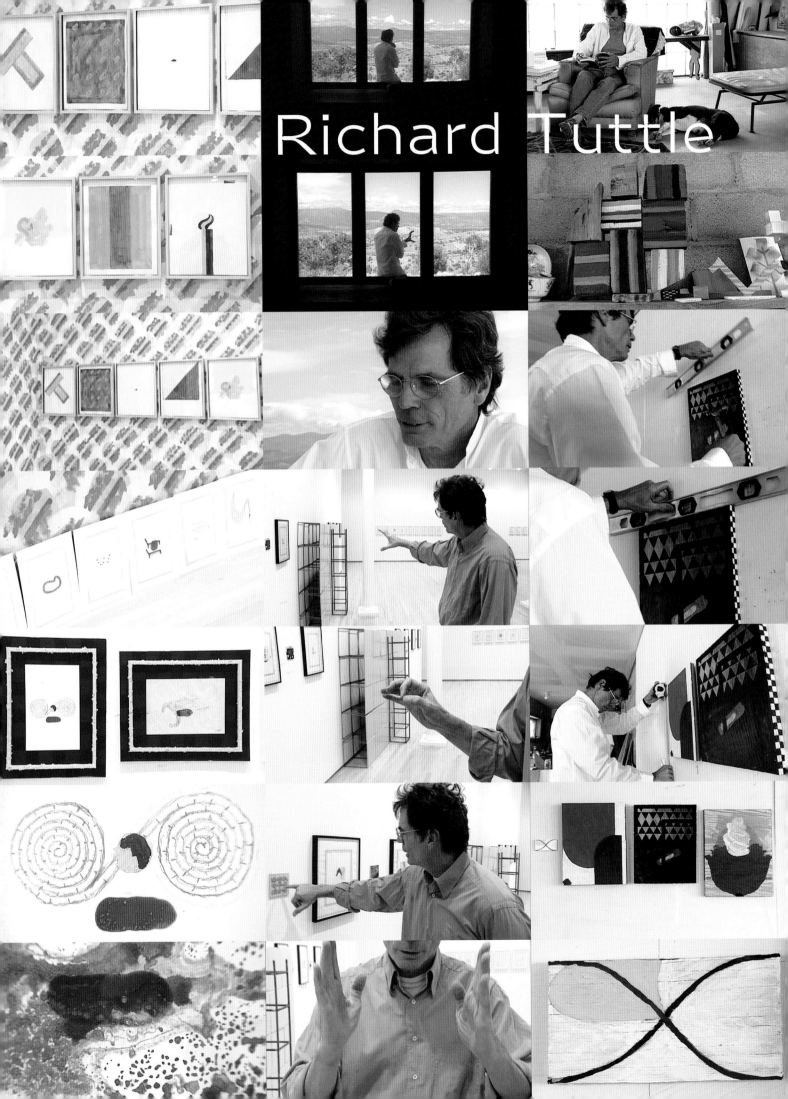

Richard Tuttle

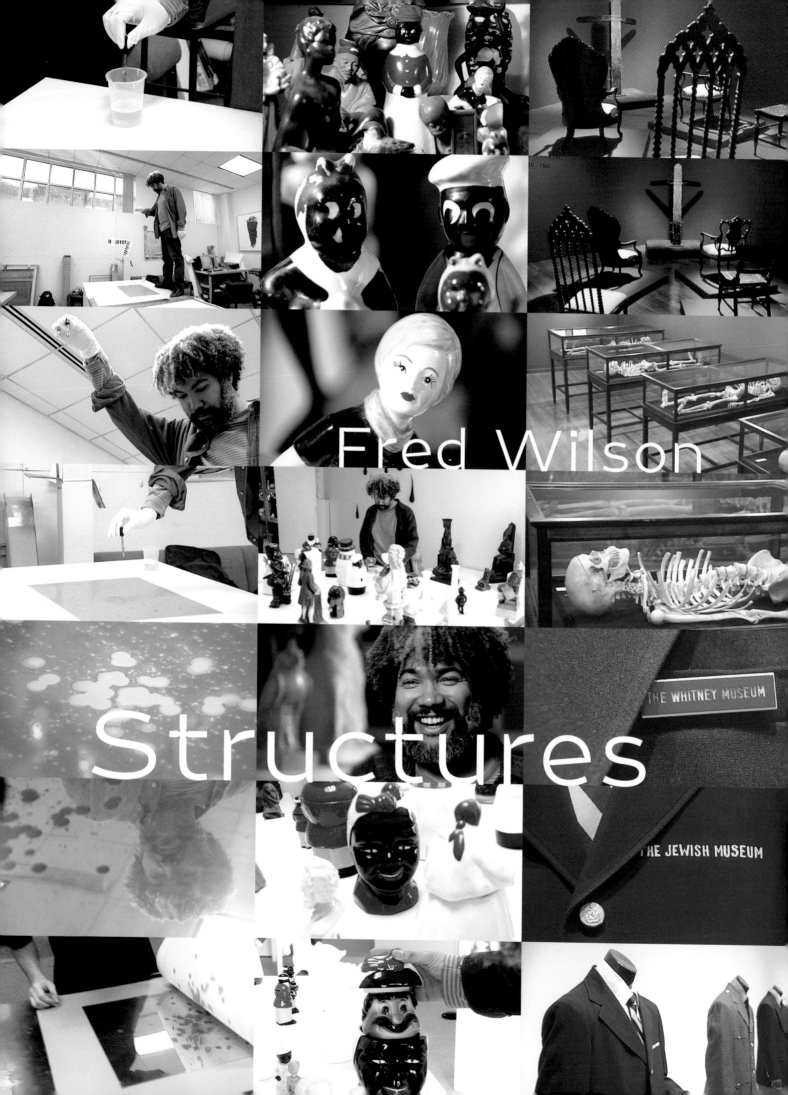

Fred Wilson

Structures

THE WHITNEY MUSEUM

THE JEWISH MUSEUM

Roni Horn

I often get questions about text pieces like the *Key and Cues* (1994). This type of work, where you're supposedly in this visual realm and all of a sudden there is text, is not easy for a lot of people. I think of text as visual—but that, I think, is oddly Jewish. When you are brought up with the graven image as forbidden, because the graven image is a metaphor for a visualization, then it's absolutely primary that language would replace that role. I never questioned it. It was only when I was asked about language in my work, in the finished object, that it became clear to me from a conscious level. I never really distinguished between symbolic visual 'language' versus descriptive visual 'photograph'. My relationship to my work is extremely verbal, extremely language-based. I am probably more language-based than I am visual, and I move through language to arrive at the visual. So I've always questioned whether I am really a visual artist. You get into this situation where your 'identity' takes over your actual being because you get stuck with whatever it is you *resemble* to other people—not who you are. They're not necessarily the same thing. . . .

There's so much written about titles. I don't like descriptive titles. I don't like titles that if you don't read them you don't get the piece. I want a title that can be an entrance to something but never an explanation. A title is more about staying away from certain things, but sort of showing you an entrance without naming it. . . .

Pictures of words. I don't really think of them as visualizing the content of the word, necessarily, or the meaning of the word. It was just *gurgles, sucks, echoes*—but a little bit about holding on to that phrase in my life. Every time I use that phrase it's like eating, like savoring something.

Roni Horn

So XII, 1998
Pigment and varnish on paper,
37½ x 50³⁄₁₆ inches
Donald L. Bryant, Jr. Family Trust

There's 'drawing' as a verb and 'drawing' as a noun. They're both interesting. It's just that the noun is a little bit more limited because it specifies a form, and the act doesn't. So the object-drawings are more traditional. And that's an important body of work—but it's much more about my relationship to drawing. Whereas everything else I do is more about the viewer's relationship to the work. I draw in all of my activities, whether it's sculpture, photography, or installations. Drawing—most of the definitions are verbs. To take aim. To metamorphose. To translate. To extract. To draw. So I'm using that word in all of those meanings, and it really applies to everything I do. If you asked me what I spend most of my time doing it would be drawing, but it wouldn't necessarily result in a picture. The actual act of doing those things is kind of a primer for what I do with all this other work. The technique is very much one of composing. It's a very elaborate process which I've been doing for so long. But I tend to work with groups of similar images that I've actually drawn on separate pieces of paper. And then I compose them into one thing—reconstruct them or recompose them. Relate them.

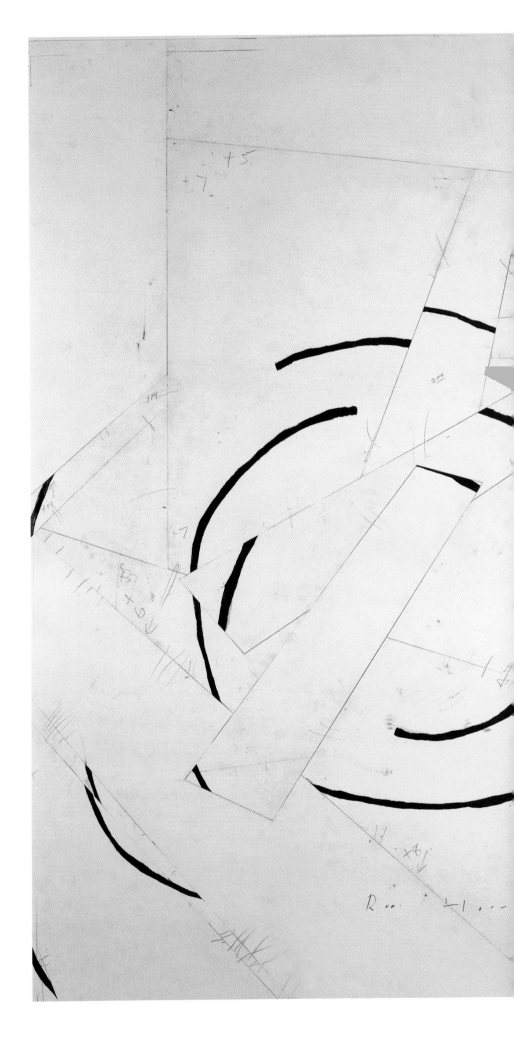

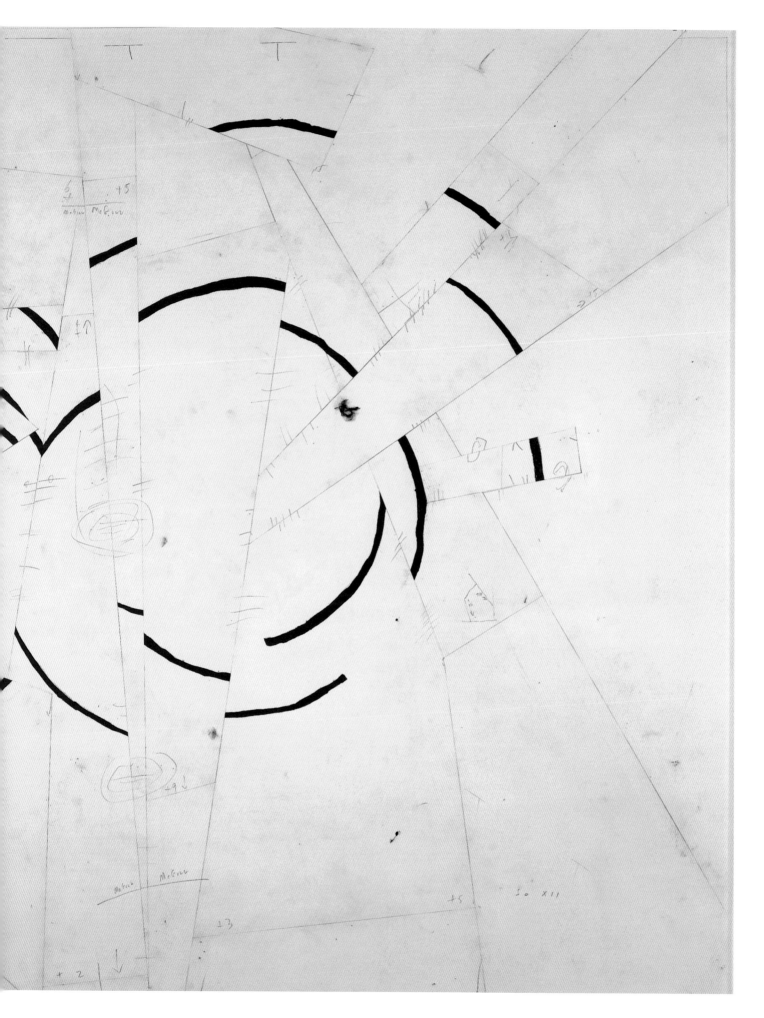

Roni Horn

Aside from the physical, sensual reality of water, the thing that I love is its paradoxical nature. Water is attractive for so many reasons. The light is part of it . . . but the Thames has this incredible moodiness, and that's what the camera picks up. I never intended to have water in everything I do but I almost feel like I rediscover it again and again. It just finds its way back into new work.

Doubt By Water (2003–04) is a form that I've been thinking about for a while. It starts with a two-faced image. That's the core of the work . . . getting a two-faced image (which is more or less like an object) into a meaningful relationship to the space or the setting, so I developed this form with the stanchions to give the two-faced image a place. It was an interesting kind of balance to hold so many pieces together while dispersing them throughout an architectural setting. The river, the glacial water, which is the gray surface, is a kind of cohesive link. I think that image, or that way of shooting water, was influenced by *Some Thames*

(2000) where you just kind of get the surface of the water, its relationship to the weather and light. Then the other side was various motifs that have occurred in different forms in other works. One is the young person—a kind of a portrait—and repetition with a slightly different nuance throughout a space. And you've got the ice, the birds.

I always think of the work in terms of drawing, and there's definitely a drawing element in putting together these visual relationships and composing these objects in a space. It's the many layers of relation that can make the work effective. . . . When you see *Doubt By Water* as a group, it's operating as an object. But as you use it to pull someone through space, it functions more like an image, an icon. So the piece flickers between a three-dimensional experience and a kind of two-dimensional image. I really wouldn't know how to describe what this work is. But it has a particular way of moving the viewer through space and through image space at the same time.

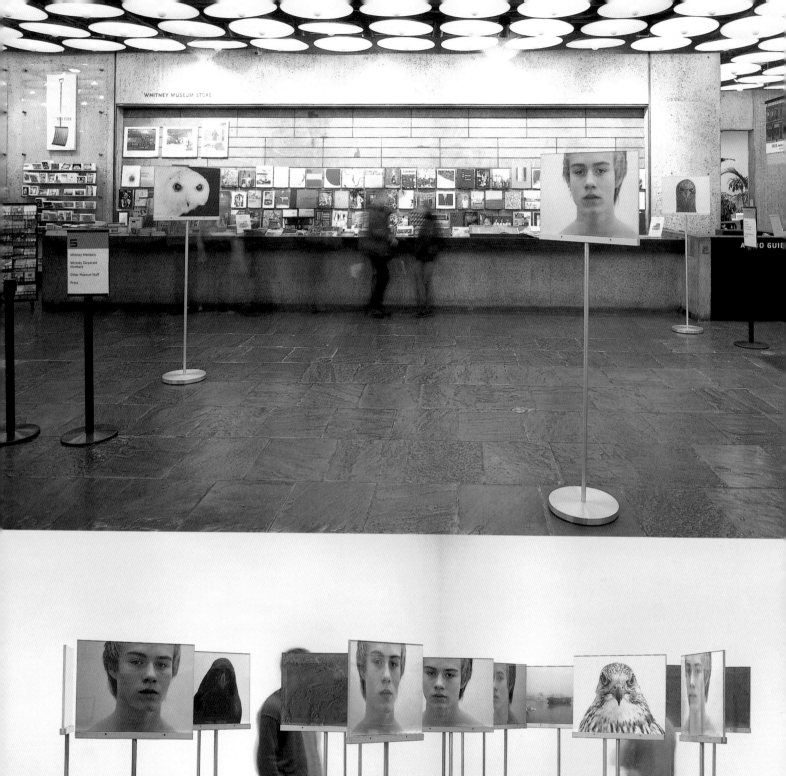
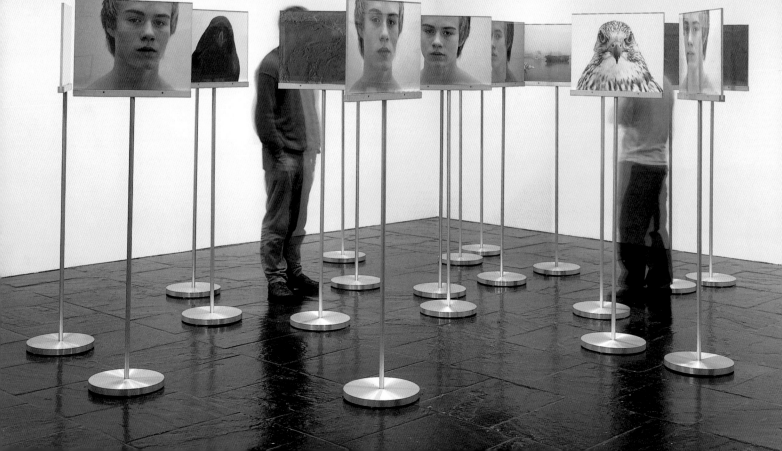

What I like about photographic installation —and I think that what I do with photographic work is informed by having been a sculptor, meaning someone who works in the actual—is that you're working with the image which is the opposite of the actual. You're working with the thing that you can peel off and still have the actual. That idea of image introduced into the actual was part of what I was questioning. *You Are the Weather* (1994–95), which is a photographic surround, is definitely connected or linked up with the architecture—more or less synonymous with it—because it goes on all four walls. You walk in and you're surrounded by a hundred images . . . which are one portrait of a person who is a multitude. The viewer's relationship to the portrait is erotic, perhaps because of the eye contact and the ambiguity, and in my

mind the ambiguity is very much about the viewer—about what the viewer wants from the subject.

When I do a portrait, mutual trust is important . . . so the person you're working with trusts that the image is fluent with who she or he is. There's a story about Georgia that hits the nail on the head for me. She had seen *You Are the Weather* as a kid. I asked if I could photograph her. She was maybe five or six years old. She said, "Oh, Roni, you can take pictures but you can't show them."

I thought, "Wow, that's interesting." I let it go. And a couple of years later she said, "Okay, Roni, you can." I really just recorded her in action, a girl becoming a woman, trying on identities. That was very much her energy. It wasn't orchestrated.

Roni Horn

BELOW
You are the Weather, 1994–95
100 color photographs and gelatin silver prints, 10 7/16 x 8 7/16 inches each
Installation view at Matthew Marks Gallery, New York
Private collection, Seattle, Washington

OPPOSITE AND VERSO
This is Me, This is You, 1997–2000
96 C-prints (installed on two walls with 48 images on each wall), 13 x 10 3/4 inches each
One member of each of the 48 pairs is composed into one of two complementary panels of individually framed images. Each panel is placed on opposite walls or from room to room. Overall size of each panel is approximately 11 x 9 feet

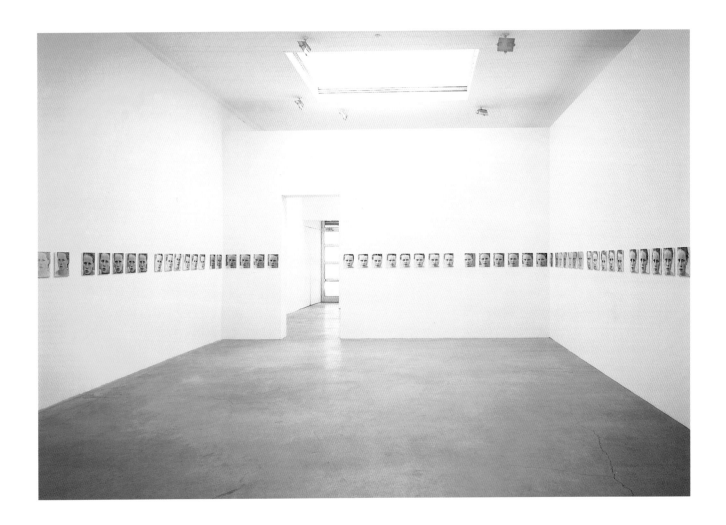

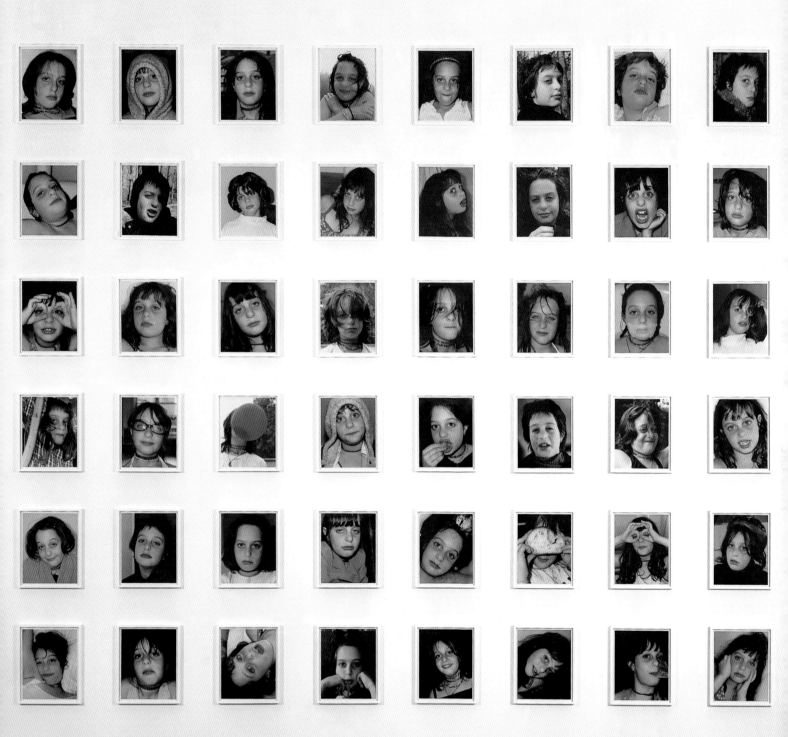

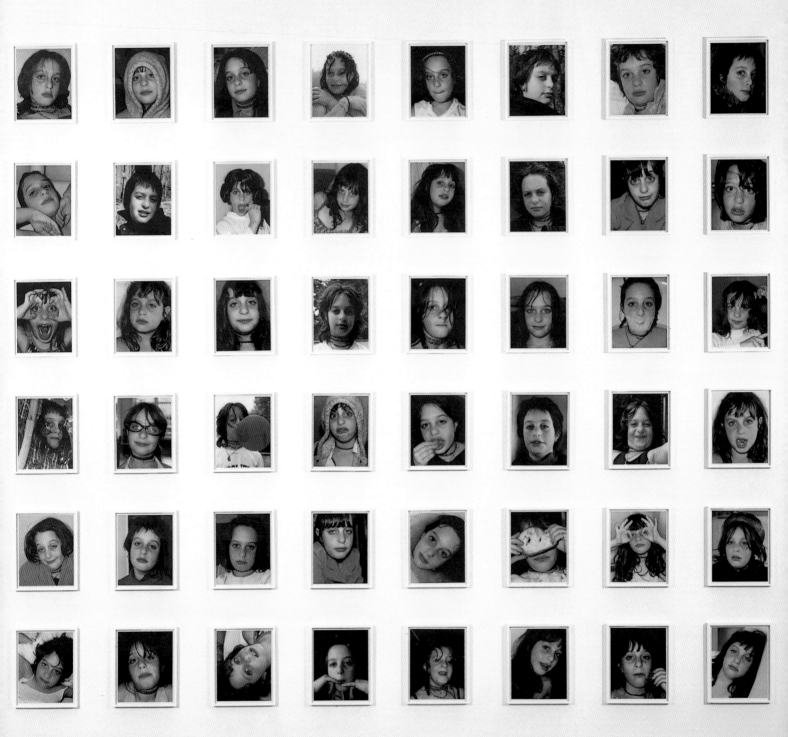

Roni Horn

BELOW, LEFT
Untitled (Yes), White, 2000
Cast optical glass, 18 x 46 x 26½ inches,
2367 lbs

BELOW, RIGHT
Untitled (Yes), Black, 2000
Cast optical glass, 18 x 46 x 26½ inches,
2367 lbs

One of the underlying interests of my work is to equate the experience of it with the content. That's kind of a leveling of difference between conceptual and formal. I use both these languages as essential parts of a whole. By formal, I don't mean stripes and squares—I mean how a thing exists in the world. And that's really important to me in terms of how a work relates itself to what is out there, whether it's the room or the person in front of it, or the circumstance more broadly. The formal aspect is a very small part of the palette. I don't think a box is a box is a box. You *know* it's a box. But you want to *talk* about it as a box? That's not interesting to me. I don't want to forsake certain languages or appear-ances because they're not popular—or they're seen as minimalistic—that's the viewer's problem, not mine. For me, it just increases my options.

It's like the androgyny issue. If you mistake me as a guy or you mistake me as a woman, that's your problem, not mine. So it's the same thing with geometry in a funny way—because if you want to take every box and reduce it to a formalist act, I would say that you're missing the potential of things in a big way.

People look so rarely with any critical sense; very few are actually aware of what they're looking at. But knowing, being aware, qualifies the experience in a different way. Whether you're articulate about it or not is irrelevant.

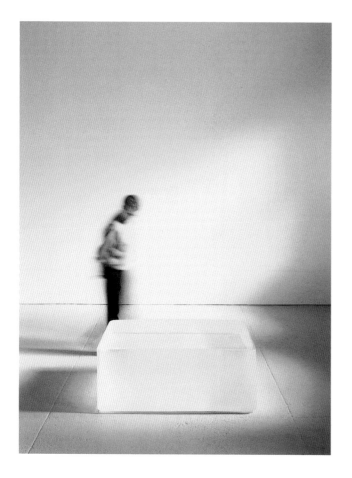

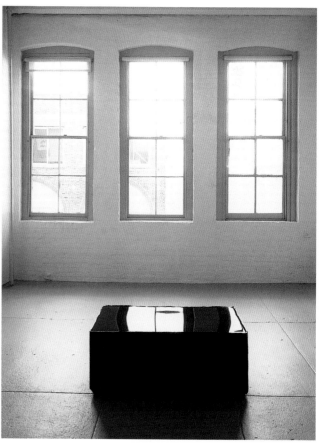

Roni Horn

ABOVE
Gold Mats, Paired (For Ross and Felix), 1995
Pure gold (99.99%), two parts:
49 x 60 x .008 inches each
The Art Institute of Chicago. Chicago, Illinois

OPPOSITE
Asphere, 1986–93
Solid copper, 12 inches x variable diameter

Pure gold. What you gather from the look of it is its relationship to light. It's not phenomenological; it's empirical. It's doing something that the gold most people have seen doesn't do, either because it's gold leaf (which has no object integrity) or carat gold (which even in purest form is alloyed with impurities that take away from its 'goldness'). So— the only point to have something with such purity is that it's the only way this object could exist. It needed that degree of purity to weld it to itself. It's soft and malleable in its purest state. And in its relationship to light are all of the mythological aspects of gold. And that's all in the experience. I'm telling you . . . if a gold mat was lying on the floor now, it would be like having the sun here. It literally was for me when I put the piece together. I had no idea what splendor was. But when I saw it, I got it. It was really like fire. I was shocked by it. When I arrived at this version, *Gold Mats, Paired (For Ross and Felix)* (1995), where you put one mat on top of the other and then get the fire . . . there was no *affect.* It was there.

I think of *Asphere* (1986–93) as a self-portrait. I don't think I made it as a self-portrait, but when I look at it I see that it has characteristics that I identify with strongly. One of those qualities is that it's not a sphere, and it's nothing else. I can relate to that. It's not an egg or a ball. It doesn't have a name or a word that closes it off from things. In the best way, it's just floating out there without a clear identity. Of course people will say, "Oh, it's like an egg." But the point is that you use metaphor to make yourself feel at home in the world. You use metaphor to extinguish the unknown. And for me the problem is that the unknown is where I want to be. I don't want it extinguished. So that's where I try to fit the experience of a lot of my work— on that edge where the metaphors start falling apart or don't really come together.

Matthew Ritchie

My work deals very explicitly with the idea of information being on the surface. And in a way, information is the subject of my work. So for people who are accustomed to thinking about visual art as purely visual . . . this is a source of friction. You can always analyze visual art in terms of content or appearance. It's a game to separate them; they're indissolubly linked. Everything in the material world around us has a narrative. To classify visual art as the one medium that shouldn't require effort to understand—to just be able to look at it as pure sensation and walk away— relegates it to the level of a rollercoaster ride. I'm saying, "Open your eyes and enjoy the ride!" Because it's much more exciting if you are thinking and questioning and you don't know what it is—and it's full of questions and statements that you can't possibly grasp. That is a truer reflection of just how extraordinary reality is than something that neatly ties it up in a bow, like, "Look at that; be at peace; go home." I'm more interested in something that leaves you asking questions.

How do you keep things going while allowing them to change? Drawing is very central to the way I work because it can be blown up, taken apart, given to another person to execute, put into a computer, eaten by the computer, spit out by the computer, redrawn as if the computer had thought of your drawing in the first place, shrunk back down to a tiny sketch, turned into a digital game. You can just keep on pushing it, like this infinite machine, which is very hard to do with almost anything else. Even with a painting. A painting becomes a very static fixed thing, like a miniature part of the world, when you're done. But you can make a drawing three-dimensional. You can make it flat. You can turn it into a sphere. You can just keep pushing it and pushing it: all it is, is information. It's just a bunch of marks. Once you understand it as this thing, it becomes very easy to think of it as a material rather than as a precious object.

BELOW
The Essential Diagrams, 2002
1 of 12 vinyl decals, dimensions variable

OPPOSITE
The Lytic Circus, 2004
Installation view at São Paulo
Bienale XXVI, São Paulo, Brazil
Mixed media, dimensions vary
with installation

Matthew Ritchie

RIGHT
The Lytic Circus, 2004
Installation view at São Paulo
Bienale XXVI, São Paulo, Brazil
Mixed media, dimensions vary
with installation

OPPOSITE
The Dead: Belphegor, 2004
Ink and graphite on Denril,
54 x 36 inches

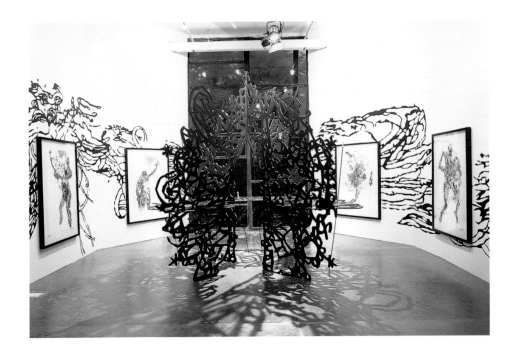

I start with a collection of ideas . . . and I draw out all these different motifs, and then I lay them on top of each other. So I have piles of semi-transparent drawings all layered on top of each other in my studio and they form a kind of tunnel of information. Out of that, you can pull this form that turns into the sculpture or the painting. It's literally like pulling the narrative out of overlaying all of the structures. That's how I end up with this structure. It's derived from a series of drawings that I scan into the computer and refine through various processes . . . and send to the sheet-metal shop down the road where it's cut out of metal and assembled into larger structures which are too big for my studio.

The Universal Cell is part of *The Lytic Circus* (2004). The São Paulo Bienale asked me to do a piece, and this was really the only thing I wanted to make. I was wrapping up this project that I've been working on for seven or eight years—a kind of narrative that, collectively, is an encyclopedia of information, a manual of how to deal with information (all the information you could possibly take on). And as I worked through it (I dealt with physics, gambling, religion, thermodynamics), I kept postponing dealing with evil. One of the things that became really clear to me was that as a culture we've defined evil in one particular way which is why we build structures to contain it. No matter what bad thing you've done, you go to jail. Every crime

has the same punishment. And I was thinking about that and then, in a larger sense, how the context of information defines everything. So in a way each of us is in our own prison. You bring it with you—the prison of your biology, your social structure, your life. And that is both a challenge and an opportunity. So I wanted to build a structure that felt like a cell, your cell in the whole universe. If the universe is a prison, this is your cell—this is where you're standing and you drag it with you wherever you go.

I was thinking about the idea of the cell. In biology, it's the sacred unit of measurement; the whole body's built out of the cell. And the thing that ruptures the cell is a virus that escapes. The name of that process is *lysis* (thus, 'lytic' in the work's title). So when a cell is ruptured by a virus building up inside it's burst open. And I kept thinking of this as a kind of a prison escape. . . . And then there was another motif that I'd been working with for a long time—structures derived from ceremonial magic—ritual mechanisms (originally designed in the seventeenth and eighteenth centuries to allow people to get out of their bodies for astral projection) that ended up being incorporated to some extent into voodoo, another interest of mine.

And there was this idea again! How do you escape the pattern that's imposed on you by the physical order of the universe? How do you make the imaginative leap?

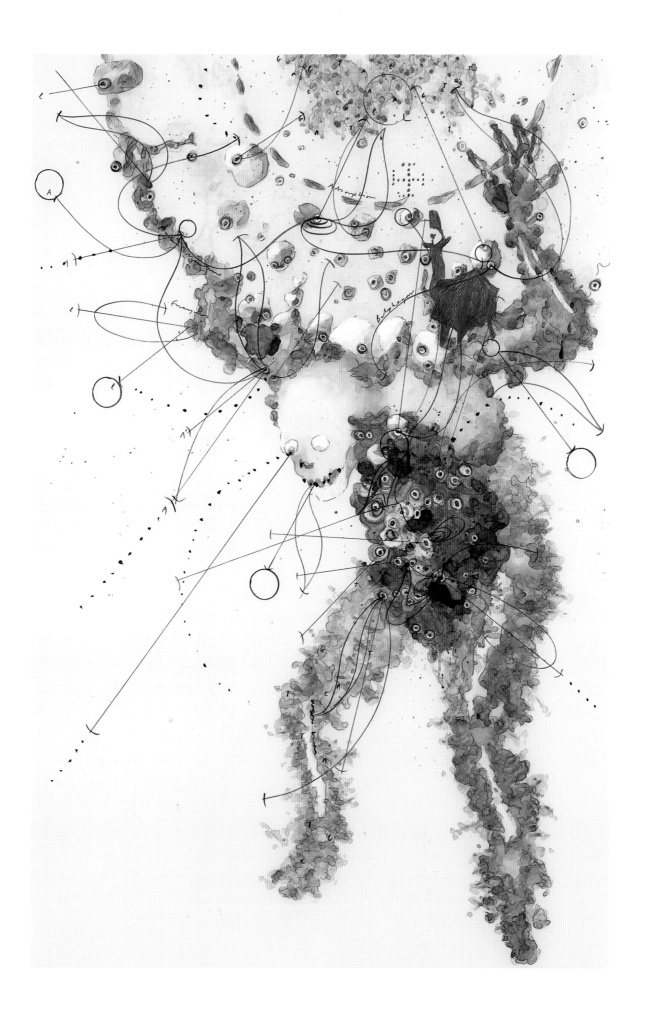

Matthew Ritchie

BELOW
Installation view: *Proposition Player*, 2003
Contemporary Arts Museum, Houston,
Texas, 2003–04

OPPOSITE
Proposition Player, 2003
Powdercoated aluminum, Minicel foam,
rubber, adhesive, electronic components,
one pair cast resin dice, and custom-
designed deck of playing cards,
42 x 98 x 42 inches

I've been working for a long time on this series of linked projects that deals with a group of properties, 49 properties or characteristics. Each of the properties or characteristics represents a function of the universe. *Proposition Player* (2003) was a gathering of a large group of those characteristics, fusing them into one project. But it left some of them out, and the ones that got left out were in *The Lytic Circus* at the São Paulo Bienal. *Proposition Player* is all about gambling and quantum mechanics, the elements of chance and risk, and how those things build into an entire continuum of meaning. *The Lytic Circus* is about what happens to the unacceptable elements of risk, the ones that you want to exclude to keep the bad out.

The slogan of *Proposition Player* was *you may already be a winner*. It's about the idea that in the moment between placing your bet and the result of the bet there is a kind of infinite freedom because all the possibilities are there. You *may* already be a winner. It's fantastic—you're like a god! Everything opens up. *Lytic Circus* is really about the opposite—a kind of prison of life where no risk is ever really rewarded. You're trapped in a set of circumstances that are biological, temporal, physical, mental—locked in to a point of view. It's about the idea that you may already be a loser—just as true as the statement that you may already be a winner. . . . So the illusion of risk, of gambling, is all that you have. But in fact it's just a circus. So *Proposition Player* and *The Lytic Circus* are like counterbalances—the utopian versus the dystopian—it's always sunny, or it's always raining. In fact, you know most likely every day's going to have a little bit of both.

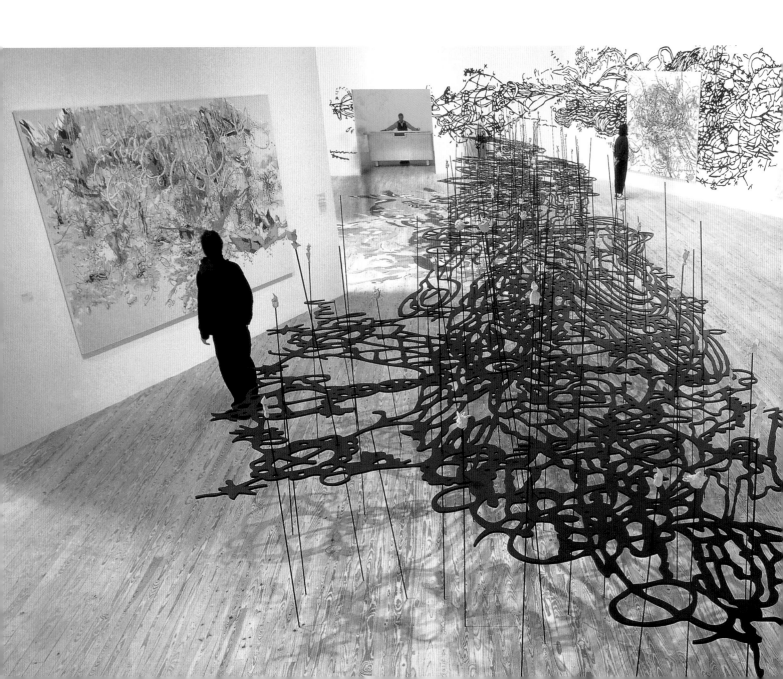

You've got a card, you take it in, you give it to a guard, and he'll let you play the game of chance—the dice game—which is also called *Proposition Player*. . . . The game builds up into all of the elements in the paintings, which take you through this narrative that describes the evolution of the entire universe. You've started out as the smallest element, and gradually you see how essential that particle is to everything else. This is literally a little way of representing you in a giant game. Come in. Put your card on the table and play. It's really just taking the traditional aspect of confronting large complex ideas about the universe—which is one of awe—and inverting it to one of play. You already own this—your body is already filled and saturated with every single thing going on in the universe . . . so you may as well enjoy it. You don't need to live in fear and shame about your relationship to this larger structure. It should be about joyous participation!

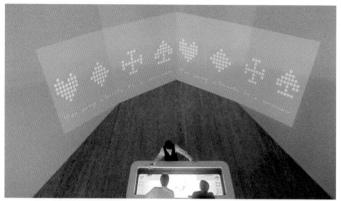

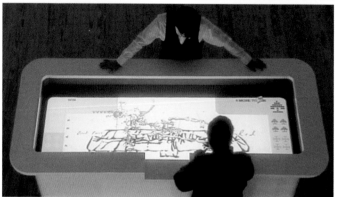

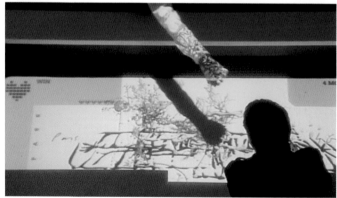

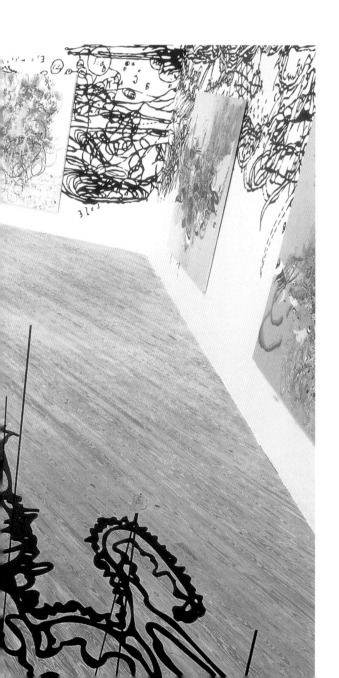

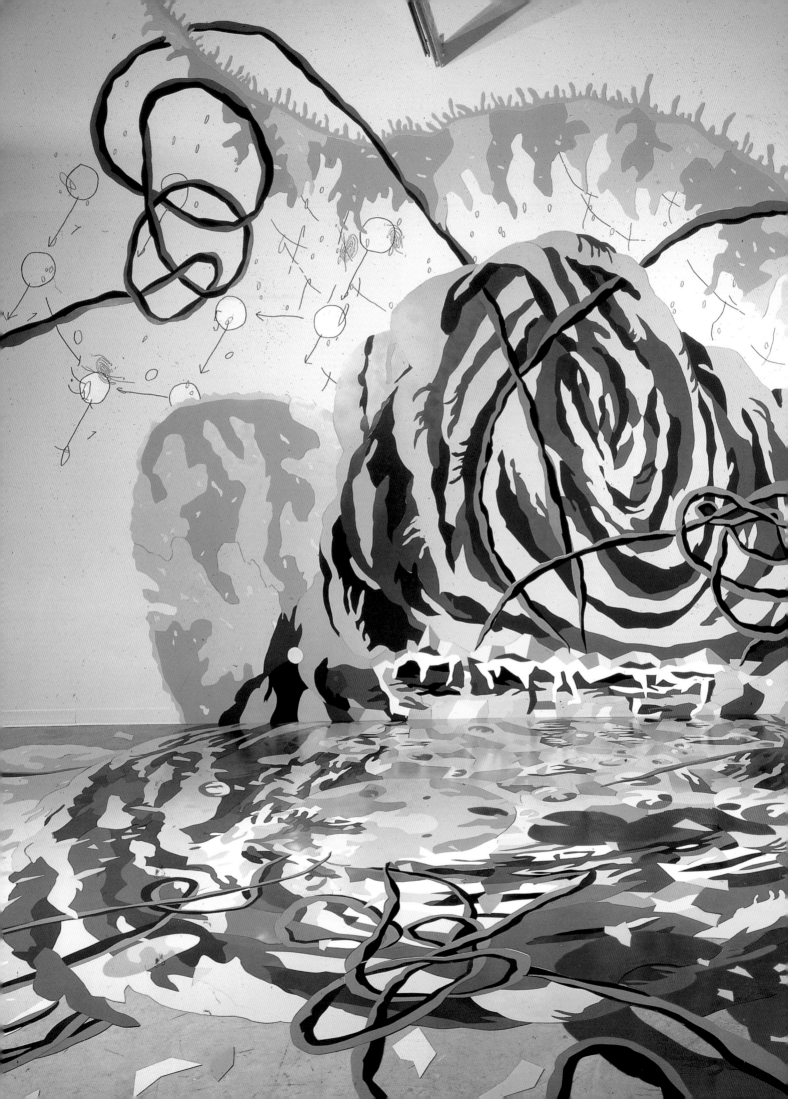

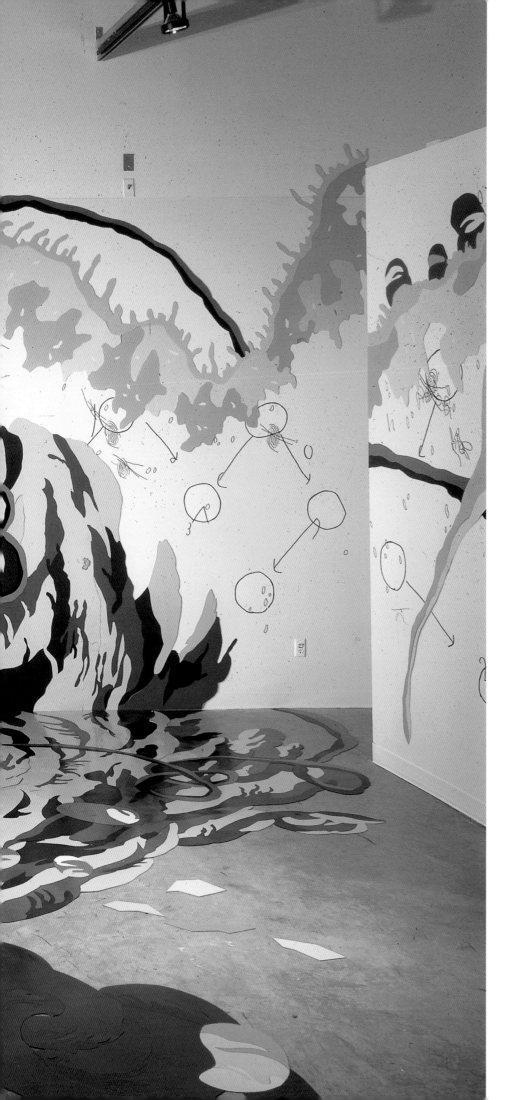

Matthew Ritchie

The Fast Set, 2000
Installation view at the Museum of
Contemporary Art, North Miami, Florida, 2000

Even the elements of my work that seem
the most outrageous or exaggerated are all
derived from moments in human history
when people passionately believed in
angels, or goblins, or demons that would
come up out of the ground to consume
you, or creatures of fire that walked the
earth to level your temple. . . . Times
when people died, in the millions, protect-
ing a completely abstract idea (based on
what they would have thought of as a
theological premise) which was really an
argument about how the universe worked.

I use the symbol of the straight line a
lot in my drawings and paintings. It usually
represents a kind of wound, or a direction.
The curved line is like a linking gesture
that joins things. But the straight line is
usually more like an arrow, or rein, or a
kind of rupture. You have the linear idea
of forward motion. It reminds me of St.
Sebastian. Whenever you see an arrow or
spear in painting, it's always much more
damaging than it is constructive, whereas
the looping sort of curved line is much
more generous and inclusive. Often, in my
drawings and paintings, you'll see figures
being pierced by multiple fates that are
sort of embodied in the lines. It's like the
lines in your destiny. Who would want a
straight-line destiny? It'd be rotten, right?

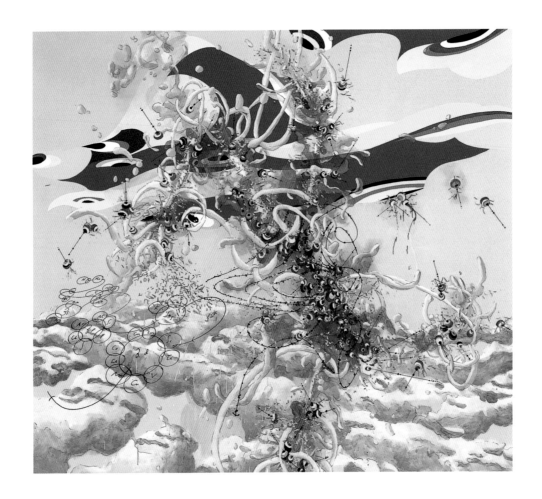

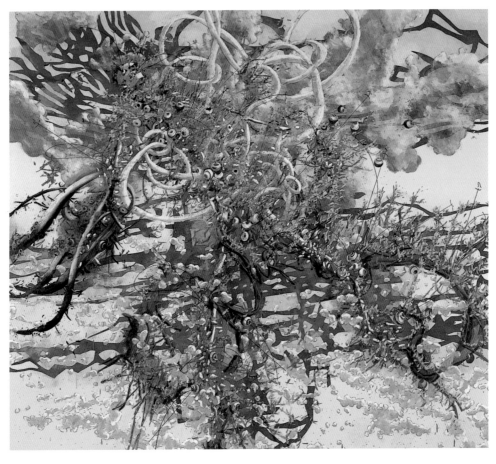

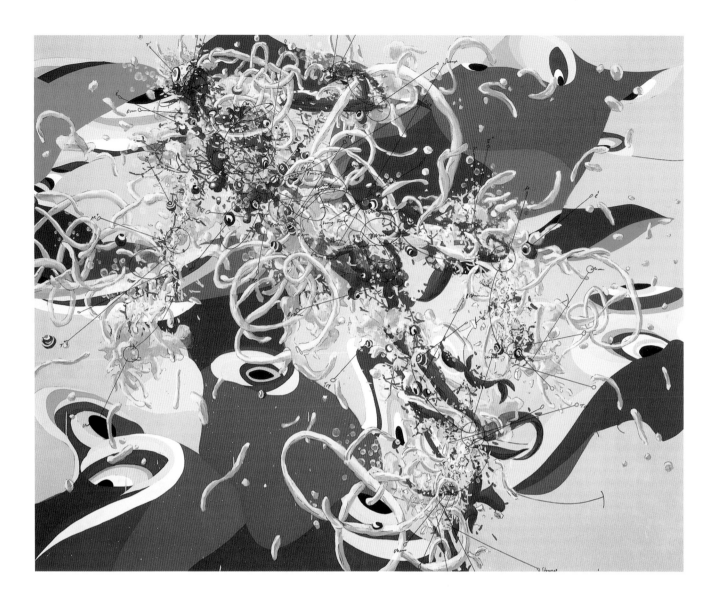

A few years ago somebody asked me, "When did you go figurative?" There's this sort of ridiculous idea, it's a very silly idea left over from the twentieth century, that abstraction and figuration are legitimate poles. I've incorporated the two things from the very start and been fascinated by the idea that there is really no distinction. It's just a question of scale. Then in the last couple of years from my last show in New York, which was after 9/11, I got drawn more to the figurative pole in the work and to this idea, I guess, of being a sort of representation presence in the work. And these figures started to emerge. Before, they had been typically more abstract in the paintings, more present in the drawings. They got very present in the drawings, as you can see now. And they're still in the paintings, a little more abstracted, but they're very much there.

It was something about this moment of incredible abstraction. If you were in New York at the time you know there was this incredible smell—this awful, awful smell—because it was just a giant bonfire of everything that was in the buildings. And you sort of felt in a strange way that the towers had become part of the whole city because, you know, odor is particulate. When you smell something, you're breathing in the actual material. It's not like a radio wave; it's actually entering your body. And we were all breathing in this terrible thing and it became part of us. And so I started to make these paintings and drawings about figures being reassembled and rebuilt inside the people that had survived.

Matthew Ritchie

OPPOSITE, ABOVE
A Glorious Martyrdom Awaits Us All at the Hands of Our Tender and Merciful God, 2003
Oil and marker on canvas, 88 x 99 inches

OPPOSITE, BELOW
The Living Will, 2004
Oil and marker on canvas, 88 x 99 inches

ABOVE
Self-Portrait in 2064, 2003
Oil and marker on canvas, 80 x 100 inches

FOLLOWING SPREAD
No Sign of the World, 2004
Oil and marker on canvas, 99 x 154 inches

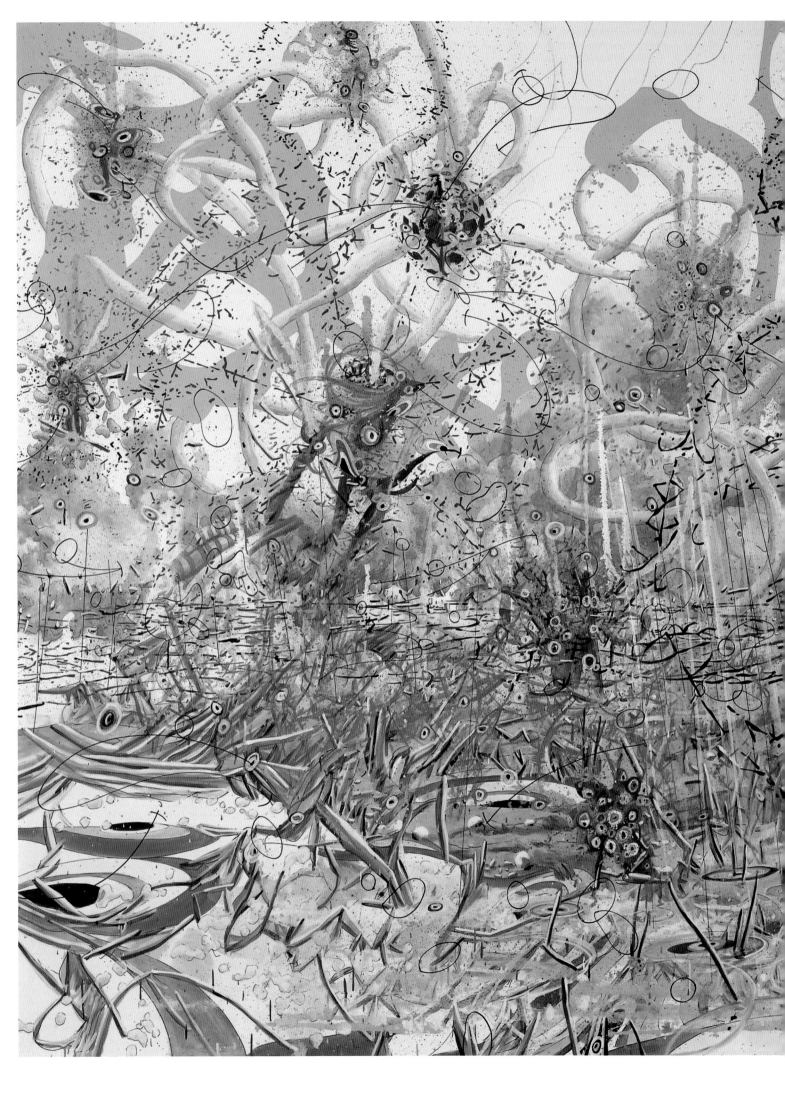

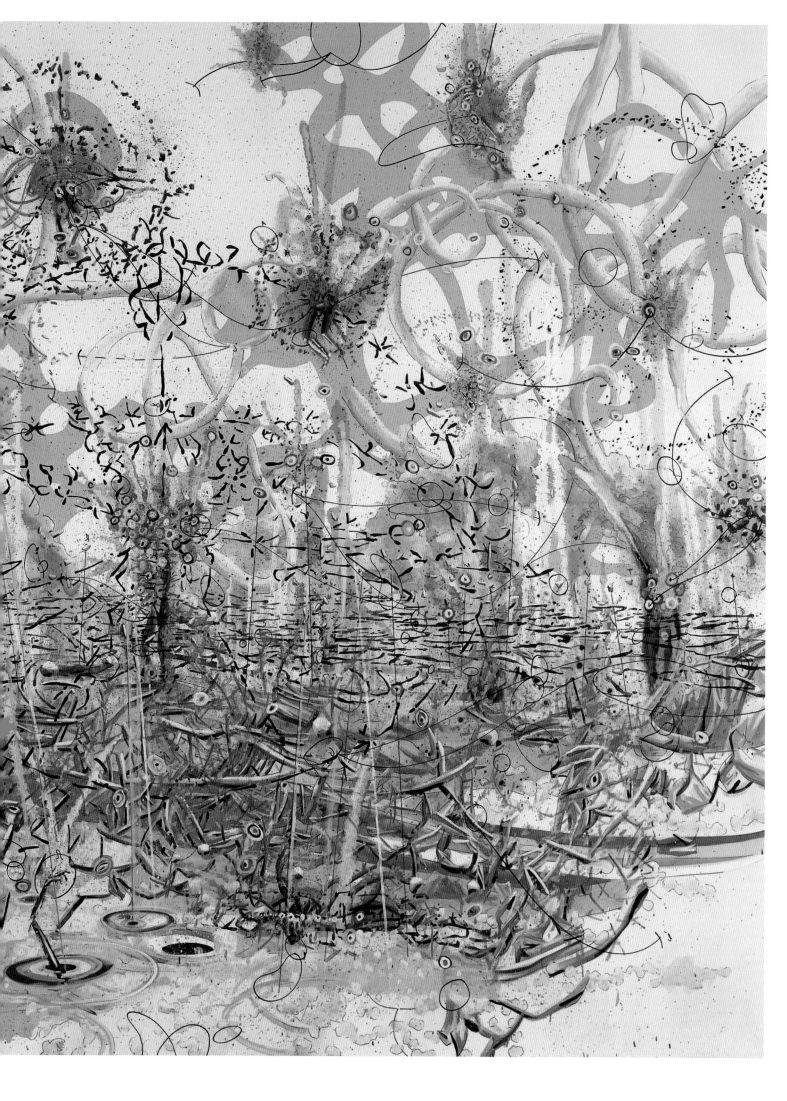

Richard Tuttle

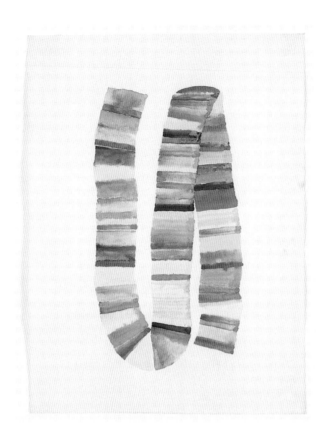

Before I went to kindergarten I really wanted to be an artist. Not that I knew what being an artist was, but on the first day of kindergarten the teacher handed out the paper and the colored crayons. And I just connected in my brain that this was the first day of my life, and that going to school was the start of everything that was important to me. I remember the drawing to this moment. I took a pencil and I just made this horizon line, and then I took the colored pencils and I made a rainbow there. And that was my drawing. I looked over and I saw that the other kindergarteners were doing their sun with the rays of the sun and drawing their flowers from the bottom of the page and all of that. And I knew that my drawing was more, say, advanced or sophisticated, but I also knew that I had lost a kind of innocence—irretrievably—that they still retained. And so I was a little bit pushed back in a state of confusion. Then, when the teacher collected the drawings, mine was not put up as one that was highly valued. I had to adjust to that, and of course I did, but my respect for the teacher was forever erased. But the story goes on. When I had my first show at the Betty Parsons Gallery when I was 23 or so, I looked over on the wall at one of my pieces, and it was kind of the same rainbow which the graphite line had changed into. It was a big, startling moment to me because that really *was* the first day of my life and quite a way from kindergarten, which I had mistakenly thought was the first day, to my show in a New York gallery.

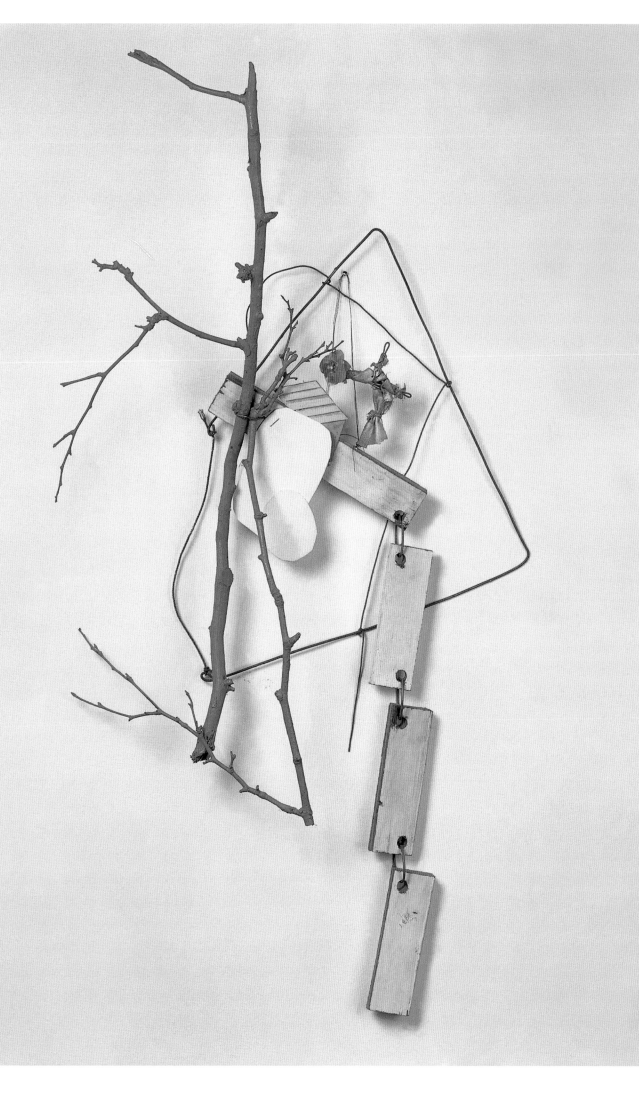

I was doing white paper octagonals on a wall at a museum in Dallas. And the critic came along and made mock introductions, "Oh, this is Richard Tuttle. He's interested in impermanence in the arts." And she said that to Betty Parsons, and Betty just immediately snapped back, "What's more permanent than the invisible?" It fits in with the whole line that in any art form there has to be an accounting of its opposite condition. If you're going to be a visual artist, then there has to be something in the work that accounts for the possibility of the invisible, the opposite of the visual experience. That's why it's not like a table or a car or something. I think that that might even be hard for people because most of our visual experiences are of tables. It has no business being anything else but a table. But a painting or a sculpture really exists somewhere between itself, what it is, and what it is not—you know, the very thing. And how the artist engineers or manages that is the question.

My beginnings were with the abstract expressionists. Part of this artistic breakthrough, which perhaps I have some historical sensitivity to, means that in the making and the critiquing there is all of life and there has to be all of life because if you don't have all of life, then how can you make anything that really has importance? But I also abhor anything that reduces the scope of art. There's a division left over from the twentieth century where certain people might think that art is something that is made outside of any personal expression (Josef Albers or the Bauhaus), that it's really coolly detached. And then there's the other side, where art is full of personal expression. I guess the personal expression side is great—but then you can get an art which is just an expression of some twisted personal idiosyncrasy. In order to get over those polarities between no personal expression and personal expression, the only possible expression is one of some sort of sublimation. . . .

Richard Tuttle

ABOVE
1st Wire Bridge, 1971
Florist wire, nails, 37½ x 38½ overall
The Rachofsky Collection, Dallas, Texas

OPPOSITE
1st Paper Octagonal, 1970
Bond paper and wheat paste,
53½ x 59 inches overall
Collection of the artist

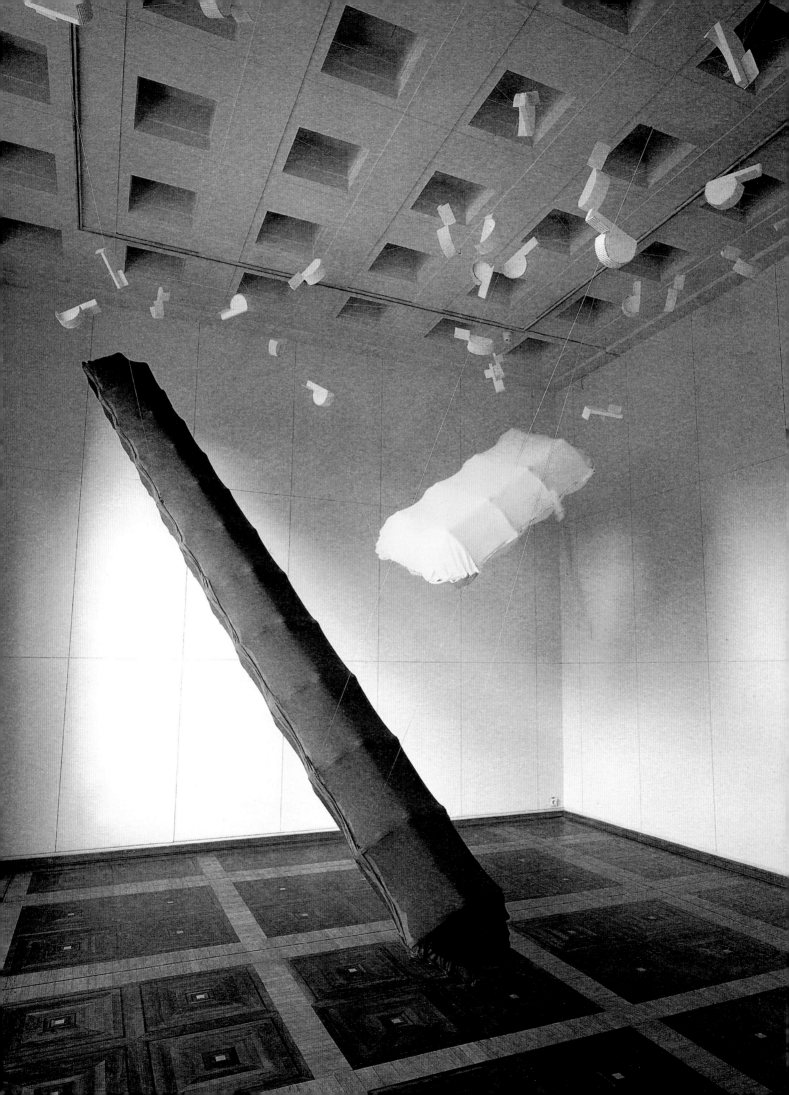

Richard Tuttle

A kind of strange part of my work is that
one instant is the same as all time, all
eternity: microcosm, macrocosm. One of
my favorite artists is Jan van Eyck who
gives you a picture that satisfies all atten-
tiveness to the smallest of the small and
all attentiveness to the largest of the large.
That's one of the things that a picture is
supposed to do for us. Ultimately, you
have to come to that flash instant which
is almost un-measurably short and then
un-measurably large.

Richard Tuttle

TOP
Waferboard 3, 1996
Acrylic on waferboard, 20¼ x 26 inches
Collection Marion Boulton Stroud,
Philadelphia, Pennsylvania

CENTER
Warm Brown (92.1.94), 1994
Acrylic on masonite, 14 x 20 inches

BOTTOM
"20 Pearls (8)," 2003
Acrylic on museum board and archival
foam core, 19¾ x 16¼ inches
Collection Byron R. Meyer, San Francisco,
California

OPPOSITE
*There's No Reason a Good Man is
Hard to Find III,* 1988
Chicken wire, wire, wood, plaster, fabric,
spray paint, plastic bucket and enamel,
53¼ x 45 x 30 inches

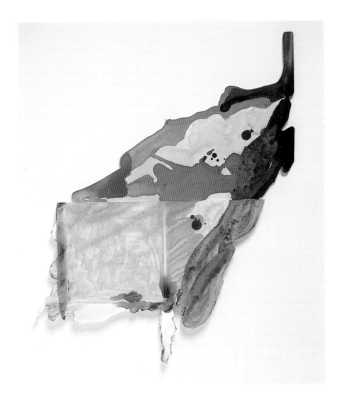

How can someone have sculptural ideas?
I can have an idea how to play a Mozart
sonata; I can have an idea how to make
baked potatoes. But a sculptural idea
is different. It's like a different mind,
where I suppose we dig up some three-
dimensional sense. We have an ability
to step back . . . and we use that third
dimension to take a distance.

There's a side of things where you
can just make yourself crazy following
some idea of what perfection is, but at a
certain moment you remember play—
that this is supposed to be fun. And I
always have this phrase—"If it ain't fun,
it's not alive"—to get a sense to draw
back. There's the form side of things, but
there's also chaos. I think that a sculp-
ture or a real work of art has to be a
truth that has to position us so that the
formal side (when we are trying to be
awake and ordered) is going to tell us
that's how we should be. And it's going
to look poorly upon the chaotic side. . . .
But there's a super sort of awareness
when we can stand back and see that
we ourselves are trying to balance the
chaos and the formal, and that the
chaos is actually good for us and in fact
absolutely necessary to our well-being.

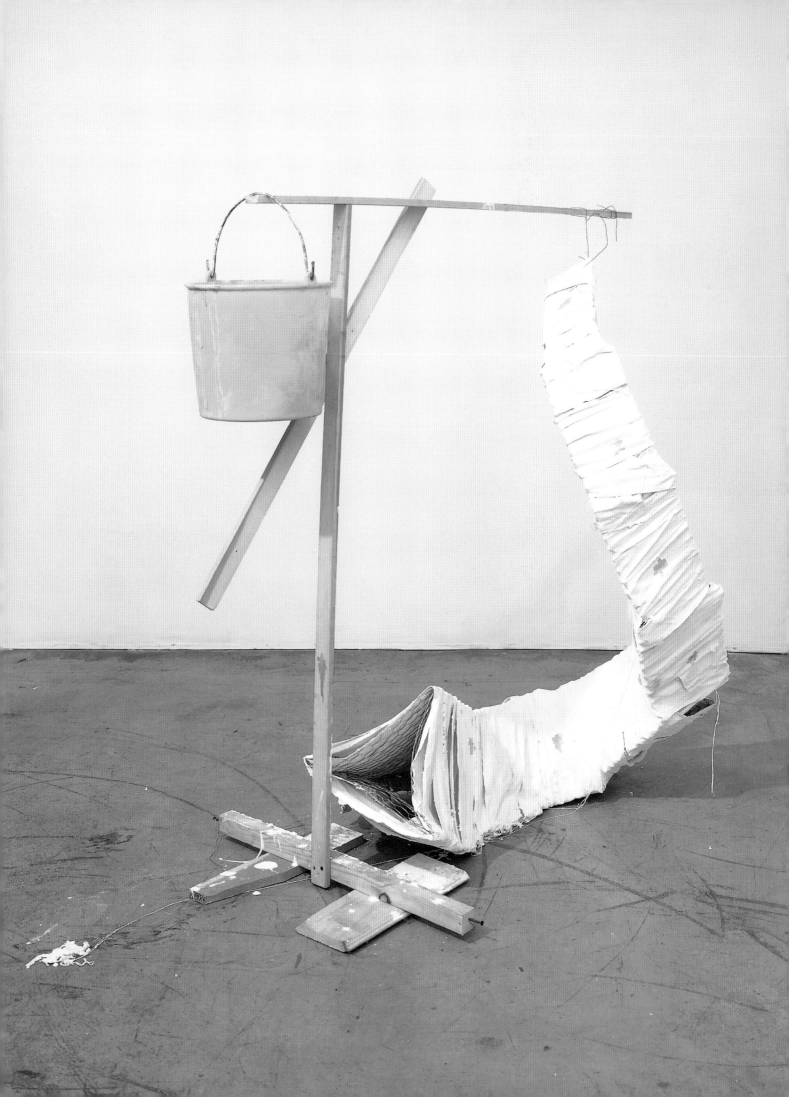

Richard Tuttle

For a show at the Drawing Center in New York in 2004, I divided the space into 'villages', each one with sculpture and drawings. Each set of drawings can be classified as having to do with where the form meets the wall, or where the form meets the floor. For me this is all about illusion, creating an illusion, not creating an illusion, being a victim of an illusion, being free of illusion. And then the piece on the floor has to do with reality and the concrete. In some sense they're both concerned with perception because whereas each *Village* has a particular subject, it's trying to address certain issues about drawing and why we think drawing is what we think it is. And in its component parts, you can look and see which drawing has to do with which issue. . . . We just naturally have come to think that drawing is about what we can *see*. But I think people are just naturally more interested in what they can't see.

One of the first things you see in *Village I* (2003) is that this curve is a certain kind of movement or flow and categorically speaking falls into a type, which we might know because of calligraphy, or from looking at water at the beach, or from the way fabric flows. It's a whole category, and to draw that or to bring that all into one new form is something that this piece is about. And the interest of that particular category is the way it starts and becomes larger and then comes back to smaller. And all the time it's undulating like that, it's also moving in a third dimension. Why that fascinates me is that how to draw something is very often a case of suggesting, stopping, and then letting what has gone before simply complete that. There's an extra little kick at the end there, where you get something that comes out, flows, and doesn't just go to the ground straightaway in a dull way, but has this little kick at the end, like a thoroughbred or a ballerina with an extra little gift.

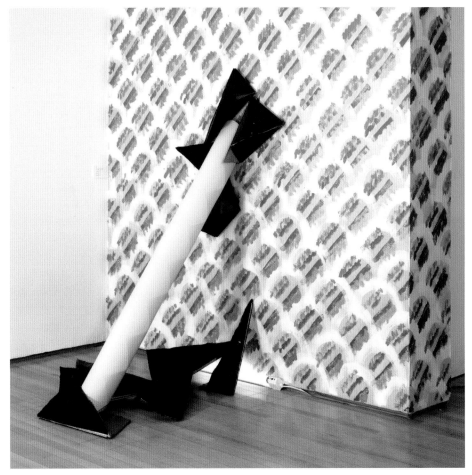

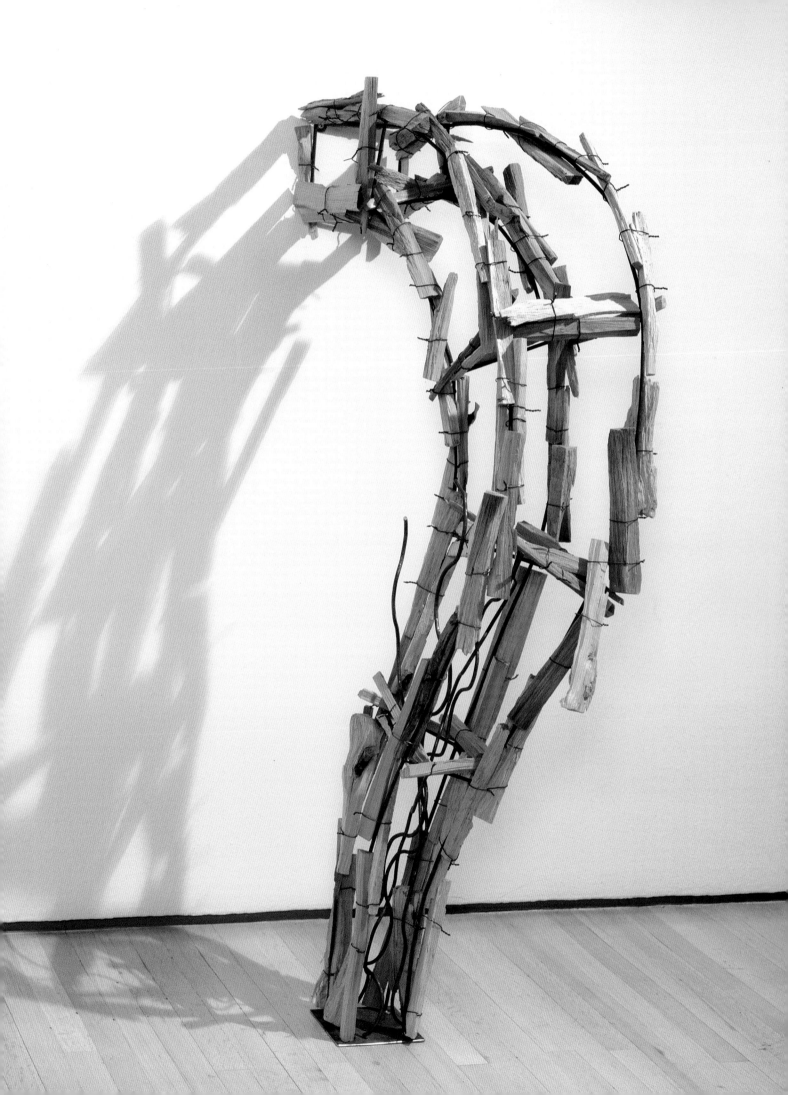

Richard Tuttle

One might say that in order to draw, you have to be able to see. Well, what about making drawings about an area you can't see? Oddly enough the drawings that go with this piece have a part in them of what you can't see. As obsessed as I am about the experience of seeing and details, what I find most interesting is the part which I can't see. And that's what I want to do—I just want to look at those kinds of places. For example *Village III* (2004) is in general about color, but in specific it's about a certain color blue. Ask somebody to draw blue, to make a drawing of blue. You know you can't do that. It's not linear, and it's not even symbolic, not a concept, and it can't be registered in any parallel notation, but there is some way, something you can do, to create the definition of what that drawing must do in the mind of the viewer or the maker that is equivalent to that color blue. I'm not philosophically-based, but you immediately get into areas where you ask, "Is that blue?" And that, indeed, gets us to this delicious subject of the wall and the floor—an old division between realism and idealism. In terms of blue—if we're going to try to draw blue—then the concrete is going to contribute and so is the ideal. But the division of the real and the ideal is basically about the ideal saying that the experience happens inside of you, which would mean that everything—from the conception of drawing to the color itself—is inside you, and the real saying that everything is outside you. I think the truth is that, yes, those are polarities that one can discuss and they can be useful, but finally it's art and art alone that can actually say what is the truth.

Fred Wilson

I really don't have any desire to make things directly with my hands. I don't know when I left that behind, because I studied art, but I get everything that satisfies my soul from the kinds of things that I do—bringing objects that are in the world and manipulating them, working with spatial arrangements, and then having things produced the way I want to see them. My work is strongly visual. I'm not a conceptual artist who is only interested in the idea. It's really rooted in the visual. That's where I get excited. But I have a great need for structure in a conceptual thread—perhaps throughout the works in a project—almost like a matrix more than a structure. Things build on one another in an installation. There's a basic matrix that they fit within and it's not something I draw up. It's a schema—another word might be 'theme'.

I was a museum guard. I always felt funny about that experience because, as guards, we were on display like everything else.

But we were also invisible. People were not there to look at the guards. In many museums, now, people talk to each other but back then nobody was talking to the guards. Years later, I was invited by the Whitney Museum to give a tour of one of their exhibitions—a show that I didn't organize. I said, "I'll do it, but I want to be in costume." I had lunch with all these people I had known for years. After lunch I said, "Okay, I'm going to change my clothes now." I put on a guard's uniform and stood by the sign that said I was going to be speaking. They all came down from lunch and wandered around, right in front of me, waiting for me to show up. So I stood for a while, while they did this, and then finally I said, "Okay, let's get this going." Even though they were embarrassed, I was very happy. I knew that you put this uniform on and you just become anonymous, which is why there are no heads on those guards in *Guarded View* (1991). You're just this suit—just a brown man in a suit.

RIGHT
Guarded View, 1991
Wood, paint, steel and fabric, dimensions variable
Whitney Museum of American Art, New York
Gift of the Peter Norton Family Foundation 97.84a-d

OPPOSITE, ABOVE AND BELOW
Modes of Transport 1770–1910, 1992–93
Various media, dimensions variable
Installation view of *Mining the Museum*, at the Contemporary and Maryland Historical Society (MdHS), Baltimore, Maryland

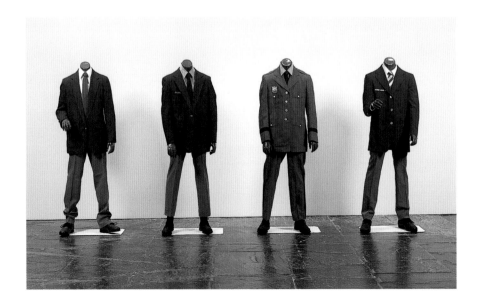

Fred Wilson

LEFT
Untitled (Eye), 1992
Plaster, 11½ x 10 x 3¾ inches
Installation view at Metro Pictures, New York

BELOW, LEFT
Cleopatra, 1992
Plaster and pedestal, 61½ x 8 x 8 inches
Installation view at Metro Pictures, New York

OPPOSITE, ABOVE
Untitled, 1992
Plaster, 11 inches diameter

OPPOSITE, BELOW
Untitled, 1992
Plaster, 28½ inches diameter

Whenever I use museum things, ancient things, I'm interested in how the metaphors relate to our contemporary situation or contemporary notions. . . . I would like to think that objects have memories—or that they're imbued with memory. A lot of what I do is capturing memory or eliciting memory from an object. I'm interested in the world of images and objects where people seem to forget about memory, forget these things have a past or multiple pasts. I think the more you know, the more you understand about something. It doesn't mean you ordinarily just don't have any new thoughts about it, but if you see something and you believe that what you think about it is all there is to know, there's something involved with the ego there. The more you know, the more you have in the world to work with. And I try to elicit those memories so that people are not walking around blinded by their environment. I look at things and wonder what they are and why they are. I see things and wonder why people are not wondering about them. Everything interests me: a gum wrapper could interest me as much as something at the Metropolitan Museum.

Fred Wilson

LEFT
By Degree, 1995
Ceramic and painted porcelain,
8 x 7 x 11¼ inches

BELOW, LEFT
Puppet, 1995
Painted porcelain, 7 x 2½ x 2 inches

BELOW, RIGHT
Funny, 1995
Painted plaster and ceramic, cork
and metal, 14 x 7½ x 6½ inches

OPPOSITE
Untitled, 1996
Mixed media, 5½ X 5 X 6 inches

I use topics like history and intellectual and cultural things in my work. But it all comes from this deep sadness inside of me that's kind of the baseline. I'm not a sad person but it bubbles up. If you look at the work in a total sense, it's not everything that's just making you cry. That's not how I go through the world but I think—if your work represents you—some of that's going to come through. So, I think there's a kind of deep sadness as an artist. And as an artist I have a way to get it out and look at it and communicate with the world without saying, "Look at me, I'm sad." It has nothing to do with that.

Fred Wilson

OPPOSITE, ABOVE
Exchange, 2004
Spit bite aquatint with color aquatint
and direct gravure, 30½ x 34 inches
Printed by Case Hudson, assisted
by Rachel Stevenson
Edition of 25

OPPOSITE, BELOW
Bang, 2004
Spit bite aquatint with color aquatint,
30½ x 34 inches
Printed by Case Hudson, assisted
by Rachel Stevenson
Edition of 20

ABOVE
Convocation, 2004
Spit bite aquatint with color aquatint
and direct gravure, 30½ x 34 inches
Printed by Case Hudson, assisted
by Rachel Stevenson
Edition of 25

I realized in printmaking that if I could just drop this stuff called spit bite—this acid—onto the plate, that it would eat onto the plate and it would make a spot or a splash. And filling it with black ink retains this spot and also has a kind of three-dimensional quality which doesn't happen when you use ink on a piece of paper. I was really thrilled. So I liked the fact that this was a very direct way to make a print. It was doing what printmaking does. It wasn't manipulating anything. I'm just dropping acid on a plate and the acid bites into the plate, and *bo-dink!* you print it, and that's it. Of course, that's *not* it, but the directness really thrilled me, and the fact that that's what I'm interested in—these drips and drops—really worked for me. Where I dropped the spots there are these 'thought bubbles'—like in cartoons—and they talk to each other. Various conversations emerge from the relationship between them. I pulled the text from black characters in novels or plays, or film screenplays. So they all talk to each other, these different characters, and the voices and personalities come out from these little blurbs. They have their various conversations and desires and trials. But they're black characters that were in plays or texts written by white writers. So these are representations of black people. To me it made sense that the representations of Africans in books would be the voices for the representations of blackness or black people in these spots.

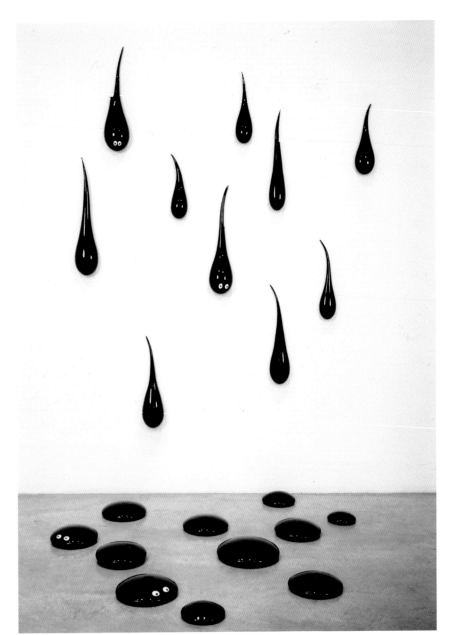

Fred Wilson

LEFT
Drip Drop Plop, 2001
Glass, approximately 8 x 5 feet

OPPOSITE
Chandelier Mori, (Speak of Me as I Am), 2003
United States Pavilion
Venice Biennale, 2003

Working with glass is very similar to work-ing with printmaking in that it's outside of what I usually do. Part of the difficult thing with glass is that it's hard to make anything that has a lot of meaning—or where the meaning is at least as strong as the beauty of the material. Infusing meaning is what I'm really interested in, so when this form came out of the process of trying different things I was very pleased. I wanted to use black glass because it looks like a liquid. It represents ink, oil, tar, and a lot of the titles in this series refer to what liquid does. I hope some of these images come through for people because that's how I'm thinking about them. Some have cartoony eyes

that bring it back to the social and histori-cal, relating to my own experiences as a child. For me, because of 1930s cartoons that were recycled in my childhood in the 1960s, these cartoon eyes on a black object represent African-Americans in a very derogatory way. Any material that was black could be made into something that represents an African-American. That, to me, is an extremely sad commentary. So I sort of view them as black tears. If I was to boil it down to a couple of words, also thinking about the disintegration of the body to an essence of just color— which really has no bearing on race or culture or anything—it's just how America thought of African-Americans.

There are several black glass things in the Venice installation. Whenever I use black it relates to some history of Africans in that particular place. It's the idea of the color black as a metaphor, or as a representation of African-Americans. It's the notion of black—blackness—and all its other mean-ings in relation to the history of race but also its meanings as just the color—or lack of color—or specific materials and their own histories, and trying to confuse that a bit. I'm teasing this apart and confusing it because this idea that black represents humans is really such a wild construction not only in America but, looking at Venice, going back to the twelfth century when Africans first met Europeans.

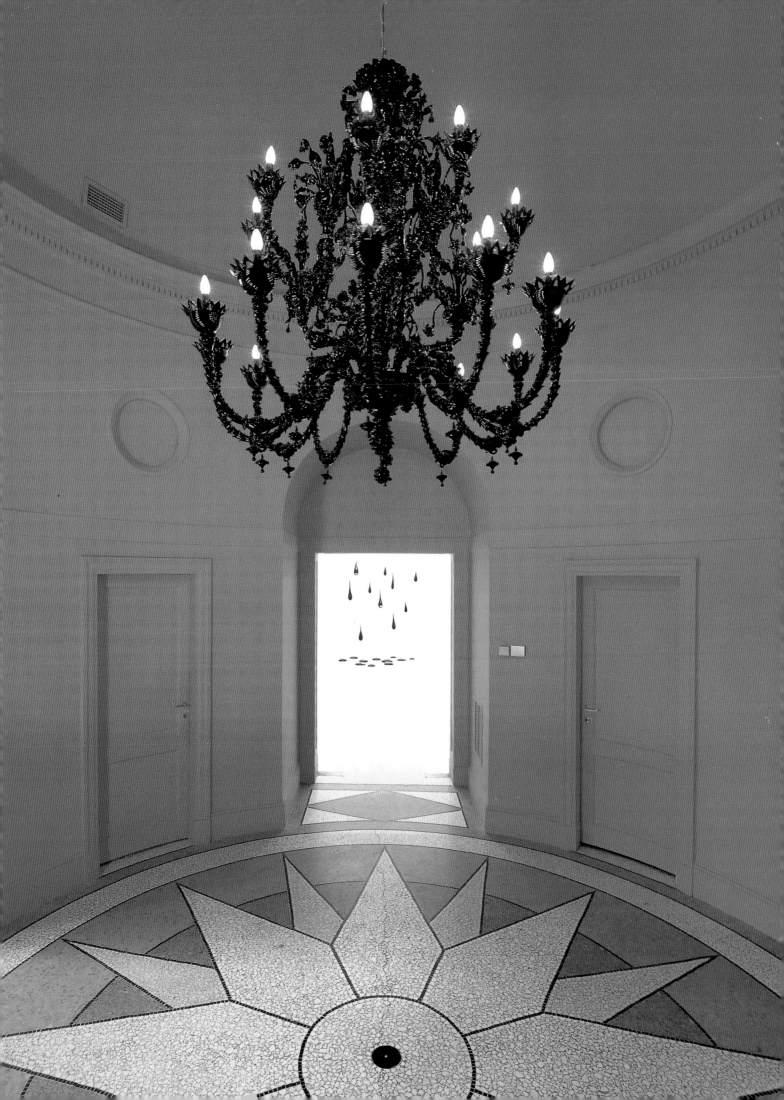

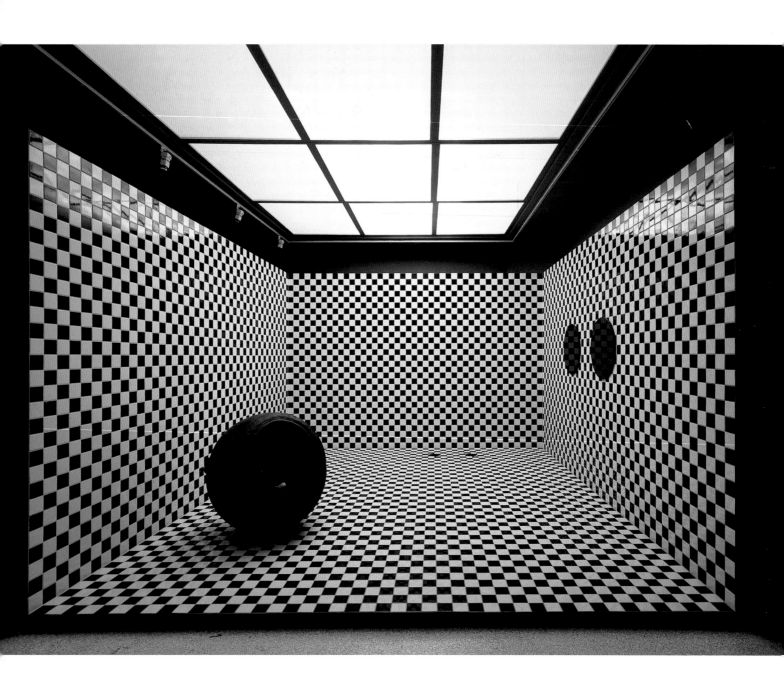

The work at the 2003 Venice Biennale had many different parts. My work is essentially about where I am—and here I was, this African-American, doing a project in the American Pavilion about the Africans of Venice. The part that was the most abstract was this room that I created of black and white tile—thinking about issues of black and white. The room vibrated if you stood there and visually offset you a little bit because of that. I was also interested in institutional spaces—the kinds of places that you're familiar with but not necessarily comfortable in, like a bathroom in an airport, where you can be alone but where you're not alone. So this is a little bit of what the tiled room was about. There was writing in the tile grout, in various colonial languages that Africans found themselves speaking at one point or another. And the quotes were about fear, about hope, about escape—all extrapolations from classic African-American slave narratives. . . . In many men's rooms you'll see writing in the grout, a kind of personal speaking-to-the-world that nobody knows you're doing. Of course, this is not quite what people write in those little things, but

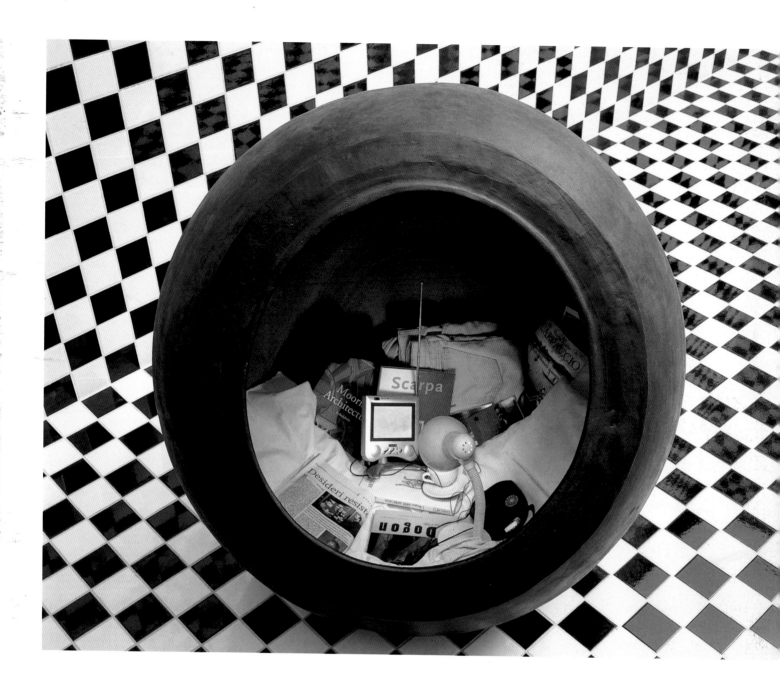

this is that kind of personal expression that you couldn't see unless you got up to the wall and really looked at it. There were holes in the floor with some liquid in there, and there were big black mirrors on the wall. Then there was a huge black urn on its side—and in it was a small bed, a cappuccino cup, some newspapers, magazines, a CD player. The whole room was called *Turbulence II*. In addition to the space, there was sound—a collage of tapes of the death scene from *Othello* from two operas and two plays—coming from behind the walls. There was also a video of four different versions of *Othello* running backwards and edited down from the death scene back to when Othello and Desdemona were in love. I did the pieces in my mind right after September 11th. And it really was about that experience and just much more, about emotions and feelings. So that room is a virtual space—a state of mind, a kind of futile, ridiculous thought, wanting the world to go back the way it was before September 11th. And the pot, with the little bed and all, that sits there in the space is called *Safe House II*. It's another emotional space. A place to be safe.

Fred Wilson

OPPOSITE
Turbulence II, (Speak of Me as I Am), 2003
United States Pavilion
50th Venice Biennale, 2003

ABOVE
Safe House II, (Speak of Me as I Am), 2003
United States Pavilion
50th Venice Biennale, 2003

Biographies of the Artists

Laylah Ali

Laylah Ali was born in Buffalo, New York in 1968. She received a BA from Williams College and an MFA from Washington University in St. Louis, Missouri. The precision with which Ali creates her small figurative gouache paintings on paper is such that it takes her many months to complete a single work. In style, her paintings resemble comic-book serials, but they also contain stylistic references to hieroglyphics and American folk-art traditions. Ali often achieves a high level of emotional tension in her work as a result of juxtaposing brightly colored scenes with dark, often violent subject matter that speaks of political resistance, social relationships, and betrayal. Although Ali's interest in current events drives her work, her finished paintings rarely reveal specific references. Her most famous and longest-running series of paintings depicts the brown-skinned and gender-neutral Greenheads, while her most recent works include portraits as well as more abstract biomorphic images. Ali endows the characters and scenes in her paintings with everyday attributes like dodge balls, sneakers, and band-aids as well as historically- and culturally-loaded signs such as nooses, hoods, robes, masks, and military-style uniforms. Laylah Ali has had solo exhibitions at the Museum of Modern Art, New York; ICA, Boston; MCA Chicago; Contemporary Art Museum, St. Louis; and MASS MoCA, among others. Her work was exhibited at the Venice Biennale (2003) and the Whitney Biennial (2004). Laylah Ali lives and works in Williamstown, Massachusetts.

Ida Applebroog

Ida Applebroog was born in the Bronx, New York in 1929. She attended the School of the Art Institute of Chicago and received an honorary doctorate from New School University/Parsons School of Design. Applebroog has been making pointed social commentary in the form of beguiling comic-like images for nearly half a century. Anonymous 'everyman' figures, anthropomorphized animals, and half human-half creature characters are featured players in the uncanny theater of her work.

Applebroog propels her paintings and drawings into the realm of installation by arranging and stacking canvases in space. In her most characteristic work, she combines popular imagery from everyday urban and domestic scenes, sometimes paired with curt texts, to skew otherwise banal images into anxious scenarios infused with a sense of irony and black humor. Strong themes in her work include gender and sexual identity, power struggles both political and personal, and the pernicious role of mass media in desensitizing the public to violence. Applebroog has received many awards, including a John D. and Catherine T. MacArthur Foundation Achievement Award and a Lifetime Achievement Award from the College Art Association. Her work has been shown in many one-person exhibitions in the United States and abroad, including the Corcoran Gallery of Art, Washington, DC; Whitney Museum of American Art, New York; the Contemporary Arts Museum, Houston; and the High Museum of Art, Atlanta, among others. Ida Applebroog lives and works in New York.

Cai Guo-Qiang

Cai Guo-Qiang was born in 1957 in Quanzhou City, Fujian Province, China. He studied stage design at the Shanghai Drama Institute from 1981 to 1985. Accomplished in a variety of media, Cai began using gunpowder in his work to foster spontaneity and confront the controlled artistic tradition and social climate in China. These projects, while poetic and ambitious at their core, aim to establish an exchange between viewers and the larger universe. For his work, Cai draws on a wide variety of materials, symbols, narratives, and traditions—elements of feng shui, Chinese medicine and philosophy, images of dragons and tigers, roller coasters, computers, vending machines, and gunpowder. "Why is it important," he asks, "to make these violent explosions beautiful? Because the artist, like an alchemist, has the ability to transform certain energies, using poison against poison, using dirt and getting gold." Cai Guo-Qiang has received a number of awards including the 48th Venice Biennale International Golden Lion Prize and the CalArts/Alpert Award in the Arts. Among his many solo exhibitions and projects are *Light Cycle: Explosion Project for Central Park*, New York; *Ye Gong Hao Long: Explosion Project for Tate Modern*, London; *Transient Rainbow*, Museum of Modern Art, New York; and *APEC Cityscape Fireworks Show*, Asia Pacific Economic Cooperation, Shanghai. His work has appeared in group exhibitions including, among others, the São Paulo Bienale (2004); Whitney Biennial (2000); and three Venice Biennales.

Ellen Gallagher

Ellen Gallagher was born in Providence, Rhode Island, in 1965. She attended Oberlin College and the School of the Museum of Fine Arts, Boston. Repetition and revision are central to Gallagher's treatment of advertisements that she appropriates from popular magazines like *Ebony*, *Our World*, and *Sepia* and uses in works like *eXelento* (2004) and *DeLuxe* (2004–05). Although the work has often been interpreted strictly as an examination of race, Gallagher also suggests a more formal reading with respect to materials, processes, and insistences. From afar, the work appears abstract and minimal. Upon closer inspection, googly eyes, reconfigured wigs, tongues, and lips of minstrel caricatures multiply in detail. Gallagher has been influenced by the sublime aesthetics of Agnes Martin's paintings as well the subtle shifts and repetitions of Gertrude Stein's writing. In her earlier works, Gallagher glued pages of penmanship paper onto stretched canvas and then drew and painted on it. Gallagher received the American Academy Award in Art and a Joan Mitchell Foundation Fellowship. Solo exhibitions include the Whitney Museum of American Art; Museum of Contemporary Art, North Miami; St. Louis Art Museum; Des Moines Art Center; Yerba Buena Center for the Arts, San Francisco; and ICA Boston. Her work appeared in the Whitney Biennial (1995). Ellen Gallagher lives and works in New York and Rotterdam.

Arturo Herrera

Arturo Herrera was born in Caracas, Venezuela in 1959. He received a BA from the University of Tulsa, Oklahoma, and an MFA from the University of Illinois at Chicago. Herrera's work includes collage, work on paper, sculpture, relief, wall painting, photography, and felt wall hangings. His work taps into the viewer's unconscious, often intertwining fragments of cartoon characters with abstract shapes and partially obscured images that evoke memory and recollection. For his collages he uses found images from cartoons, coloring books, and fairy tales, combining fragments of Disney-like characters with violent and

sexual imagery to make work that borders between figuration and abstraction and subverts the innocence of cartoon referents with a darker psychology. In his felt works, he cuts shapes from a piece of fabric and pins the fabric to the wall so that it hangs like a tangled form resembling the drips and splatters of a Jackson Pollock painting. Herrera's wall paintings also meld recognizable imagery with abstraction, but on an environmental scale that he compares to the qualities of dance and music. Herrera has received many awards including, among others, a DAAD Fellowship. He has had solo exhibitions at Centre d'Art Contemporain, Geneva; Dia Center for the Arts, New York; Centro Galego de Arte Contemporánea, Santiago de Compostela; the Whitney Museum of American Art, New York; and UCLA Hammer Museum, Los Angeles, among others. His work appeared in the Whitney Biennial (2002). Arturo Herrera lives and works in Berlin and New York.

Oliver Herring

Oliver Herring was born in Heidelberg, Germany in 1964. He received a BFA from the University of Oxford (Ruskin School of Drawing and Fine Art), Oxford, England, and an MFA from Hunter College, New York. Among Herring's early works were his woven sculptures and performance pieces in which he knitted Mylar, a transparent and reflective material, into human figures, clothing, and furniture. Since 1998, Herring has created stop-motion videos and participatory performances with 'off-the-street' strangers. Open-ended and impromptu, Herring's videos have a dreamlike stream-of-consciousness quality. Embracing chance and chance encounters, his videos and performances liberate participants to explore aspects of their personalities through art in a way that would otherwise probably be impossible. In a series of large-scale photographs, Herring documents strangers' faces after hours of spitting colorful food dye, recording a moment of exhaustion and intensity that doubles as a form of abstract painting. Herring's use of photography takes an extreme turn in his most recent series of photo-sculptures. For these works, Herring painstakingly photographs a model from all possible angles, then cuts and pastes the photographs onto the sculptural form of his subject. Herring has received grants from Artpace; New York Foundation for the Arts; and the Joan Mitchell Foundation. He has had one-person exhibitions at the Museum of Modern Art, New York; the Solomon R. Guggenheim Museum, New York; and the New Museum of Contemporary Art, New York, among others. Oliver Herring lives and works in Brooklyn, New York.

Roni Horn

Roni Horn was born in New York in 1955. She received a BFA from the Rhode Island School of Design and an MFA from Yale University. Horn explores the mutable nature of art through sculptures, works on paper, photography, and books. She describes drawing as the key activity in all her work because drawing is about composing relationships. Horn crafts complex relationships between the viewer and her work by installing a single piece on opposing walls, in adjoining rooms, or throughout a series of buildings. She subverts the notion of 'identical experience', insisting that one's sense of self is marked by a place in the here-and-there, and by time in the now-and-then. She describes her artworks as site-dependent, expanding upon the idea of site-specificity associated with Minimalism. Since 1975 Horn has traveled often to Iceland, whose landscape and isolation have strongly influenced her practice. *Some Thames* (2000), a permanent installation at the University of Akureyri in Iceland, consists of 80 photographs of water dispersed throughout the university's public spaces, echoing the ebb and flow of students and learning over time at the university. Roni Horn received the CalArts/Alpert Award in the Arts, several NEA fellowships, and a Guggenheim fellowship. She has had one-person exhibitions at the Art Institute of Chicago; Dia Center for the Arts, New York; and Whitney Museum of American Art, New York, among others. Group exhibitions include the Whitney Biennial (1991, 2004); Documenta (1992); and Venice Biennale (1997), among others. Roni Horn lives and works in New York.

Hubbard / Birchler

Teresa Hubbard was born in Dublin, Ireland in 1965. Alexander Birchler was born in Baden, Switzerland in 1962. Both received MFAs from the Nova Scotia College of Art and Design, Halifax, Canada. As life partners and artist-collaborators, Hubbard and Birchler make short films and photographs about the construction of narrative time and space without the context of a traditional story line. Their open-ended, enigmatic narratives elicit multiple readings in the construction and negotiation of space, architecture, and the function of objects in three dimensions. In the video installations *Detached Building* (2001) and *Eight* (2001), the camera moves in and out of buildings in seamless loops, blurring the physical and chronological borders between here-and-there, before-and-after. Their productions reveal a strong sense of carefully constructed *mise-en-scène* that owes as much to natural history-museum dioramas as to cinematic directorial techniques. Hubbard and Birchler cite as influences Hitchcock, Malick, Mamet, Kafka, Flaubert, and Hopper, all of whom are notable for use of the psycho-spatial dimension. Hubbard and Birchler's work has been shown at the Whitney Museum of American Art at Altria, New York; Centro Galego de Arte Contemporánea, Santiago de Compostela; Museum of Contemporary Art, Berlin; Foundation for Photography, Amsterdam; Center for Photography, Salamanca; Venice Biennale (1999); and National Gallery, Prague. Teresa Hubbard and Alexander Birchler live and work in Austin, Texas.

Mike Kelley

Mike Kelley was born in Detroit, Michigan in 1954. He received a BFA from the University of Michigan, and an MFA from the California Institute of the Arts. Kelley's work ranges from highly symbolic and ritualistic performance pieces, to arrangements of stuffed-animal sculptures, to multi-room installations that restage institutional environments (schools, offices, zoos). A critic and curator, Kelley has organized numerous exhibitions incorporating his own work, work by fellow artists, and non-art objects that exemplify aspects of nostalgia, the grotesque, and the uncanny. His work questions the legitimacy of 'normative' values and systems of authority, and attacks the sanctity of cultural attitudes toward family, religion, sexuality, art history, and education. He also comments on and undermines the legitimacy of victim or trauma culture, which posits that almost all behavior results from some form of repressed abuse. Kelley's ongoing pseudo-autobiographical project, *Extracurricular Activity Projective Reconstruction*, begun in 1995, is a planned compendium of 365 sculpture and video works, inspired by mundane yearbook photos. Kelley's aesthetic mines the rich and often overlooked

history of vernacular art in America, and his practice borrows heavily from the confrontational "by all means necessary" attitude of punk music. Mike Kelley received the Skowhegan Medal in Mixed Media and two grants from the National Endowment for the Arts. Major solo exhibitions include the Whitney Museum of American Art, New York; Los Angeles County Museum of Art; Hirshhorn Museum and Sculpture Garden, Washington, DC; and Kunsthalle, Basel, among others. He lives and works in Los Angeles.

Josiah McElheny

Josiah McElheny was born in Boston, Massachusetts in 1966. He received a BFA from the Rhode Island School of Design, and apprenticed with master glassblowers Ronald Wilkins, Jan-Erik Ritzman, Sven-Ake Caarlson, and Lino Tagliapietra. McElheny creates finely crafted, handmade glass objects that he combines with photographs, text, and museological displays to evoke notions of meaning and memory. Whether recreating miraculous glass objects pictured in Renaissance paintings or modernized versions of nonextant glassware from documentary photographs, Josiah McElheny's work takes as its subject the object, idea, and social nexus of glass. Influenced by the writings of Jorge Luis Borges, McElheny's work often takes the form of 'historical fiction'. Part of McElheny's fascination with storytelling is that glassmaking is part of an oral tradition handed down artisan to artisan. In *Total Reflective Abstraction* (2003–04), the mirrored works themselves refract the artist's self-reflexive examination. Sculptural models of Modernist ideals, these totally reflective environments are both elegant seductions as well as parables of the vices of utopian aspirations. Recipient of a Louis Comfort Tiffany Foundation Award (1995) and the 15th Rakow Commission from the Corning Museum of Glass, McElheny has had one-person exhibitions at the Henry Art Gallery, Seattle; Isabella Stewart Gardner Museum, Boston; Yerba Buena Center for the Arts, San Francisco; and Centro Galego de Arte Contemporánea, Santiago de Compostela. His work has been exhibited at SITE Santa Fe and the Whitney Biennial (2000). Josiah McElheny lives and works in New York.

Matthew Ritchie

Matthew Ritchie was born in London, England in 1964. He received a BFA from Camberwell School of Art, London, and attended Boston University. His artistic mission has been no less ambitious than an attempt to represent the entire universe and the structures of knowledge and belief that we use to understand and visualize it. Ritchie's encyclopedic project stems from his imagination, and is catalogued in a conceptual chart replete with allusions drawn from Judaeo-Christian religion, occult practices, Gnostic traditions, and scientific principles. Ritchie's paintings, installations, and narrative threads delineate the universe's formation as well as the attempts and limits of human consciousness to comprehend its vastness. Ritchie's work deals explicitly with the idea of information being 'on the surface', and information is also the subject of his work. Although often described as a painter, Ritchie creates floor-to-wall installations, freestanding sculpture, web sites, and short stories which tie his sprawling works together into a narrative structure. He scans his drawings into the computer so that images can be blown up, taken apart, made smaller or three-dimensional. One ongoing work that Ritchie calls an endless drawing contains everything he has drawn before. Ritchie's work has been shown in one-person exhibitions at the Contemporary Arts Museum, Houston; MASS MoCA; SFMoMA; and Museum of Contemporary Art, North Miami, among others. His work was also exhibited at the Whitney Biennial (1997), Sydney Biennale (2002), and São Paulo Bienale (2004). Matthew Ritchie lives and works in New York.

Susan Rothenberg

Susan Rothenberg was born in Buffalo, New York in 1945. She received a BFA from Cornell University. The first body of work for which she became known centered on life-sized images of horses. Glyph-like and iconic, these images are not so much abstracted as pared down to their most essential elements. The horses, along with fragmented body parts (heads, eyes, and hands) are almost totemic, like primitive symbols, and serve as formal elements through which Rothenberg investigated the meaning,

mechanics, and essence of painting. Rothenberg's paintings since the 1990s reflect her move from New York to New Mexico, her adoption of oil painting, and her new-found interest in using the memory of observed and experienced events as an armature for creating a painting. These scenes excerpted from daily life, whether highlighting an untoward event or a moment of remembrance, come to life through Rothenberg's thickly layered and nervous brushwork. A distinctive characteristic of these paintings is a tilted perspective in which the vantage point is located high above the ground, investing the work with an eerily objective psychological edge. Susan Rothenberg received a fellowship from the National Endowment for the Arts and the Skowhegan Medal for Painting. She has had one-person exhibitions at the Museum of Fine Arts, Boston; Hirshhorn Museum and Sculpture Garden, Washington, DC; Los Angeles County Museum of Art; Museum of Contemporary Art, Chicago; Walker Art Center, Minneapolis; and the Tate Gallery, London, among others. Susan Rothenberg lives and works in New Mexico.

Jessica Stockholder

Jessica Stockholder was born in Seattle, Washington in 1959. She studied painting at the University of British Columbia, Vancouver, and received an MFA from Yale University. Stockholder is a pioneer of multimedia genre-bending installations. Her site-specific interventions and autonomous floor and wall pieces have been described as "paintings in space." Stockholder's complex installations incorporate the architecture in which they have been conceived, blanketing the floor, scaling walls and ceiling, and even spilling out of windows, through doors, and into the surrounding landscape. Her work is energetic, cacophonous, and idiosyncratic, but close observation reveals formal decisions about color and composition, and a tempering of chaos with control. Bringing the vibrant, Technicolor plastic products of consumer culture to her work, she later adds painted areas of bright purple, turquoise, pink, orange and green, calibrating each color for maximum optical and spatial impact. Stockholder's installations, sculptures, and collages affirm the primacy of pleasure, the blunt reality of things, and the

rich heterogeneity of life, mind, and art amid a vortex of shifting polarities— abstraction/realism, classical order/ intuitive expressionism, conscious thought/unconscious desire. Jessica Stockholder is Director of Graduate Studies in Sculpture at Yale University. Her work has been exhibited at Dia Center for the Arts, New York; the Whitney Museum of American Art, New York; SITE Santa Fe; the Venice Biennale; Kunstmuseum St. Gallen; and Centre Georges Pompidou, Paris, among others. Jessica Stockholder lives and works in New Haven, Connecticut.

Hiroshi Sugimoto

Hiroshi Sugimoto was born in Tokyo, Japan in 1948. Central to Sugimoto's work is the idea that photography is a time machine, a method of preserving and picturing memory and time. This theme provides the defining principle of his ongoing series including, among others, *Dioramas* (1976–); *Theaters* (1978–); and *Seascapes* (1980–). Sugimoto sees with the eye of the sculptor, painter, architect, and philosopher. He uses his camera in a myriad of ways to create images that seem to convey his subjects' essence, whether architectural, sculptural, painterly, or of the natural world. He places extraordinary value on craftsmanship, printing his photographs with meticulous attention. Recent projects include an architectural commission at Naoshima Contemporary Art Center in Japan, for which Sugimoto designed and built a Shinto shrine, and the photographic series, *Conceptual Forms*, inspired by Marcel Duchamp's *Large Glass: The Bride Stripped Bare by her Bachelors, Even.* Sugimoto has received fellowships from the Guggenheim Foundation and the National Endowment for the Arts; the 2001 Hasselblad Foundation International Award in Photography; and has had one-person exhibitions at the Metropolitan Museum of Art, New York; Museum of Modern Art, New York; LAMoCA; MCA Chicago; and Hara Museum of Contemporary Art, Tokyo, among others. The Hirshhorn Museum and Sculpture Garden, Washington, DC, and the Mori Art Museum, Tokyo, are joint organizers of a 2005 Sugimoto retrospective. Hiroshi Sugimoto lives and works in New York and Tokyo.

Richard Tuttle

Richard Tuttle was born in Rahway, New Jersey in 1941. He received a BA from Trinity College, Hartford, Connecticut. Although most of Tuttle's prolific artistic output since he began his career in the 1960s has taken the form of three-dimensional objects, he commonly refers to his work as drawing rather than sculpture, emphasizing the diminutive scale and idea-based nature of his practice. He subverts the conventions of modernist sculptural practice (defined by grand heroic gestures, monumental scale, and the 'macho' materials of steel, marble, and bronze) and instead creates small, eccentrically playful objects in decidedly humble, even 'pathetic' materials such as paper, rope, string, cloth, wire, and plywood. Tuttle also manipulates the space in which his objects exist, placing them unnaturally high or oddly low on a wall. Influences on his work include calligraphy, poetry, and language. A lover of books and printed matter, Tuttle has created artist's books, collaborated on the design of exhibition catalogues, and is a consummate printmaker. Richard Tuttle received a National Endowment for the Arts fellowship and the Skowhegan Medal for Sculpture. He has had one-person exhibitions at the Museum of Modern Art, New York; Whitney Museum of American Art, New York; ICA Philadelphia; Kunsthaus Zug, Switzerland; and the Centro Galego de Arte Contemporánea, Santiago de Compostela. SFMoMA is the organizer of a 2005 Tuttle retrospective. Richard Tuttle lives and works in New Mexico and New York.

Fred Wilson

Fred Wilson was born in the Bronx, New York in 1954. He received a BFA from SUNY/Purchase. Wilson creates new exhibition contexts for the display of art and artifacts found in museum collections, along with wall labels, sound, lighting, and non-traditional pairings of objects. His installations lead viewers to recognize that changes in context create changes in meaning. While appropriating curatorial methods and strategies, Wilson maintains his subjective view of the museum environment. He questions— and forces the viewer to question—how curators shape interpretations of historical truth, artistic value, and the language of

display, and what kinds of biases our cultural institutions express. In his groundbreaking intervention, *Mining the Museum* (1992–93), Wilson transformed the Baltimore Historical Society's collection to highlight the history of slavery in America. For the 2003 Venice Biennale, Wilson created a mixed-media installation of many parts, focusing on Africans in Venice and issues and representations of black and white, which included a suite of black glass sculptures; a black-and-white tiled room with wall graffiti; and a video installation of *Othello* screened backwards. Wilson received a John D. and Catherine T. MacArthur Foundation Achievement Award (1999) and the Larry Aldrich Foundation Award (2003). He is the Distinguished Visiting Fellow in Object, Exhibition, and Knowledge at Skidmore College. Fred Wilson represented the United States at the Biennial Cairo (1992) and Venice Biennale. Fred Wilson lives and works in New York.

Krzysztof Wodiczko

Krzysztof Wodiczko was born in 1943 in Warsaw, Poland. Since 1980, he has created large-scale slide and video projections of politically-charged images on architectural façades and monuments worldwide. By appropriating public buildings and monuments as backdrops for projections, Wodiczko focuses attention on ways in which architecture and monuments reflect collective memory and history. In 1996 he added sound and motion to the projections and began to collaborate with communities around chosen projection sites, giving voice to the concerns of heretofore marginalized and silent citizens. Projecting images of community members' hands, faces, or entire bodies onto architectural façades, and combining those images with voiced testimonies, Wodiczko disrupts our traditional understanding of the functions of public space and architecture. He challenges the silent, stark monumentality of buildings, activating them in an examination of notions of human rights, democracy, and truths about the violence, alienation, and inhumanity that underlie countless aspects of present-day society. Wodiczko heads the Interrogative Design Group and is Director of the Center for Art, Culture, and Technology at the Massachusetts Institute of Technology. His work has appeared in many international exhibitions, including the São Paulo Bienale (1965, 1967, 1985); Documenta (1977, 1987); the Venice Biennale (1986, 2000); and the Whitney Biennial (2000). Wodiczko received the 1999 Hiroshima Art Prize, and the 2004 College Art Association Award for Distinguished Body of Work. Krzysztof Wodiczko lives in New York and Cambridge, Massachusetts.

List of Illustrations

Photographic Credits and Copyrights

COMMISSIONED VIDEO SEGMENTS: p. 9, photo by Stefan Rohner, courtesy the artists and Tanya Bonakdar Gallery, New York; pp. 10–12, 13 (bottom), 16–17, courtesy the artists and Tanya Bonakdar Gallery, New York; p. 13 (top), photo by Shaune Kolber, courtesy the artists and Tanya Bonakdar Gallery, New York; pp. 14–15, photos by Bill Records, courtesy the artists and Tanya Bonakdar Gallery, New York.

POWER: pp. 22, 23 (top), 25, jacket back (bottom), courtesy the artist; p. 23 (center & bottom), 26–28, 29 (bottom), 30 (top), 31–33, courtesy 303 Gallery, New York; p. 24, photo by Walker Art Center, Minneapolis, courtesy the artist and 303 Gallery, New York; p. 29 (top), courtesy Miller Block Gallery, Boston; p. 30 (bottom), photo by Contemporary Art Museum, St. Louis, courtesy 303 Gallery, New York and Miller Block Gallery, Boston; pp. 34, 38, 42, photos by Dennis Cowley, courtesy Ronald Feldman Fine Arts, New York; pp. 35–37, 40–41, 43, photos by Jennifer Kotter, courtesy Ronald Feldman Fine Arts, New York; p. 39, photo by Patricia L. Bazelon, courtesy Ronald Feldman Fine Arts, New York; pp. 44–45, production by Rita MacDonald and Robert MacDonald, courtesy Ronald Feldman Fine Arts, New York; pp. 2–3, 46–47, 52–53, 55, photos by Hiro Ihara, courtesy the artist; pp. 48–51, photos by Kevin Kennefick, courtesy the artist; p. 54, courtesy the artist; p. 56, photo by Cai Guo-Qiang, courtesy the artist; p. 57, photo by Chris Smith, courtesy Hirshhorn Museum and Sculpture Garden, Smithsonian Museum; pp. 58–69, jacket front (bottom), courtesy the artist and Galerie Lelong, New York.

MEMORY: pp. 74–77, courtesy the artist; p. 78, photo by Geoffrey Clements, photograph copyright © 1998: Whitney Museum of American Art, New York; p. 79, courtesy Jablonka Galerie, Cologne; pp. 80–81, photos by Fredrik Nilsen, courtesy Jablonka Galerie, Cologne; p. 82, photo by Sandak/Macmillan Publishing Company, photograph copyright © 1998: Whitney Museum of American Art, New York; p. 83–85, photos by Nic Tenwiggenhorn, courtesy Jablonka Galerie, Cologne; pp. 86–87, 89–91, 96–97, jacket front (top), photos by Tom Van Eynde, courtesy Donald Young Gallery, Chicago; p. 88, photo by Stephen White, courtesy Donald Young Gallery, Chicago; p. 92, photo by Clare Garoutte, courtesy Donald Young Gallery, Chicago; pp. 93–94, photos by Mark Ritchie, courtesy Donald Young Gallery, Chicago; p. 95, photos by Ron Amstutz, courtesy Donald Young Gallery, Chicago; pp. 98–109, © 2005 Susan Rothenberg/Artists Rights Society (ARS), New York, courtesy Sperone Westwater, New York; pp. 111, 119, 120–121, photos by Hiroshi Sugimoto, courtesy the artist; pp. 112–118, courtesy the artist.

PLAY: p. 126, ll. 1–18, 33–37; p. 132, ll. 1–19; p. 136, ll. 1–28, © 2004 The Fruitmarket Gallery, Brian Ross, Ellen Gallagher; pp. 126–127, photos by Robert McKeever, courtesy Gagosian Gallery, New York; p. 128, photo by Sheldan C. Collins; pp. 129–131, photos by D. James Dee, courtesy Two Palms Press, New York, © Ellen Gallagher; pp. 132–137, photos by Tom Powel, courtesy Gagosian Gallery, New York; pp. 138–149, courtesy Brent Sikkema, New York; pp. 150–155, 160–161, endpaper (back), courtesy Max Protetch Gallery, New York; p. 156 (left), photo by Oliver Herring, courtesy Max Protetch Gallery, New York; pp. 156 (right), 157, endpaper (front), photos by Chris Burke Studio, courtesy Max Protetch Gallery, New York; pp. 158–159, photo by Dennis Cowley, courtesy Max Protetch Gallery, New York; pp. 4–5, 166 (left), 167, 170, 172–173, courtesy the artist and Mitchell-Innes and Nash, New York; p. 163, photos by Jessica Stockholder, courtesy the artist and Mitchell-Innes and Nash, New York; pp. 164–165, courtesy the artist and Kunstmuseum St. Gallen, Switzerland; p. 166 (right), photo by AC Castoradis, courtesy the artist and Mitchell-Innes and Nash, New York; p. 168, photo by Oren Slor, courtesy the artist and Mitchell-Innes and Nash, New York; p. 169, courtesy the artist and Dieu Donné Papermill, New York; p. 171, photo by Ville de Nantes, Musée des Beaux-Arts, Alain Guillard and Jessica Stockholder, courtesy the artist and Mitchell-Innes and Nash, New York.

STRUCTURES: pp. 178, 183–184, photos by Bill Jacobson, courtesy Matthew Marks Gallery, New York; pp. 179–181, photos by Oren Slor, courtesy Matthew Marks Gallery, New York; pp. 182, 185–186, 188–189, courtesy Matthew Marks Gallery, New York; p. 187, photos by Nic Tenwiggenhorn, courtesy Matthew Marks Gallery, New York; pp. 190–192, 196–197, photos © Matthew Ritchie, courtesy Andrea Rosen Gallery, New York; pp. 193, 198–201, photos by Oren Slor, © Matthew Ritchie, courtesy Andrea Rosen Gallery, New York; pp. 194–195, jacket back (top), photos by Hester + Hardaway, © Matthew Ritchie, courtesy Andrea Rosen Gallery, New York; p. 195 (right), © Art21, Inc.; pp. 202– 213, courtesy Sperone Westwater, New York; p. 214, photo by Geoffrey Clements, photograph copyright © 1998: Whitney Museum of American Art, New York; pp. 215–216, courtesy PaceWildenstein, New York; pp. 217–218, photos by Kerry Ryan McFate, courtesy PaceWildenstein, New York; p. 219, photo by Ellen Labenski, courtesy PaceWildenstein, New York; pp. 220–221, courtesy Crown Point Press, San Francisco; p. 222, courtesy Metro Pictures, New York; pp. 223–225, photos by R. Ransick/A. Cocchi, courtesy PaceWildenstein, New York.

PRODUCTION STILLS: pp. 18–21, 70–73, 122–125, 174–177, © Art21, Inc.

For Harry N. Abrams, Inc.:
Project Manager: Margaret L. Kaplan
Production Manager: Jane Searle

For Art21, Inc.:
Assistant Curator: Wesley Miller
Designer: Russell Hassell

Library of Congress Cataloging-in-Publication Data

Sollins, Susan.
 Art 21 : art in the twenty-first century 3 / Susan Sollins.
 p. cm.
Summary: Companion book to Art in the Twenty-First Century, the first broadcast series for National Public Television to focus exclusively on contemporary visual art and artists in the United States today.
 ISBN 0-8109-5916-x (vol. 3) (permanent paper)
 1. Art, American—20th century. 2. Art, American—21st century. 3. Artists—United States—Interviews. 4. Artists—United States—Biography.
I. Title: Art twenty one. II. Title: Art in the twenty-first century 3. III. Art:21 (Television program) IV. Title.

N6512.S637 2005
709'.2'273—dc22 2005006130

Published in 2005 by Harry N. Abrams, Incorporated, New York

Printed and bound in China
10 9 8 7 6 5 4 3 2 1

Harry N. Abrams, Inc.
115 West 18th Street
New York, N.Y. 10011
www.abramsbooks.com

Abrams is a subsidiary of

ENDPAPER, FRONT: Oliver Herring, *S. Swings J. With Add. Vines*, detail, 2003. Multi-layered C-print, 19¼ x 27¼ x 2½ inches

ENDPAPER, BACK: Oliver Herring, *S. Swings J. With Roots*, detail, 2003. C-print with permanent black marker, 23¼ x 27¼ x 1½ inches

TITLE PAGE: Cai Guo-Qiang, *Inopportune: Stage One*, 2004. Installation view at MASS MoCA, North Adams, Massachusetts. Cars, sequenced multi-channel light tubes, dimensions variable. Collection of the artist

TABLE OF CONTENTS: Jessica Stockholder, *Skin Toned Garden Mapping*, 1991. Installation at the Renaissance Society, Chicago, Illinois. Paint, red carpet, 2 x 4s, roofing tar, refrigerator doors, hardware, yellow bug lights and fixtures, cloth, vinyl composition floor tiles, concrete and tinfoil, 3140 square feet overall